Culturally
Relevant
Teaching

Studies in the
Postmodern Theory of Education

Shirley R. Steinberg
General Editor

Vol. 396

The Counterpoints series is part of the Peter Lang Education list.
Every volume is peer reviewed and meets
the highest quality standards for content and production.

PETER LANG
New York • Washington, D.C./Baltimore • Bern
Frankfurt • Berlin • Brussels • Vienna • Oxford

Darius D. Prier

Culturally Relevant Teaching

Hip-Hop Pedagogy in Urban Schools

PETER LANG
New York • Washington, D.C./Baltimore • Bern
Frankfurt • Berlin • Brussels • Vienna • Oxford

Library of Congress Cataloging-in-Publication Data
Prier, Darius D.
Culturally relevant teaching: hip-hop pedagogy in urban schools /
Darius D. Prier.
pages cm. — (Counterpoints: studies in the postmodern
theory of education)
Includes bibliographical references and index
1. African Americans — Education. 2. African Americans —
Social conditions. 3. Hip-hop. 4. Education, Urban — United States.
5. Multicultural education — United States. I. Title.
LC2717.P75 371.829'96073 — dc23 2011046875
ISBN 978-1-4331-1057-3 (hardcover)
ISBN 978-1-4331-1058-0 (paperback)
ISBN 978-1-4539-0535-7 (e-book)
ISSN 1058-1634

Bibliographic information published by **Die Deutsche Nationalbibliothek**.
Die Deutsche Nationalbibliothek lists this publication in the "Deutsche
Nationalbibliografie"; detailed bibliographic data is available
on the Internet at http://dnb.d-nb.de/.

The paper in this book meets the guidelines for permanence and durability
of the Committee on Production Guidelines for Book Longevity
of the Council of Library Resources.

© 2012 Peter Lang Publishing, Inc., New York
29 Broadway, 18th floor, New York, NY 10006
www.peterlang.com

Printed in the United States of America

To my wife, Lucia, and my daughters, Ariana and Anaiah.

Contents

Acknowledgments

First and foremost, I would like to thank God, who gives me the spiritual sustenance to do the work that I do. I would also like to thank the entire EDL Department at Miami University, Oxford; you have played a tremendous role in my development as a scholar and researcher. The ideas expressed throughout this text have in many ways been inspired by the critical, progressive work being done in this department. Special thanks goes to Lisa Weems, Denise Baszile, Dennis Carlson, Michael Dantley, and Sherill Sellers who were members of my dissertation committee, and provided great insight and critiques from which many of the ideas in this text first germinated. Lisa, thank you for encouraging me to explore the cultural intersections between Black male identity, hip-hop culture, and urban education. You were a supportive chair who understood the richness of hip-hop culture as a critical pedagogical site of inquiry within qualitative studies in educational research. Denise, the conversations we had on the radical and revolutionary potential of hip-hop to be recognized as its own form of curriculum and pedagogy reaffirmed my commitment of doing cultural work in social justice education. Michael, thanks for inviting me to interrogate the idea of re-radicalizing notions of social justice in educational leadership on several panel discussions at UCEA conferences over the past few years. These series of critical conversations, and within the department, deepened my understanding of educational leadership in a way that is not limited to the technical management of administration. Subsequently, situating education leadership to a discourse of democracy and social justice expanded my own epistemological questions in the role educational leaders can play in reshaping the culture of schools in ways that include, legitimize, and respond to urban youth of the hip-hop generation. In addition, I would like to extend an additional thanks to Dennis Carlson for his reviews, critiques, and insights of this book. Your mentorship and advice as a scholar has been invaluable to the development of this text. I would also like to thank the undergraduate and graduate students I've taught over the years for their critical insights and perspectives on urban youth and

hip-hop culture. I would like to thank the youth in this study who have served as the inspiration for the ideas I have put forth in this body of work. Your creativity and intellect have much to teach the world about who we are as a society, and how much farther we have to go in holding the ideals of democracy true to its promise in the U.S. constitution. Many thanks and appreciation are extended to Chris Myers (Managing Director), Shirley Steinberg (Editor), Sophie Appel (Design and Production Supervisor), and the rest of the Peter Lang team for their patience and believing in this project. I am forever grateful for your support and encouragement.

Finally, I would like to thank my family who has been with me throughout this journey. To my wife, Lucia, I love you. You have been my greatest supporter, ally, and advocate. Words can't express my gratitude and indebtedness to you for your unyielding support during a time of great sacrifice for both of us in my academic journey, our two daughters (Ariana and Anaiah), and our entire families. I never could have completed this project without you. To my father and mother, Elmon and Wilhelmina Prier, as educators I am truly inspired by your commitment to students in urban education over the years. I stand on your shoulders and take up your legacy and commitment to social justice. To my brothers, Jamil and Andre, thank you for your ongoing words of encouragement that provided me with a little extra push to keep moving toward my goal to complete this book. To my in-laws, Manuel, Manola, Maria, and Cecilia, thank you for your prayers, thoughtfulness, and support. Finally, I would like to thank all of my colleagues across the country; and friends, particularly Dr. James B. Ewers, Rev. Rudolph Pringle, and Rev. Gregory Tyus in my former hometown community in Middletown, Ohio, who have supported me in various ways over the years. Thank you.

Please note that names of youth and youth advocates in conversations from the local community in the study throughout the text have been changed to pseudonyms.

Foreword

The publication of this volume is timely, as the nation's attention has been focused in recent years on a crisis of black masculinity. Of course, this crisis is not new. Black men have been kept in their place since the era of slavery by keeping them uneducated, economically subordinated, and under tight surveillance by oppressive policing and penal systems. But in an age of economic downsizing and the reorganization of the labor force through globalization, the situation of young black men has worsened relative to other groups. All unskilled and poorly educated workers in the new globalizing economy have lost ground, but none more so than black men. By 2004, 50 percent of black men in their 20's with a high school education were unemployed. Over 70 percent of black male high school dropouts were unemployed — compared to 34 percent for white males and 19 percent for Hispanic males. Meanwhile, incarceration rates for black males climbed throughout the 1990's to historic highs. In 1995, 16 percent of black men in their 20's who did not attend college were in jail or prison. In 2004, that number has risen to 21 percent. (Western, 2007; Eckholm, 2006).

It is, of course, far too easy to blame the victim for his victimization. That has been the strategic commonsense response of a hegemonic culture of whiteness throughout American history — first to see in blackness, and more particularly black masculinity, the mark of an "underdeveloped" race, and then, in more "enlightened" modern times, to see inner-city, young black males as victims of "broken" families without a strong male figures to guide them, and consequently as victims of "cultural deprivation," of various psycho-social disorders, and of self-destructive and delinquent tendencies. We all know this litany of blaming the victim all too well, for it is the "commonsense" of the dominant culture. Furthermore, there is usually some good sense in all commonsense. That, after all, is what makes it work so effectively to explain achievement gaps, high drop-out rates, and high rates of incarceration. Poverty and chronic discrimination is disabling, and that is one of the primary reasons why the elimination of poverty is so essential to a genuinely democratic education. But a

"culture of poverty" is not primarily responsible for the low achieve-
ment levels and high drop out rates of urban black males. The public
schools that poor black males attend have too often become apparat-
uses for the control, discipline, and punishment of black male bodies
more than democratic institutions for their empowerment. Education
for the working class and poor in America has long been conceived of
as an education for docility, but this has been particularly the case for
young black males whose every attempt at self-affirmation is viewed
as a threat to be met with a "zero tolerance" policy, a swift and
unforgiving punishment of suspension and referral to juvenile court.
As someone who has worked in a juvenile detention facility in a big
city, I know just how much juvenile detention—against the best
intentions of most—is a training ground for prison, and how the
resistance of the human spirit is both broken and hardened. All of this
only makes sense if we recognize and know something about the
history of black masculinity in America, for that history is still alive,
and the poor, black man child growing up in the mean streets of
urban America—perhaps particularly in the rust belt that has become
the upper mid-West—is a distant cousin of the slave. Which also
means that the anger and rage, the existential despair, and the hope of
poor, black, inner-city youth is potentially radical and transformative.
This is what makes Prier's narratives of working with urban black
adolescent males in a hip hop community center not only compelling
but also important pedagogically and politically.

Prier's argument is that hip hop, with all its contradictions and limi-
tations, provides an entrée way for reaching and engaging disaffected
and alienated youth. It suggests a curriculum and pedagogy for
liberation based on capacity to critique controlling images of black,
inner-city youth produced by the media industry. But Prier calls for a
pedagogy that goes beyond critique to praxis, to a pedagogy aimed at
creatively re-constructing and re-performing black masculinity within
the context of a broad-based movement for social and economic justice
in America. For hip hop to serve as for the construction and perfor-
mance of a new black masculinity it must, at the same time, be the
subject of considerable critique. Indeed, as Prier demonstrates, a hip
hop pedagogy invites a critical decoding of highly-commercialized rap
lyrics and videos as misogynistic and homophobic texts. This, of

course, means that the role of the teacher as an "organic intellectual," helping young people critically decode commercial hip hop, is of central importance.

The story that Prier has to tell is complex and nuanced, but it affirms the importance of a culturally relevant curriculum and pedagogy for inner-city youth in an age when the standards reform movement has made the curriculum less culturally relevant. By now we know well the effects of such normalizing regimes of standardized testing in the education of urban youth, particularly poor black and Latino/a youth. In the name of leaving no child behind, urban schools have been turned into factories for the production of standardized test scores. The curriculum is further stripped of cultural relevance or cultural responsiveness as attention is focused on "basic skills" and state standards (Carlson, 2005, 2008; Sleeter, 2005). As the social and education service function of the state is defunded and dismantled, the state is simultaneously being transformed into a disciplinary apparatus of "biopower," to use Foucault's term, engaged in the policing, surveillance, and control of various sub-populations as well as the construction of "normal" subjectivities and docile bodies.

Prier shows us how hip hop can open up a critical space to "undo" hegemonic performances and representations of black masculinity and "redo" black masculinity in ways that are empowering and that politicize black male rage, alienation, and discontent. This also means for Prier linking hip hop masculinities to struggles for social and economic justice and against sexism and heterosexism. The role of the teacher is recast in the process. In an age of technical-rationality, of holding teachers and principals accountable for raising test scores in urban schools, a culturally relevant pedagogy calls for to return to an ethical grounding for pedagogy and educational leadership, one that is actualized as a response to a call to responsibility. Derrida asked, in a lecture on the role of the public intellectual: "What do we represent? Whom do we represent? Are we responsible? For what and to whom?" (Derrida, 2004, p. 83). These are questions, he argued, that should be the basis of our most important conversations, that should animate our responses as public educators and public intellectuals to the crisis of democratic public life.

If we are responsible for the development of young people to be-
come full, contributing members of democratic communities and
public life, then we must stand on the side of urban youth as their
advocates demanding that the system live up to its promise to be the
great equalizer. At the same time, as Prier acknowledges, public
schools are not, at least for the most part, critical spaces where ques-
tions of identity, power, and knowledge can be easily raised, or where
teachers feel free to bring youth culture to the center of the curriculum.
This means that at least for now, the kind of culturally relevant hip hop
pedagogy represented in this book will need to be nurtured and
sustained in counter-spaces in civil society, as spaces which counter the
continuing mis-education of urban youth in public schools.

This also means that for most poor and working class black males
growing up in urban America today, their education will also be part
of their un-doing. Judith Butler (2004; 1) has observed that normative
conceptions of identity can "undo one's personhood, undermining the
capacity to persevere in a livable life." If people are "undone," in this
negative sense, by the internalization of racism, sexism, classism, and
heterosexism so that they literally or figuratively self-destruct, then
the very survival of urban black males depends on "escaping the
clutch" of those hegemonic norms for the performance of their
identity. Many young black men, full of hope and promise and
intelligence, have not been able to fully escape the clutches of white
racism. In James Baldwin's novel, *Another Country* (1962), the central
character, Rufus, whose death by suicide haunts the pages of the
novel and each of its characters, represents the killing of the spirit of a
young man full of great promise and creativity, pulled down by the
internalization of the master's image of him, and his attempt to assert
his manhood by dominating women (Shin & Judson, 1998).

There are scenes in the novel when Baldwin suggests Rufus might
still be saved, might not come undone, and interestingly these are set
in two spaces in New York City of relative freedom within a hege-
monic white, middle class culture, jazz joints where blacks and whites
could participate in a common scene, and even jam together into the
night. One of these is the white space of the Village and the other is
the black space of Harlem, and true fans of jazz traveled the A Train
back and forth between these two spaces, constructing a hybrid,

interracial space of improvisation and even racial solidarity, in which blackness was not something to be ashamed of but rather proud of, in which a musical form grounded in the black urban experience began to draw people together across racial and other divides. White youth followed jazz in Harlem clubs much like white, Asian, and American Indian youth today follow hip hop. In Baldwin's novel, Rufus remembers one time in a jazz joint in Harlem, in the wee hours of the morning, when he was playing bass in a jazz band. The members of the band were playing off of each other, in a delirious improvisation. Suddenly, the saxophonist takes off on a solo:

> He was a kid of about the same age as Rufus, from some insane place like Jersey City or Syracuse, but somewhere along the line he had discovered that he could say it with a saxophone..... They [the audience] were being assaulted by the saxophonist who perhaps no longer wanted their love and merely hurled his outrage at them with the same contemptuous, pagan pride with which he humped the air.... Each man knew that the boy was blowing for every one of them (1962, p. 6).

The amateur jazz player, expressing his rage and his passion through his music, represents a disturbing element in hegemony, just as the street corner rap singer does. One has the sense that if Rufus could have stayed with jazz, and the community that jazz offered him, he might not have come undone.

Hip hop music and culture, like the jazz scene, might do the same for many urban youth today—but surely not in the highly commercialized and commodified form mass produced by the media industry. A critical hip hop pedagogy has to help young people deconstruct and demystify hegemonic hip hop, even as it helps them appreciate and produce a more authentic and politically progressive hip hop. As Patricia Hill Collins has argued, early on in its history, hip hop provided a way of turning the gaze of power back on whiteness and racism, and confronting power through music. But by the mid-1990s, gangsta rap turned the gaze "back upon itself in fascinating and troubling ways,...[a] sexist reverse gaze, a posture of cursing, crotch grabbing, 'in your face' spectacle that rejects middle class discourses on Black respectability" (2008, p. 79). This is not a call by Collins for blacks to act

"respectable," if that means middle class means acting docile and not talking back to power, but rather a call for black youth to resist playing the opposite, the Thug or Gangsta. Like Collins, Prier calls for a third educational space for identity construction, a space in which young people can affirm a hip hop, hybrid, evolving sense of self in public schools that set high expectations for them to achieve, and that treat them as active agents in their own self production.

Dennis Carlson, Miami University

References

Baldwin, James. (1962). *Another Country*. New York: Dial.

Butler, Judith. (2004). *Undoing Gender*. (New York: Routledge).

DuBois, W. E. B. (1973) *The Souls of Black Folk*. Milkwood, N.Y.: Kraus-Thomson Organization Ltd.

Carlson, D. (2008). Neoliberalism and Urban School Reform: A Cincinnati Case Study. In Bradley Portfilio and Curry Malott (eds.), *The Destructive Path of Neoliberalism: An International Examination of Urban Education*. New York: Sense Publishers, 81-102.

Carlson, D. (2005). Hope Without Illusion: Telling the Story of Democratic Educational Renewal, *International Journal of Qualitative Studies in Education*, 18 (1), 21-45.

Collins, Patricia Hill (2008). Reply to Commentaries: Black Sexual Politics Revisited, *Studies in Gender and Sexuality*, Vol 9.

Derrida, J. (2004). *Eyes of the University*. (Stanford, CA: Stanford University Press).

Eckholm, Erik. (2006). Plight Deepens for Black Men, Study Warns, *New York Times* online (published March 20).

Lorde, Audre. (1984). *Sister Outsider*. Trumansburg, New York: Crossing Press.

Shin, Andrew, and Judson, Barbara. (1998). "Beneath the Black Aesthetic: James Baldwin's Primer of Black American Masculinity," *African American Review*, 32 (2), 1-14.

Sleeter, Christine. (2005). Standardizing Knowledge in a Multicultural Age, *Curriculum Inquiry* (Spring, Issue 1), 27-46.

Western, Bruce. (2007). *Punishment and Inequality in America*. (New York: Russell Sage).

Introduction

To think about the origins of hip-hop in this culture and also about homeland security is to see that there are, at the very least, two worlds in America, one of the well-to-do and another of the struggling. For if ever there was the absence of homeland security it is seen in the gritty roots of hip-hop. For the music arises from a generation that feels, with some justice, that they have been betrayed by those who came before them. That they are at best, tolerated in schools, feared on the streets, and almost inevitably destined for the hell holes of prison. They grew up hungry, hated, and unloved. And this is the psychic fuel that generates the anger that seems endemic in much of the music and poetry. One senses very little hope above the personal goals of wealth to climb above the pit of poverty. In the broader society the opposite is true. For here, more than any other place on earth, wealth is so wide spread and so bountiful, that what passes for the middle-class in America could pass for the upper-class in most of the rest of the world. Their very opulence and relative wealth makes them insecure. And homeland security is a governmental phrase that is as oxymoronic as crazy as say military intelligence or the U.S. Department of Justice. They're just words...

— From Death Row, Mumia Abu-Jamal
Letter to the President: The Streets Get Political, 2004

Hip-hop has always been about having fun, but it's also about taking responsibility. And now we have a platform to speak our minds. Millions of people are watching us. Let's hear something powerful. Tell people what they need to hear. How will we help the community? What do we stand for? What would happen if we got the hip-hop generation to vote, or to form organizations to change things? That would be powerful.

-DJ Kool Herc in *Can't Stop Won't Stop* (Chang, 2005, p. xiii)

I have been following the culture and art form of hip-hop since I was in middle school and started collecting *The Source*, one of the most respected urban magazines on hip-hop music, culture, and politics. To this day, I have stacks of these magazines that have chronicled and kept me informed on the voices, concerns, and politics of urban youth in the contemporary moment. In the words of Chuck D, rap music (within the culture of hip-hop) was our Black CNN. KRS-One often defined hip-hop as edutainment, discursively merging "education"

and "entertainment." Hip-hop gave us critical insights and reports from the street on what was going on in our communities, the latest artists and music that often reflected these experiences, and the ways in which the music and culture politically underscored where we were on particular issues related to social justice. In most cases, these narratives and experiences were not covered in mainstream media. Urban youth were producing texts that informed the larger public of what cultural and social processes shaped the context of the many complex identities they fashioned for themselves. They were producing knowledge that emerged from the margins of their everyday lived experiences. They were revealing the underside of failed democratic commitments to young people that America never wanted the public to see. In this regard, hip-hop emerged from conditions of desperation, of significant joblessness, and thereby, poverty for Black male populations; this created the time and space for a Black male-centered persona to claim his voice and visibility as critical to Black male identity in U.S. society (Powell, 2003, p. 105).

I have always been drawn to hip-hop for its politics and street narratives of resistance; however, I have also been drawn to the culture because it allowed me to express myself creatively. For example, in middle school I remember wearing my denim jeans to class, inscribed with the faces and quotes of Martin and Malcolm on each pant leg, with a studded rhinestone X cap, a sweatshirt with the logo of Public Enemy on the front, and Michael Jordan's famous Nike Air insignia on the back of my hooded sweatshirt. These graphic designs in hip-hop style and aesthetic were all painted and designed by myself. It was as if I was creating my own history text through the culture of hip-hop, a text that was absent from school. In a postmodern sense, art was history and politics, and history and politics could be art in hip-hop culture. However, it was also entertainment for pleasure and play. Hip-hop never imposed any disciplinary boundaries. As I reflect back, the cultural production of meaning inscribed within my clothes was reflective of my desire to be heard in more critical, creative, and authentic ways that the pedagogy and curriculum in schools didn't allow. Ironically, every time I wore these clothes to school, the curriculum and pedagogy of these texts evoked heated discussions with my white classmates about why I had chosen to

wear such apparel with the signs and symbols that intertwined hip-hop and Black history texts. These texts represented an affront to an assumed culture and history they deemed as the norm. Contrary to this belief, I knew there was a history that wasn't being taught in the classroom because my parents (who were community activists and educators) had a complete Black history library in their basement of critical scholars such as Frantz Fanon, W. E. B. DuBois, James Baldwin, Ralph Ellison, Stokley Carmichael, Kenneth Clark, H. Rap Brown, Bobby Seale, Lerone Bennett Jr., Richard Wright, Paul Robeson, Malcolm X, Martin Luther King Jr., among countless others. Of course, with the exception of Martin Luther King Jr., none of these figures were ever mentioned throughout my entire private and public education experience. My own consciousness of critical knowledge of what was absent in schools became present through my creative sensibilities within the culture of hip-hop. In some sense, I had inscribed the narratives, experiences, and histories of freedom fighters of the past through the contemporary culture of hip-hop where music, art, politics, and history converge to deploy a pedagogical form of resistance to the status quo of traditional education and schooling practices.

It could also be said that my earliest influence of how the art and pedagogy of hip-hop could be made educational and political was through my father's independent work as a poet in the local community of my childhood upbringing. It is impossible to separate poetry and the spoken word movement during the Black Arts renaissance of the 1960s and early '70s from what we know today as rap music in hip-hop. In this regard, my father used poetry to stimulate critical consciousness and social transformation of local citizens in disenfranchised urban neighborhoods. He used his work to discuss matters of race and racism, poverty, drug abuse, teenage pregnancy, education, the politics of the government, civil rights and social justice issues, etc. As a public school teacher for over thirty years, he saw poetry as a very public form of pedagogy to teach and engage citizens about the social ills of the day. Whoever would listen, he would take his work into local barbershops, churches, community centers, and public schools for the purpose of teaching and empowering youth to see different visions of themselves than what was being presented in their

own present circumstance and reality. It is the narratives of the streets, crafted in poetic form that can now be seen in rap music. It is this evolution of poetry into contemporary forms of rap music that has had a deep impact on the pedagogical potential I see in alternative forms of critical and culturally relevant education for urban youth in low socioeconomic neighborhoods.

While I have been interested in what Manning Marable calls a politics of art in hip-hop, many of my friends honed the craft of their lyrical skills as emcees. In the hallway, at the lunch table, at the local football game, or on the street, youth would battle (e.g., likened to the dozens in the African American community) one another or "freestyle," an improvisational, rhetorical method where one comes up with complex, poetic, rhyme schemes unrehearsed or memorized. At other moments, students would come to school, prepared with a structured story, reflective of home life, the community, or boastful aspirations and dreams of makin' it out of the confines of one's neighborhood. The ability of students, particularly from urban working-class communities, to put words and rhymes together in complex ways gave him or her voice, visibility, and respect. What they had to say was worth being heard. It gave them a sense of being an organic intellectual, dispensing knowledge in ways familiar to the people of the community in urban working-class conditions. The music was raw, uncensored, and uninhibited by public spaces and places that implicitly or explicitly attempted to shut off urban youths' creative sensibilities. It was in these particular spaces where their intellect was most valued for the improvisation, creativity, critical knowledge, and clever wordplay that was acknowledged by their peers. There was a contradiction I often observed between the brilliance I saw in these spaces versus their reports of low academic performance and disillusionment in English classrooms. It is ironic that these classrooms taught many of the same techniques of metaphors, tropes, and similes these youth were effortlessly incorporating into the lyrics of their self-authored rap songs. There seemed to be no pedagogical and curricular translation between the critical and cultural relevance of what they were doing in the streets into the classroom.

My reflection of growing up with hip-hop was not only about appreciating the cultural practices of an emcee, deejay, graphic artist, but listening closely to the narratives of the culture's most respected emcees of the day. Emcees/groups such as Rakim, Nas, KRS-One, Dr. Dre, Ice Cube, Mobb Deep, Big Daddy Kane, Wu Tang Clan, Tribe Called Quest, Tupac Shakur, Notorious B.I.G., Jay-Z, Fat Joe, Red Man, and Master P. (to name a few) were in constant rotation in our cassette and CD players. Many of these emcees claimed to keep it "real," in all of its performative manifestations. "Real" was imagined, performed, and acted out between life and art, sometimes blurring the lines between fiction and reality. However, in all cases some form of "truth" was being presented to tell a story that constructed meaning about some aspect of urban life. These authors of the street were speaking to us about our world in a way that was relevant, critical, and meaningful to the complexities and contradictions we observed in our everyday lives. We would often rewind a tape or skip back to the same track, over and over again to make sense of metaphors, similes, and vivid imagery artists used to articulate the emotions, tensions, struggles, conflicts, and attitudes reflective of cultural contexts and concrete, societal conditions that shaped the different discourses in hip-hop. For example, some artists took on a more political tone, such as Tupac Shakur's *Me Against the World* album when he wrote "the power is in the people and politics we address," meaning that we as a collective community have a say in speaking out against social inequalities that confront the conditions of a marginalized people. At other moments, artists provided ethnographic, storytelling narratives in the gangsta genre. For example, lines in Ice Cube's *Ghetto Vet*, such as "Fool I'm a vet, you can bet that I could dance underwater and not get wet, it's rainin' bullets and I'm still there." Songs such as these highlighted the violence and invincibility of a "ghetto vet," metaphorically referenced as a veteran street soldier in a war, seemingly impermeable to the fatal tragedies of gang violence. This narrative ends with the soldier paralyzed from the waist down. In addition, artists speak to the obsessive consumerism of market-driven commercial discourses in hip-hop. For example, Kanye West said it best on *Graduation* (2007) when he stated, "I had a dream I can buy my way to heaven, when I awoke, I spent that on a

necklace." West confronts the vulnerabilities and pitfalls of capitalist consumerism in the hip-hop industry that often take precedence over nonmarket values that more authentically represent the collective interests of local communities. Examples within each of these discourses tell us something about the way in which the cultural and social world of hip-hop is represented; the lessons that can be learned; the imposition of social inequality; the moral and political dimensions posed; the choices and decisions negotiated; the nihilism, disappointment, and empowerment felt; and the consequences and outcomes of urban life in all of its complexity. As students of the culture, we rewound or pushed pack the track, rereading these discourses, to critically reflect on what these narratives meant to our own lives, how they related to what we had observed in our communities, and why different predicaments and circumstances shaped different identity formation processes of urban youth. However, I always kept in mind that some artists were not necessarily trying to convey any particular meaning, reflective of any particular reality. As in any form of entertainment, the creativity of the lyrics and pulsation of the beat were simply performed for play and pleasure, to "snap ya' neck and make ya' head nod," as we would often say in the vernacular of hip-hop.

Perhaps more than anything, I was aware that rap music gave urban youth a voice to speak about tensions and struggles in their communities. The pain and defiant resistance heard in rap music were cultural expressions that confronted an America that viewed them as problems. What was different about the music and culture more broadly is that hip-hop unflinchingly spoke back to America without apology or permission. This is what gave the culture its power and potency of a young generation who reorganized language in a way that was "disobedient" and resistant to the status quo. Hip-hop artists found the strength of their voice that struck a chord with the so-called "lost generation." For example, hip-hop groups such as N.W.A., Public Enemy, and Outkast politically named and marked themselves in ways that signified the attitudes and experiences of a people who had been displaced and marginalized in society. While Outkast was more eclectic in the nature of its sound, meaning, and message, the political rage of N.W.A. and Public Enemy were reminiscent, in some ways, of the Black Poets in the 1960s. For those who lived in what

Cornel West calls vanilla suburbs, you could no longer ignore the ugly, devastating realities and political consequences of racial and economic oppression in chocolate cities. The political implications of rap with messages of resistance unsettled our consciousness, and made us listen and pay attention to the circumstances and experiences of youth who had been abandoned by the nation-state. Police brutality, run-down neighborhoods, violence, underemployment, poverty, lack of social services, and the drug trade were suddenly put on wax to be heard and felt, awakening white mainstream America from its sleepwalking. This is perhaps why Tupac Shakur's popularly coined phrase T.H.U.G. L.I.F.E. resonated deeply with youth in hip-hop culture. This term was signified as "**T**he **H**ate **U** (You) **G**ave Little Infants **F**____ks Everyone." The idea of "Hate" being "Given" from "You," meaning society, was a post-structural inscription of cultural politics between society's injurious treatment of urban youth and the consequences of an internalized form of oppression from external forms of injustice. These narratives speak to the ways in which urban youth often communicated through the culture of hip-hop in ways that suggest they have been estranged from and targeted as the opposition to the common public in American society. The lyrics of these artists were in many ways the soundtrack to the lives of friends and classmates I grew up with who lived in disparate, poverty-stricken conditions of the projects, who had witnessed the economic strain that impacted vulnerabilities to drug abuse and trafficking, who were subjects of obsessive policing in their communities, and who were recipients of disinvestment of badly needed social services in their neighborhoods. As one student once stated to me, in reference to Tupac, "I feel the pain that he felt, me and him the same." In many ways, the coded language and rhetoric in the music reflected and captured what Henry Giroux calls the politics of disposability, where the nation-state problematizes, devalues, and renders its young people useless.

It was not lost on me that rap music within hip-hop culture has also been a contradiction. Artists' political insights about peace, love, and empowerment of the community have always cohabitated with their more violent, sexist, misogynistic, and homophobic lyrics. I am reminded of this as I recall the look on my parents' faces when they found out

my brother, in all of his youthfulness at the time, had purchased a 2 Live Crew album when we were visiting in my father's hometown of Miami, Florida. Imagery on the cover alone was considered explicit, much less the lyrics to their songs that celebrated what we might call the gluteus maximus of a woman's hind parts. This group, along with many others (e.g., Too Short, Snoop Dogg, Ice-T), falls within what Tricia Rose calls the gangsta, pimp, ho trinity (2008). The sexual objectification of women's bodies in videos, the masculine expressions of overdosed testosterone energies of male rappers, the nihilistic celebration of violence, the momentary linguistic defamation of Black history (e.g., N-word), and market-oriented ambitions of the drug trade represent certain segments of a patriarchal, masculine culture that should be strongly critiqued as self-destructive to the moral fabric and character of the African American community. Michael Eric Dyson, Tricia Rose, and bell hooks remind us that if more progressive visions of manhood and feminist politics are to take shape, commercial representations of hip-hop's version of masculinity, rooted in patriarchal norms of dominant mainstream society, must be challenged, critiqued, and eradicated (Dyson, 2007; Rose, 2008; hooks, 2004). These identities are often uncritically celebrated merely for leisure, pleasure, play, entertainment, economic gain, and exploitation of women's bodies. Subsequently, the critique of these matters is important as we know that words and images in popular culture can have a significant impact on impressionable youth in search of an identity.

In a household where I grew up with a strong prophetic, spiritual base and moral values, the market-oriented, commercial segments of the culture that consent to the aforementioned values of sexism, misogyny, and violence always placed me in tension and odds to what I felt was corrosive to the power and potential of art to engage in urban movements and struggles for social justice. There were times when I felt, and at times feel to this day, as rap artist Common felt in 1994, with the classic hit "I Used the Love H.E.R." As indicated by the title, he used the metaphorical, socio-cultural context of love and relationships to express his former love of hip-hop, which is his former love. The love is lost for hip-hop when "she" sells herself out to the commercial industry of the music business. In this particular song, she, meaning hip-hop, makes herself available to everyone-the

market, while no longer resembling any organic reflection of her original self. In one stanza he mentions that the chick (hip-hop) used to be creative, but when the man (corporate industry) "got you well" (paid), he "altered her native." He later states that when the "man" convinced her to get an image and a gimmick to make profit, she sold out for economic gain, losing her sense of self in the process. It was almost as if Common is suggesting that once she, metaphorically referenced as hip-hop, found out she could make some money, she prostituted herself, selling her talents and creativity to the highest bidder in commercial industry of the music business. In essence, a love was lost for hip-hop when she sold out the local origins of her creativity to the commercial industry of the culture. Yes, even in the mid-1990s, which is often said by scholars and social critics such as James Peterson and Kevin Powell to be the "golden age of hip-hop," many artists began to recognize and question the future viability of preserving organic messages in the culture, tied to the local concerns of the urban community. Two years later, The Roots reflected similar sentiments as Common on their 1996 *Illadelph Halflife* album. In this particular text, they too argued that the original organic urban struggles of hip-hop, the principles that grounded and shaped the culture, were being "forsaken" and that "It's all contractual and about money makin'." In 2006, Nas caused quite a storm when he came out with the album track, "Hip-Hop is Dead." He too felt that hip-hop had become too commercial, to the point that the personification of hip-hop had died. According to Nas, the talents and creativity of hip-hop artists had become commodified, diluted, and where similarly packaged into objectified, consumable products for mainstream, popular culture. This is why he was "Reminiscin' when it wasn't all business" and why the people now "gather here for the dearly departed." Nas spoke to the market-oriented practices of the hip-hop industry prepackaging the voices and experiences of the artists in a set formula, killing off the originality, politics, and creativity of an art that seems to no longer resemble what it used to be — critical voices reflecting the diverse experiences of local everyday people in urban communities. What has been at stake, these artists suggest, is that more authentic representations of hip-hop are

losing ground to the monopoly, exploitation, and privatization of the culture.

My struggles with hip-hop in the present moment, "my love for H.E.R.," and my critique of market segments of the culture are rooted in a deep concern in how youths' voices will be heard, represented, and responded to in a corporate society that is less concerned with the potential of what young people can strive to become than profit from the production and exploitation of commodified "urban life." In this context, I am speaking to the power, control, and manipulation of dominant, corporate consumption that attempts to decontextualize and erase the experiences and histories of urban life; take advantage of young artists from disadvantaged, low socioeconomic conditions in search of quick fame and money being marketed and sold to them; and commodify Blackness in a way that celebrates the production of exoticized representations through a racist, voyeuristic lens (Haymes, 1995). When urban life is merely sold as a commodity for profit, without attention to the historical context of the Black freedom struggle, without attention to the miseducation in urban schools, without attention to job loss affecting the economic predicament of Black folk, without attention to internal violence in urban communities, without attention to domestic violence and sexism against women, and without attention to extraordinary levels of poverty, the authentic narratives of people committed to local community concerns get silenced to the corporate imperatives of the industry. Therefore, the complicity in the "erosion of values" that disenfranchised urban youth at times succumb to must be placed in the context of the power of multinational corporations in the music industry who control the production, circulation, and consumption of Black popular cultural narratives in the hip-hop industry.

Although the culture of hip-hop has its own internal contradictions, it is too easily used as a scapegoat and is targeted for anything that has gone wrong in urban America. For example, mainstream political pundits (i.e., Bill O'Reilly) and conservative scholars (i.e., John McWhorter and Stanley Crouch) tend to monolithically write off hip-hop as inherently problematic. These critics tend to suggest that hip-hop is anti-intellectual, debasing to mainstream American values; celebrates violence, sexism, and misogyny; promotes criminal behavior;

and is profane to decency and civility of all that is morally right. Such arguments suggest that the totality of the culture, and urban youth who identify with it, is inherently bad. Even well-intentioned civil rights activists and other significant leaders who actually care about the plight and predicament of the Black community, who have come from the same socioeconomic conditions as the urban youth they critique, have come off as aloof to the full complexity of contemporary realities that shape the cultural contexts of hip-hop. For example, Bill Cosby went on a citywide tour some years ago chastising the urban poor for not holding up their end of the bargain from the Civil Rights Movement. Oprah Winfrey held a town hall meeting with hip-hop artists and business moguls in response to the infamous Don Imus incident, where he blamed Black males in hip-hop for his on-air, racist remarks, calling the Rutgers women's basketball team "nappy headed hoes." Noticeably absent from Oprah's town hall meeting were the major investors (traditionally all white males) of multinational corporations that profit from, finance, and produce the records of hip-hop artists. Cosby's speeches were meant to be a call to action, an urgent plea to correct "the crisis in Black America." However, many communities to which he was speaking interpreted his arguments as reductionist in isolating their choices, actions, and attitudes from structural conditions that severely limited their options for economic, educational, and social sustainability and mobility. In addition, I remember attending an event where the brother of a deceased civil rights icon was to speak to a group of teenage youth who were visiting our college campus for the first time in their lives. This was an educational opportunity where the political significance and struggle of the past could offer hope and possibility to these youth of the present. Instead, much of the conversation became reducible to how young people wore their hair, and the size of and level at which their jeans sagged. His comments served as a chastisement and rebuke of a style and aesthetic associated with the hip-hop generation. In my mind, this was a missed teaching and learning opportunity to meet young people where they are, and engage their minds and consciousness to continued struggles for social justice across and between the Civil Rights and hip-hop generations. I am not placing the politics of the hip-hop generation on equal par with hard fought civil rights struggles won by cultural movements of the sixties.

I'm only suggesting that a cross-generational dialogue needs to take place between the two generations if a more progressive movement for social justice on behalf of urban communities is to take root in the 21st century.

My historical reflections and contemporary debates over the value and representation of hip-hop are important because ultimately these discussions are about the value and representation of urban youth. While there is no doubt the culture of hip-hop has developed as a global phenomenon, the public face of the culture in U.S. contexts in mainstream media continues to be predominated by urban male youth (Prier & Beachum, 2008; Rose, 2008). Given this fact, the images and identities produced in the hip-hop industry, and the associated meanings we give to them, significantly shape how America perceives urban youth in the public consciousness of society. This discussion becomes important for those of us who work with urban youth in public schools, community centers, churches, juvenile detention centers, and other various public spaces in local neighborhoods. The identities they take on and perform in hip-hop enter into the public institutions in which we work. Therefore, we cannot remove or isolate ourselves from the most significant form of popular culture that impacts their lives in complex ways. If we take a self-righteous, noncritical and judgmental stance, we also remove ourselves from understanding larger historical, racialized, socioeconomic, gendered, and political conditions that have played a significant role in shaping the subculture of hip-hop. As many urban youth increasingly process who they are and construct their social worlds through the subculture of hip-hop, it becomes necessary for us as cultural workers in urban education to understand the sociocultural contexts that shape these experiences. The contexts of these experiences give us a pedagogical window from which we can learn from and co-construct knowledge with young people in ways that offer hope, possibility, and transformation of urban struggles that fight for the cause of social justice on behalf of these youth.

Given the significance and importance of hip-hop in my own life, I know it continues to affect many youth today. While I have never morally agreed with, celebrated, or advocated all of what artists say or do in hip-hop, I understand the power and importance of the

subculture to the lives of many disenfranchised urban youth across the nation, and indeed, around the globe. It is a culture created out of the broken promises of American democracy. The culture of hip-hop represents the unremovable residue of deliberate speed practices gained from the Civil Rights era that have been stalled by the nation-state to implement significant legislative measures of progress. In the words of King, America has left Black folk a bounced check, marked insufficient funds. In this respect, citizens, social activists, and critical educators who stand up for justice and equality have a moral obliga-tion to hear, listen, and understand what young people are saying about the conditions they are living in, how they are being miseducated by less than adequate schools, and the socioeconomic inequalities they are surviving. It is in this sense that critical, progressive forms of hip-hop can be a significant cultural movement for social justice in addressing these matters. What we might learn and be taught from this urban youth culture presents creative and transform-ative, pedagogical opportunities in urban education.

Hip-Hop and Urban Education

Yes, it's entertaining; yes, it could be funny. But where's the adherence for hip-hop to be respected for the changes it can do in education, for the changes it can do just in social order? Where's the communication for people who have been I guess incarcer-ated in the prison industrial complex? There's a lot of movements that have been going on, have been raised on hip-hop, but hip-hop has not had that accepted portal of acceptance for people to say, "Hey, wow, this is a wonderful basis that I've learned from."

—Chuck D of Public Enemy
Interview with Tavis Smiley
August 15, 2007

In all my years as a critical educator and community activist, I have been a witness to a series of tragic realities in my pedagogical en-gagement with African American male youth on the streets, in public schools, and in higher education. As an administrator who came back home some years ago to work at a university in his community, I directly worked with many students and former childhood friends who were trying to attend the university after they had served ten- to

fifteen-year prison sentences. I've worked with students who have been homeless, did not know where their next meal was coming from, and have had to watch their fathers literally die in prison. I've worked with a friend who came to see me about his prospects of attending the university, and no more than two or three weeks later he was found shot dead in the back of an alley, and for whom my father had to perform the eulogy. I've had to write letters to judges in juvenile courts, asking them to give high school students that I have worked with in precollege programs, one more chance to finish high school. What I have found when listening to the lyrics of students' self-produced rap songs is that the aforementioned narratives often circulate in complicated ways through the culture of hip-hop. As schools are situated in these larger societal contexts, it may benefit us to think about how we might critically read the culture of hip-hop in relationship to urban education. That is, if the culture of hip-hop is approached in a positive and critical manner, there are significant learning opportunities for educational leaders who work with African American male youth in urban public schools. However, to suggest there are critical learning opportunities in hip-hop means that we must first value it as a significant form of social knowledge, produced and constructed by urban youth in various cultural contexts. This presents fertile ground for critical pedagogues to better understand and assist with politically intervening in difficult circumstances often reflected through the culture. It is these societal circumstances that impact their day-to-day experiences in schools that are communicated through the culture of hip-hop. As urban youth continually gravitate toward hip-hop and educators come to value the culture as a form of social knowledge, possibilities exist in what Paulo Freire calls the co-construction of knowledge and learning in the teacher-student, and student-teacher, pedagogical relation.

Please note that my specific focus on the cultural intersections between African American male youth, hip-hop, and urban education is not to privilege the experiences of males of color over other marginalized groups. It also does not assume that all urban African American male youth behave the same, think the same, or have the same attitudes about life. However, this work makes the necessary distinction and focus on systematic ways in which public institutions in

popular cultural life play a significant role in the shaping of masculine constructions of urban life for African American males. Historical and contemporary sociocultural contexts suggest there has been a narrative about African American males that resigns him as a menace and problem to a white male power structure in society. In this regard, it has to be understood that many urban youth self-fashion identities for themselves related to and measured against the values and ideals of white, capitalist, patriarchal contexts (hooks, 2004). Therefore, conditions and ways in which many urban male youth respond are distinct from cultural dimensions and power relationships of what it means to be a white male or female, and that contrast with studies that only engage in a class analysis. This is not to support or suggest there is an inherent way to define what is masculine in relationship to what it means to be Black. Also, the cultural dimensions of class remain and are interwoven throughout my analysis and explanation of youth identity formation of African American males. My intention is to delineate the different cultural contexts in government, media, schools, and larger societal contexts that create a different atmosphere, with different political consequences, for African American male youth that is different from other populations. Hip-hop is one of the most potent and relevant urban youth subcultures by which we can analyze the cultural dimensions and intersections between race, class, and gender as it relates to the African American male experience in education and the larger society. It is in this sense that my focus and specificity of urban male youth are meant to be complementary to a larger discussion about disenfranchised youth in urban education around the globe.

We are at a moment in urban education where African American male youth in urban schools continue to lag behind their peers for a variety of reasons that make analytic comparisons inadequate to tell the full story. These students face statistically significant struggles with academic proficiency, school suspensions, expulsions, and high school dropout rates. Many of these youth have been disengaged, alienated, and displaced from the urban school system a long time ago. They do not see themselves in the official school curriculum. Therefore, urban schools are not seen as spaces and places where they can be empowered by and construct a positive sense of self and

identity. Many of these students are presumed guilty before being proven innocent when they socially interact with public school officials. In this way, they see schools as a place of punishment rather than what Nell Noddings calls an institutionalized structure of care. Finally, the cultural dimensions and intersections between race, class, and gender operate in complex ways that make educational experiences of urban African American male youth a difficult journey in urban schools. Collectively, the material conditions of these experiences have pushed these students toward subcultures such as hip-hop. The task, it seems, is not to demonize hip-hop but to find critical and culturally relevant educational opportunities that exist within it. As will be evident and crucial throughout this text, I do not limit "public education" to the traditional structure and "official" curriculum of schools. However, the political implications of how I reconceptualize what education means to African American youth through hip-hop, dialectically, says something about what's absent and missing from the current culture of traditional urban schools. The gap in urban youths' self-identification processes between the official school curriculum and hip-hop culture can provide new avenues and political implications in praxis for educational leaders. Hip-hop musicologist and historian Kevin Powell suggests that given how bankrupt North American school systems are in teaching urban youth about their history and culture, it logically follows that these youth will turn to other arenas for their knowledge base such as hip-hop culture (Powell, 2003, p. 142). Given its significance as an enterprise and mainstream popular culture, hip-hop has "become a lever that young Black people pull to process their own experiences, a reflection to help them make sense of their own lives and condition" (Powell, 2003, p. 142). In this way, hip-hop has become central to this shift in curriculum and pedagogy for the everyday lived experiences of urban youth, and Black males in particular.

As schools have resorted to zero tolerance forms of discipline, punishment, and control, or have failed to incorporate texts or teaching practices that are reflective of and relevant to the lives and culture of students of color, students feel marginalized from public schooling. In this way, understanding how Black male youth learn and process what it means to be Black and male in urban ghettos across U.S.

society through the music, discourse, and everyday lived culture of hip-hop, which emerges from these conditions, provides a kind of pedagogical blueprint that can in turn be useful to educators who seek to redefine the curriculum of democracy and education. Khaula Murtadha-Watts locates hip-hop as one of the crucial sites of identity negotiation for Black male youth, and states that educators cannot ignore a culture that has so much significance and impact on the lives of Black male youth. Black males' adoption of hip-hop's cultural forms and practices is in response and reaction to dominant, mainstream codes and values produced in schools (Murtadha-Watts, 2000). Bakari Kitwana and others state that "Today, more and more Black youth are turning to rap music, music videos, designer clothing, popular Black films, and television programs for values and identity" (2002, p. 9; Prier & Beachum, 2008, p. 524).

As a critical educator, I have always been intrigued with students who show me notebooks full of pages with lyrics or poetry they had written. I have even seen students' setups of their own studios in their basements with complicated technology for recording sessions with local artists in their communities. Some students have even gained enough confidence to self-publish their rap music on their own CDs, or have independently published their own book of poetry. Personally, I've hosted open mic nights, an open forum for rap and spoken word poetry, which attracted many Black male youth from the community who were formerly incarcerated, struggled and nearly self-selected out of high school, or who never made it through college. This democratic space displayed the intelligence and genius of how these youth rhetorically freestyled or performed complex street narratives that spoke to their own vulnerable pains and frustrations in relationship to dispossessed and alienating conditions of urban society that framed their everyday lived realities. I've seen similar narratives and discursive strategies of rap and spoken word employed by young adults at an urban high school hip-hop summit, who used it as a pedagogical strategy for urban Black male youth who had served time at a juvenile detention center. It has been my experience, in speaking with many of these youth, that the excitement, passion, intelligence, creativity, and knowledge that students articulated through hip-hop within these spaces are rarely valued, recognized, or

celebrated in schools. For many of them, schools have been more confining to, rather than embracing of, their identity and popular cultural knowledge that otherwise could demonstrate useful and relevant learning experiences between students and teachers, and that could evoke empowerment, social change, and transformation in the lives of the students. According to these students, their educational experiences in schools were far removed from what they experienced outside schools in urban contexts. So often I have heard that if it wasn't for hip-hop, many of them said that they would be out on the street doing other things.

As I think about the experiences I've had as a critical educator in working with young people, it is the critical knowledge of hip-hop that presents possibilities for understanding and politically intervening with the lives of Black male youth toward social transformation in urban education. Many of them feel free to define and construct their social world on their terms, and in ways that feel empowering and liberating to their life's potential. Hip-hop can be an unrestricted urban, public space upon which many urban Black male youth feel unrestrained by the strictures of legal authority, schools, or the government. Many segments of these institutions have proven, time and again, to be repressive rather than ameliorative to their life predicament and circumstance. Subsequently, my respect and value in understanding hip-hop's importance and significance to the identity formation and lived experiences of urban youth were the motivation and impetus in having a series of conversations with African American male youth (9th and 10th graders) who were a part of an after-school program at a local hip-hop community center in the lower socioeconomic area of a northern urban rust belt city. Many of these students were having difficult schooling experiences, which were in no small way unrelated to what these youth had to face in the larger society. I came to find out that many of these youth came from homes where their family members and friends are going through drug addiction, had participated in the commodification of the underground drug market economy, or have had a family member gunned down through street violence. Their lives read like movie scripts in that they had seen and experienced too much, too soon, at the ripe old ages of 14 and 15. I admired and respected them for the

everyday struggles they survived in their communities. In this respect, I feel there is much they have to teach the world, given the knowledge they have acquired from life in the urban city. The hip-hop community center recognized the value, significance, and relevance of the culture of hip-hop in promoting social change and transformation in the lives of these students.

I became temporarily involved in the curriculum development area of the center through my initial meeting with the director and the students some years ago. The purpose of the hip-hop community center was not for youth just to hang out. It was a community center that used the cultural practices of hip-hop as educational tools to develop critical awareness of self, violence prevention, and retention in high school. Part of this strategy involved the use of critical media literacy in which students critiqued the commonsense meanings and images in hip-hop that have the potential to be self-destructive to the character of Black life. Through critical discourse analysis, they also analyzed and made sense of the lyrics of various hip-hop artists in relationship to the sociocultural context of their own lives. In addition, they used the cultural practices of the deejay, the emcee, graffiti artist, and the b-boy element as critical modes of self-expression. In this way, alternative, pedagogical practices employed through hip-hop culture in critical ways gave these youth new choices and options to think about in their lives, other than the streets. The center's overarching goal was to create pedagogical conditions that would facilitate positive social change and transformation in the lives of Black male youth in high school who were in at-risk situations.

The way in which the community center made use of hip-hop was quite different from how the culture is publicly imagined in mainstream media. The students were engaged in ongoing dialogue that critiqued, challenged, and did not celebrate market-driven, commercial discourses in hip-hop that tend to be preoccupied with money, sex, violence, drugs, and pure pleasure. The consumption of these values by youth in popular culture is reflective of socioeconomic contexts, heavily racialized and gendered in mass media culture. The discussion of these matters has everything to do with education and social justice as urban youth are given space to resist and reconstruct alternative identities that go against the grain of corporate exploita-

tion and reorganization of urban life. As discussed earlier, images, identities, and representations of African American males are most pervasive in the popular cultural world of the hip-hop industry. The celebration of gaining fast money, power, and respect that are associated with these images and identities is often seen as an elixir for youth in racial and economically oppressive circumstances who seek alternate ways in which to validate themselves and the identities they perform. Therefore, as a matter of principle and practice, it becomes important to work alongside youth to unveil the contradictions and distortions that are present in the corporate, commercial order of the hip-hop industry. The corporate order of the hip-hop industry often reinforces structures of marginalization as they do not ask urban youth to do anything but consent their mind and consciousness to a set of values that work against transforming themselves and their own communities.

The insight and knowledge these students possessed enabled them to have some sense of agency over their lives. As hip-hop artists, the students at the center were encouraged to write the scripts of their own lives in ways that would allow them to be critically conscious of the choices and decisions in their life that went against the grain of what had previously been the norm for them. As they became critical students of hip-hop, rather then commodified consumers, they had a sense of history related to the African American experience and the culture of hip-hop that was empowering to their sense of self and identity. Students read and discussed hip-hop texts in relation to their own lives. This opened up dialogue about politics and government, the culture and curriculum of education and schooling, and how hip-hop spoke to them and their identities in ways that traditional texts didn't. We were having "public" education in the streets to understand their place in the world, how to make sense of it, and negotiating what being Black and male meant in this society through the urban space of hip-hop culture. These conversations underscored what were some of the major investments, priorities, and motivations for how they construct and negotiate their identities, given the social world they live in.

The space and place of my research site, a hip-hop youth empowerment center, as opposed to the conventional space of a traditional

classroom, were crucial to me understanding what urban Black male youth felt was absent in public schools and how hip-hop filled in the void. I was able to address the schism between urban youths' investments in hip-hop and urban schools because they were not traditional students. They were hip-hop artists from disenfranchised communities who used the education and cultural practice of hip-hop to transform the conditions of their circumstances. The institutional practices of schools had been less than effective in preparing these students to be critical, democratic, citizens. In this regard, my research site itself proved to be an important cultural and social site in understanding its utility as a pedagogical and curricular text, as well as a dialogical discursive space to understand how Black male youth negotiate and make sense of their identities through the culture. It was also important to understand the subsequent impact that these identity negotiations have on their experiences with education and schooling. Subsequently, this study gives attention to critical youth research that centers the specific experiences of urban Black male youth, and their cultural practices with hip-hop, to answer some of the larger questions about their identity formation processes in relationship to education and schooling.

Reading the culture of hip-hop in urban education in a critical manner is guided by the following questions: What might we learn from urban youth and hip-hop culture? What are young people saying that is so important to them? What does hip-hop have to do with education? What are the political consequences of denying hip-hop's value and significance as an important cultural site of inquiry for educational practitioners, scholars, and researchers who work with youth in urban communities? Why are urban youth, Black males in particular, drawn toward the culture in ways that are qualitatively different than the traditional culture of public schools? How is hip-hop viewed as a culture differently from the dominant culture, and how do youth respond to these distinctions? How might the culture be read as an alternative form of curriculum and pedagogy that can address matters of social justice? The heart of these questions drive my overarching concern to hear and understand the voices of urban youth, spoken through the culture of hip-hop, that may open up new pedagogical possibilities in urban education.

In thinking about the significance of hip-hop to the histories, identities, and cultural contexts of urban youth, new models in educational leadership and teacher-preparation programs are needed if we take the political work of education for democracy seriously. This is particularly true for those practitioners who will enter into high-density, low socioeconomic areas of concentrated minority student populations. These models in teacher-preparation and educational leadership programs must not be predicated on a pure technical-rational approach. Traditional organization of the curriculum content, institutional policies and practices of the school, and the day-to-day social and pedagogical interactions and relationships with the students, from the Taylorist model, privilege notions of objectivity and are completely removed and detached from the everyday lived experiences and cultural contexts urban youth bring with them to school. In this regard, we must "become aware of how federal policies in education, steeped in supposedly, objective, neutral, apolitical, Taylorist, scientific management paradigms continue to suppress the identity and culture of youth in predominantly African American populated schools in ways that affect academic achievement, and critical citizenship for democracy and social justice" (Dantley, 2005; Prier & Beachum, 2008, p. 520). As Jabari Mahiri states,

> In this century, more knowledge work in schools will need to involve educators in understanding how students and communities use symbiotic resources for their own ends as well as for the dramatically changing literacy demands of sites beyond school. If schools are not able to meet this challenge, according to Willis (1990: 147), "they will become almost totally irrelevant to the real energies and interests of most young people and no part of their identity formation." (2005, p. 3)

If it is mutually agreed by educators that the purpose of schools is centered on the lives of students, we must be cognizant of the changing cultural contexts that significantly mediate the production of knowledge in their lives. In this regard, the changing literacy demand beyond school walls to which Mahari is referring is the cultural site of popular culture. For the purpose of this work, hip-hop is centered as the primary popular cultural site and new literacy of urban youth that

educators need take note of if we want our work to be relevant and
critical to reshaping democratic practices in urban education.

This work is intended to move beyond the discussion of critiquing
hip-hop culture. It is a work that foregrounds the significance of hip-
hop culture as a culturally relevant form of critical pedagogy for
African American male youth that can open new possibilities in
reshaping the traditional contours of urban education. In some ways,
this work will help us think about how we might transform current
educational policies that have been repressive and confining to the
identities and everyday lived experiences of African American male
youth. In other ways, this work acknowledges the value of progres-
sive forms of hip-hop as a cultural practice that empowers youth to
develop a critical consciousness, enabling them to be democratic
citizens who can make positive choices and decisions in their lives.
Finally, this work gives us glimpses of the transformative changes
that can happen when a community takes political action, and mobi-
lizes its own creative resources through hip-hop to address the
specific challenges, interests, and needs of a vulnerable population.

This discussion is hopefully a starting point for progressive educa-
tors and community activists in understanding the critical discourse
of urban youth through hip-hop culture. As cultural workers in urban
education come into contact with such a culture, they suddenly
understand what Dead Prez understood in 2000: "It's bigger than hip-
hop." It is about the teaching and "reading" of the culture to mobilize
pedagogical experiences between communities and classrooms in
ways that keep urban youth in schools. It is about urban schools
entering into the public space of hip-hop to redefine its democratic
role beyond the academic achievement of test scores. It means under-
standing urban youths' cultural practices of consumption and pro-
duction of oral, written, and visual texts in hip-hop that tell us
something about their confrontations with the cultural intersections
and power relationships between race, class, and gender in society.
What we learn from urban youth in hip-hop may offer new insights
that challenge educators to think creatively about the possibilities of
where "public education" happens, the political and empowering
purposes to which it can serve, and different teaching, learning, and
educational policies and practices that may emerge in urban schools

and the communities that surround them. This is ultimately a larger conversation about social justice and democracy in urban education.

Organization of the Book

The overall purpose of this book is to address how we as educators might "read" hip-hop culture as a critical pedagogical text in urban pre-service teacher education programs, and educational leadership more broadly. While there have been works about how to apply hip-hop to certain subjects (e.g., English, social studies, Black world studies, and sociology) in higher education or urban public schools, there has been limited discussion or implementation of hip-hop as critical pedagogy in urban pre-service teacher education programs. That is, how can we see the culture of hip-hop not just as a cultural and symbolic expression of creativity and entertainment? How can we see the culture as a valuable and viable pedagogical space that has something to say and teach future educators about the deeper sociocultural realities of students they will be teaching and socially interacting with in urban communities? Subsequently, it is out of this broad conversation that I will devote some specific attention to understanding how African American male youth negotiate hip-hop as a form of critical pedagogy in relationship to their cultural processes of identity formation between popular culture, urban public schools, and larger societal contexts. What we see absent for these youth in urban public schools in relation to larger social, political, economic, and racialized contexts foregrounds the conditions upon which a critical pedagogical space emerges within hip-hop culture. In this way, student narratives in the book will reveal what has been hindering the project of democracy for these youth, and more important, the cultural meanings and transformative, pedagogical possibilities these youth associate with hip-hop culture to their everyday lives. Given what we learn from these youth, it is my intention to underscore how this knowledge might impact the transformation of pedagogical aims, means, intent, and purpose of how we go about the study of urban education in pre-service teacher education programs in the classroom and the community at large. The aforementioned insights will, in part, be based on reflections from my

previous dissertation work, which used a cultural studies approach to critical discourse analysis of hip-hop texts and open-ended interviews with socioeconomically, disenfranchised African American male high school students from a local urban neighborhood community.

First, we often limit the discussion of democracy and citizenship to voting, and other official practices of the nation-state as the only means by which we think of democracy in society. While these are important elements, these understandings confine democracy to methods of participation within official state politics, and narrow broader notions of democracy within the public sphere of society. Traditionally, public education has been seen as the main conduit by which self-actualization and practice of democracy can happen for all students in public schools. However, the very structure of education and schooling, as presently constructed, has not served in the best interests of urban youth in democratic ways. In many ways, the educational policies from the nation-state that have been mandated in public schools have actually prevented the action and practice of democracy from flourishing in the best interest of and for many urban youth. Therefore, chapter 1 situates rap music and the culture of hip-hop as a site of democratic practice for urban Black male youth. The political consequence of this framework challenges traditional notions of how we think about the practice and implementation of educational projects in urban communities. It also sets the tone for new innovative, pedagogical strategies that can best address vulnerable realties of youth in transformative and empowering ways, given the conditions and present moment of urban education.

It is evident that urban youth in hip-hop engage in multiple discourses. Contrary to what is often portrayed in mainstream media, the culture is not homogenous in its representation of values, politics, and interests. Urban youth engage in socially and politically conscious discourses that critique inequities in society, are grounded in historical and political contexts that shape their outlooks on present-day circumstances, and at times, forge movements of social justice that seek to transform injustice, with respect to racism, classism, and gendered politics. However, some urban youth have taken on the discourse of an outlaw, gangsta mentality or what Elijah Anderson calls a street orientation. These discursive events are marked by extreme levels of

disappointment in a society they feel has failed to live up to its prom-
ise of the democratic ideal. In this sense, they often take matters into
their own hands, dispensing a discourse that is at times political, and
at times nihilistic to the self-destruction and detriment of their cause.
Finally, many urban youth have taken on market-oriented, commercial
discourses in hip-hop where business interests and monetary gain take
precedent over the local experiences of the people, as mentioned
earlier. Subsequently, in chapter 2, I outline social/political, gangsta,
and commercial discourses as three different modes of communication
that are shaped within three different genres, networks, and communi-
ties in the culture of hip-hop. I develop these discourses largely as
interpretive devices by which the reader might understand the hetero-
geneous and intertextual narratives of urban youth that are respond-
ing to ongoing sociocultural changes in society within larger racial,
social, political, and economic contexts. It is through showcasing each
of these discourses in relationship to urban youths' identity formation
processes that we come to better understand and make sense of
conditions that impact and shape how students from the hip-hop
generation view the government, media, and schools within each of
these interpretive contexts. It is a useful conversation for public school
officials who have dismissed or been completely removed from a
culture that has so much impact on the lives of students they work
with on an everyday basis.

In chapter 3, I analyze the historical and sociocultural contexts
that have shaped the ways in which the African American male has
been seen as the public enemy in popular culture. How society
socially constructs Black males in popular culture as criminals,
deviants, thugs, and menaces to society — "the Public Enemy" — is of
consequence to how he is treated by and in government, schools, and
other public institutions that hinder his interests, rights, and opportu-
nities in a presupposed democratic society. In this regard, the sense of
social alienation he feels and experiences is closely related to how he
is viewed within the public imagination of American society. That is,
historically and in the contemporary moment, the medium of popular
culture has been a constant, primary conduit of producing certain
images about Black male youth that are closely related to cultural
tensions and antagonisms between themselves and authority in

public institutions (e.g., government, prisons, and schools). Subsequently, this chapter foregrounds new racial formations of gendered contexts that now place the image of hip-hop culture at the center of Black masculine identity constructions. How students of the hip-hop generation see themselves in relationship to how dominant media institutions in popular culture produce visuals about them is, in part, of political consequence to social conflicts with teachers, administrators, and other school officials.

Conversations about rap and the culture of hip-hop as sites of democratic practice are important in this overall work because they are dialectically reflective of the culture of displacement and exclusion that many urban Black male youth feel in society. In chapter 4, I discuss how students read Tupac Shakur's song "Trapped" from the *2Pacalypse* album of 1991. The reading of this text mobilized youths' narratives in the multiple, complex ways in which they discuss how they are both confined and pushed to the margins of urban public space. In this way, they discuss how they have been shut out in public schools, urban communities, and other public institutions in the society at large. The ideology and cultural politics of race, class, and gender serve as constitutive elements by which urban displacement takes shape for these youth. Subsequently, the cultural formation and material conditions of underemployment, miseducation of standardized testing, and struggles and social conflicts in neighborhoods are significant ways in which students discuss the multiple contexts of their sense of being trapped and displaced within the new cultural and racial politics of neoliberalism.

In chapter 5, students discuss what it means to be "that dude" in high school. Masculine ideas of what it means to be that dude are based on market-driven discourses of the hip-hop industry. As critical cultural workers, students discuss the ways in which their peers struggle to be accepted in school, based on the production of commodified images of hip-hop artists in music videos that students emulate. The latest styles and fashions, excessive jewelry, and expensive accessories in hip-hop are cultural, symbolic texts of value and self-worth to the students. Those students who do not keep up with the latest hip-hop fashions are seen as lame, or unpopular. Their desire to be "that dude" is part of a larger narrative of what Philip

Wexler calls becoming somebody. That is, youth turn toward market niches and brand identification processes in subcultures, such as hip-hop, to fill in a void of emotional and communal bonds of caring and nurturing relationships between teachers and students in schools. This sense of emotional detachment between teachers and students is reflective of neoliberal reforms in urban schools that have privileged discipline and punishment, testing and social order, and technical management and rote memorization. These conditions of social, interactional, and relational lacking set the stage for which youth turn toward market niches in popular culture to shape new cultural modes of identity making to be "that dude" or become somebody.

In chapter 6, I look at how the culture of hip-hop can be used as counter public spaces of resistance in urban local communities. Given the cares, concerns, and experiences of vulnerable urban Black male youth, chapter 6 provides the reader with new ways to think about critically relevant, responsive, and empowering education that addresses issues of life and death, poverty and absentee fatherhood, violence and peace, and new definitions of student success and achievement. Schools cannot solve all the complex challenges students face in their everyday lives. Subsequently, I discuss how the pedagogical space of a hip-hop community center can play an integral role in curbing high school dropout rates and encourage new motivations in students' education and learning experiences inside and outside of school settings. The hip-hop community center serves as an alternative counter public space to the traditional structure of the school that allows students to express themselves creatively, to become authors and change agents within the circumstances of their social worlds, and to lead and live healthy and productive lives as critical citizens.

I conclude, in chapter 7, with a discussion of pedagogical possibilities of teaching a course on hip-hop in pre-service teacher education programs. Given the importance hip-hop has for many urban youth, I discuss how the study of the culture might be involved in the study of urban education in pre-service teacher education programs in the classroom. How might the study of the culture transform our pedagogical relationships with Black male youth in urban communities and neighborhoods? In what ways might we rethink the production

of critical knowledge and learning between the classroom and the streets? What are the benefits of addressing these kinds of questions to administrators, teachers, and school officials who work with these youth in urban school communities on an everyday basis? (In other words: What does hip-hop have to do with me as an educator, practitioner, or scholar?) To address these questions I discuss some of the possibilities in the kinds of pedagogical projects that can develop critically self-reflective teachers about the conditions and motivations shaping the urban youth culture of hip-hop. This discussion is meant to be empowering and transformative to pre-service teachers in teacher education programs or community activists who are thinking about teaching and working with youth in urban school districts. I draw from my experiences in teaching a special topics course on hip-hop that fulfilled partial requirements for our education majors within our department's division of Education and Allied Professions and our liberal arts plan within Miami University's Cultural Studies and Public Life thematic sequence. In sum, it is my intention for this chapter to progressively further the curricular and pedagogical agenda of pre-service teacher education programs in nontraditional ways. While this chapter gives some specific attention to males of color in urban contexts, it will inevitably discuss the broader political implications for all students within disenfranchised communities.

Chapter 1
Hip-Hop as Democratic Practice

So as the nation began to take shape, and articulate its own self understanding, what it felt democracy to be, what it felt justice to be, what it felt was the righteous path to take, people of color who were African slaves were systematically excluded from the larger circle of American privilege. So how do you reconcile on the one hand, the expression of a document that celebrates the universal freedom of human beings and exclude folk on the other hand? Black leadership steps into the gap to try to articulate the grievances of exclusion of African-American people from that larger circle of American privilege and they begin to defend the gains that are necessary to close the gap between the ideal and the reality. So, from the very beginning Black leadership is about reinterpreting the fundamental premises of American democracy so that the ideals after which they aim can be embodied, and the noble goals that they articulate can be lived up to.

—Michael Eric Dyson
Tavis Smiley Black Agenda Forum
March 20, 2010

This democratic vigilance has been disproportionately expressed by artists, activists, and intellectuals in American life. They have and can play a unique role in high-lighting the possibilities and difficulties of democratic individuality, democratic community, and democratic society in America.

—Cornel West in *Democracy Matters*
(2004, p. 67)

I remember when Sean Combs, otherwise known as P. Diddy in the world of hip-hop, started a "Vote or Die" campaign in support of John Kerry back in 2004. The phrase implicitly gave historical reference and homage to Black freedom fighters who fought and died for the natural rights of citizenship that young people enjoy today. This was a cultural, symbolic representation of democratic activity in hopes of getting young people in the hip-hop community socially active in the voting process. One can assume that P. Diddy's inspiration by the "Vote or Die" campaign was inspired by his earlier financial support and involvement as a board member of the Hip-Hop Summit Action Network, founded in 2001. Voter registration of

young people is one of the network's major initiatives. Even though the cultural movement to attract young voters was not as successful in the 2004 presidential campaign as John Kerry had hoped for, those efforts increased numbers of voter participation of young people and raised questions about whether or not hip-hop culture could be a political force in U.S. politics. Since that time, the presidential election of Barack Obama in 2008 has inspired a number of artists, activists, and intellectuals who are fighting on numerous fronts to get their voices heard in matters of social justice in the urban community. For example, community activist and former writer at *Vibe* magazine Kevin Powell ran in the Tenth Congressional District of Brooklyn in 2010; Wyclef Jean had a brief stint running for presidency of his homeland of Haiti; hip-hop activist Rosa Clemente was on an independent presidential ticket as vice presidential pick alongside independent presidential nominee Cynthia McKinney of the Green Party in the 2008 election; and politically conscious rapper Ryhmefest recently announced he is running for alderman of Chicago's Twentieth Ward during the 2011 election cycle. While many of these artists and activists did not win their elections, the more important point is that a cultural shift is taking place in the leadership of hip-hop culture. The messages in their music and books are being translated in concrete political terms in an attempt to meet the local concerns of their communities. That is, these artists and activists recognize the culture must extend its reach in matters of social justice if the pain, struggles, and voices of urban youth in the music are to be heard, felt, and addressed in concrete terms. These artists and activists are seeking to unsettle the boundaries and possibilities of hip-hop as a democratic practice in the body politic of U.S. society.

Hip-hop was always born out of race and class struggle, and Black popular culture has always been connected to Black politics (Marable, 2002). True enough, in recent times the elasticity of these origins has been made thin by the power and influence of corporate culture of the commercial industry. This is the risk taken with all art when it goes "pop" or commercial. When a culture, created out of the ash heap and rubble of ghetto conditions in the urban city, becomes a multibillion enterprise, the local origins of its style and message can get manipulated, lost, and exploited amongst a vulnerable, disenfranchised

people. "There has always been a fundamental struggle for the 'soul' of hip-hop culture, represented by the deep tension between politically conscious and 'positivity' rap artists and the powerful and reactionary impulses toward misogyny, homophobia, corporate greed, and crude commodification" (Marable, 2002, p. 260). However, situating hip-hop as a democratic practice addresses matters related to educational inequality, the erosion of dilapidated neighborhoods, joblessness, police brutality, poverty, and violence amongst gangs in the inner city (Marable, 2002). When we situate hip-hop as a democratic practice, it is not limited to voting and electoral politics. Urban youth are attempting to find their voice and freedom of expression and individuality in a multitude of ways that reflect the contradictions and possibilities of America's grand democratic experiment. It was through urban youths' own experiences with disappointment, neglect, and rejection that simultaneously created the conditions upon which young people resisted, formed their own subculture, and gained a sense of collective community amongst themselves.

In the postmodern era, hip-hop wields significant influence in shaping the identity and lived experiences of young people, and urban youth in particular. It is a form of youth subculture that shapes the way they look at the world. They are producing new forms of social knowledge through hip-hop in ways that compete and contrast with the traditional culture of urban schools (Dimitriadis, 2001; Giroux, 1996; Prier & Beachum, 2008). In spite of this, the traditional, neoliberal culture of schooling and education often rejects popular cultural contexts as critically relevant pedagogies for urban youth. Culturally relevant pedagogies in hip-hop reflect a set of life experiences, reflective of their realities in ways that can be communicated to them in contemporary ways that traditional curricula and pedagogies in urban schools ignore. Further, the critical dimension in hip-hop culture allows urban youth to interpret their realities in ways that recognize and critique the role of power, culture, and ideology in society, and how to be empowered to transform the conditions from their own experiences through sociopolitical strands of hip-hop. Young people demonstrate democratic practices through interpretations of their own social reality through emceeing and scratching a record to the break beat sample of artists such as James Brown or the civil rights speeches of Malcolm X or

Martin Luther King Jr.; they rhetorically flip words into similes, meta-
phors, and tropes, and inscribe their name on the pavement of "the
concrete jungle" in graffiti to mark their visibility in a society of institu-
tional neglect. Back in the day, hip-hop heads would take a piece of
cardboard from the remains of the ghetto metropolis and contort their
bodies in ways that defied human logic. It was about creating and
making something out of nothing. Matters of culture and politics in
hip-hip are expressions of urban youths' democratic practices to
"anchor their art into the life-and-death (and 'def') struggles of African-
American and Latino communities, which largely consist of poor
people and the working poor, the unemployed, and those millions who
are warehoused in prison and jails" (Marable, 2002, p. 269).

> Democracy is always a movement of an energized public to make
> elites responsible—it is at its core and most basic foundation the tak-
> ing back of one's powers in the face of the misuse of elite power. In
> this sense, democracy is more a verb than a noun—it is more a dy-
> namic striving and collective movement than a static order or sta-
> tionery status quo. Democracy is not just a system of governance, as
> we tend to think of it, but a cultural way of being. This is where the
> voices of our great democratic truth tellers come in. (West, 2004, p.
> 68)

Hip-hop as a democratic practice signifies how urban working-
class communities attempt to mobilize the cultural and symbolic
resources to make places and spaces for themselves in a society that
has rejected and pushed them to the margins.

> That such powerful poetry and insightful social critiques could be
> created by youths who have been flagrantly disregarded, demeaned,
> and demonized by the dominant market-driven culture-targeted as
> cannon fodder by a racist criminal-justice system and a growing
> prison-industrial complex, in disgraceful schools and shattered fami-
> lies…and violent environments—is a remarkable testament to the
> vital perspective and energy that can be injected into our democracy
> by the young, who have not made their compromises yet with the
> corrupted system. (West, 2004, p. 182)

While many students are reclaiming democratic energies through the street curriculum of hip-hop culture, urban public school institutions ignore a vital cultural site that reflects the cultural, identification processes of urban youth at their own peril. As one local resident recently told me, "These kids are interested in art and music, but they don't want to teach them about that." Most schools do not value the cultural production of hip-hop as a form of knowledge. Subsequently, they do not value the knowledge and intelligence that many young people possess, who draw upon the oral, linguistic, and artistic traditions of hip-hop culture. I often ask my undergraduate students in pre-service teacher education programs and graduate students in principal certification programs who could write me a short autobiographical sketch of their life in two pages. All hands are raised. When I ask them who could give me that same narrative, on the spot, in the freestyle tradition of rap music, no one ever raises their hands. The point of this exercise is not to suggest that school officials need to begin honing their emcee skills to relate to students, or that schools need to become rap studios for learning. However, it is to recognize that educational policies in schools place value and legitimacy on certain kinds of knowledge that are no more or less sophisticated than the sociocognitive skills urban youth have learned in the streets of hip-hop culture. Subsequently, the cultural contexts in how they process knowledge in relationship to their everyday lived experiences are devalued, ignored, and rendered absent. The identity and cultural contexts of students' lives are, then, rendered void from the larger conversation about the meaning of democratic practices in public education. In the 21st century, urban schools will need to think about the central role popular culture plays in students' lives, and how school leadership practices can translate that knowledge in meaningful ways that carry out the ideals and social justice ends of democracy.

If school leaders in urban schools are to value and read the cultural context of hip-hop as a democratic practice, they must reconstitute the meaning and purpose of education and schooling in a different manner than is constructed in the current moment. At present, there are very limited conversations in urban education about alternative pedagogies in hip-hop because policies, school leadership practices,

and teaching methods are driven by the corporate influence of the market. If the public commonsense narrative is that schools are about democracy, then we must raise some fundamental, competing questions about the meaning and purpose of schools, and to what political ends they are serving students in socially just ways. The ways in which we define the role, purpose, and meaning of education can either cut off or open up the transformative, pedagogical possibilities of hip-hop culture for urban youth. The fundamental questions we have to ask are whether or not the purpose of schools is merely to prepare students to be academically excellent and efficient, as defined by the objectives of market-driven measures of standardized testing and global competition, which reflect the language of corporations; or, do we hold schools "accountable" to the ideals and goals of democracy, which reflect the language and values of social justice (Quantz, Cambron-McCabe, & Dantley, 1991). The language of social justice raises questions about who decides the definition, meaning, purpose, motivation, and goals of public education. This kind of language raises questions regarding whose knowledge is being valued and legitimized, and to what and whose interests is this knowledge serving? What, and in whose image, identity, and history of the curriculum is being constructed? Whose images, identities, histories, and lived experiences are being left out or distorted? Having the power in public institutions of the nation-state to decide what counts as teaching and learning, what counts as student success, and what it means to be a citizen in a democratic society often has political consequences that position the cultural capital of urban communities one down. Subsequently, the critical questioning of what a more democratic education means and the purposes and interests to which it serves marginalized, urban youth is ultimately a matter of social justice in urban school environments. For me, this is an argument about how to achieve just schools in critically relevant and innovative ways for urban youth whose identities and experiences have been left out of the equation of traditional, American public schools. In many ways, their everyday struggles in urban communities necessitate and depend on this kind of knowledge.

Historically, struggles for democracy as a goal and an ideal in re-lationship to educational equality for African American communities

have not been a given in the social context of U.S. society. That is, the very premise and foundation upon which education was built is predicated on the specific denial and exclusion of persons of color the right to knowledge to give aspiration to the rights, privileges, and ideals of citizenship in American society. Subsequently, the recognition of where education can take place, how it might be implemented, and the purposes for which it serves have been important questions that African American communities have had to consider for centuries. Our very lives have depended on it. These questions speak to power struggles over "official" and "unofficial" curricula between traditional state practices of public schools and alternative curricula forged by African American communities to resist, survive, and transform the social reality of dehumanizing experiences and conditions in which they lived. For example, the historical context of literacy for African Americans reveals that the act of reading for Black folk gave consequence to punishment, and even death in many cases. Therefore, acquiring literacy and knowledge was seen as a political act of struggle, as a practice of freedom, and was never taken for granted, given that the threat of death was always a possibility. In this sense, "Due in large part to the persistence of structures, both legal and de facto, that have limited or completely obstructed their access to quality formal education since slavery, black people have looked outside of schools for learning. In addition, those who have had the benefit of formal schooling often depend on out-of-school educations in order to earn a 'dual degree,' or a supplemental education designed to ward off the disingenuous, disempowering, and dehumanizing aspects of the official school curriculum" (Hill, 2010, p. 110).

Today, urban youth are attempting to fight off the dehumanizing effects of neoliberal reforms in education. In "Preparing School Administrators for Democratic Authority: A Critical Approach to Graduate Education" (1991), Richard Quantz, Nelda Cambron-McCabe, and Michael Dantley remind us that traditional approaches to education and schooling in the American school system have relied on technical, scientific management models, dependent on the economic values of world corporatism. They argue that schools must be seen as arenas and sites of cultural politics, where ongoing power struggles between the authority of school leadership and students

take root. These authors argue that when schools work to celebrate the cultural context and identities of a few, at the expense of many (e.g., race, class, gender), it should come as no surprise that "those students whose cultures lose in those struggles may come to resist and reject the best intentions of the educators who work within those schools" (Quantz, Cambron-McCabe, & Dantley, 1991, p. 6). As it relates to urban youth in hip-hop, when we consider what is happening in schools "young hip-hoppas publicly mark and make visible the 'otherside' of American national identity, the side where young people are struggling with and within their Americaness. As they perform, literally and figuratively, the dilemmas of a 'ghetto life,' these young cultural critics are problematizing many of the notions upon which American national identity rests—equality, freedom, and justice" (Baszile, 2009, p. 14).

When school leaders and scholars value and use the language of social justice, it leads us to raise different questions and produce different methodologies in research and practice about different pedagogies and structures that enable administrators, teachers, students, families, and the community to question the society in which they live, and how to transform the conditions around them, which reflects the ideals, governance, and language of democracy (Quantz, Cambron-McCabe, & Dantley, 1991). When I adopt the language of social justice for the values of democratic ideals in education, I do not assume the work of school leaders and educators is merely about the technical, management of control, order, and basing student success on performance measures of standardized testing. Second, the authority of where powers reside in the teaching and learning process is not relegated and isolated to vertical, top-down, technical, management models to guide the structure of the schooling environment, and the kinds of knowledge generated in those structures. That is, as Paulo Freire would suggest, critical knowledge for the empowerment of oppressed groups can be co-constructed between school leaders and teachers, teachers and students, between the school and the community. Third, democratic practices of education are not limited to what is taught and learned inside the walls of urban public schools. Cornel West argues that true democratic practices in education are nonconformist, resistant, and empowering to individu-

als and groups who are committed to its ideals and the politics that govern those practices (2004). He suggests that deep democratic traditions rest on new, nonconformist visions of one's own sense of democratic individuality, creativity, and possibility. In this context, we can begin to think differently about alternative, democratic spaces and practices for how one becomes educated for cultural citizenship. I argue that new democratic public spheres are being created through subcultures such as hip-hop, enabling urban youth to affirm their identities and lived experiences in creative, transformative, and empowering ways. Subsequently, a major political part of this project in critical youth research is to center the ways in which urban youth engage in democratic practices in urban education through their readings and practices of hip-hop culture. The research done at the hip-hop community center represents a series of critical conversations that emerged with and between students, community activists, and critical educators coming together to create our own democratic society, centering our own prophetic voices to politically reclaim the progressive, rather than market-driven, possibilities of hip-hop culture. It is in this sense that democratic practices in hip-hop can open up new avenues of teaching and learning that can assist with the transformation of both consciousness and the conditions that urban youth confront in their everyday lives.

When urban youth, who are living at the margins of society, look toward education outside the walls of the school, it is because they do not feel the democratic ideals of the nation-state are being lived up to. They see the contradictions between an educational system that purports to be equal and just, versus the reality in the production of a curriculum that renders absent the identities and lived experiences of urban youth who are on the verge of giving up hope. It is quite difficult to get excited about learning when you don't see yourself in it, or how it relates to life and death struggles of survival that you face on a daily basis. This is particularly troubling when neoliberal policies in urban public schools negate the importance of critical knowledge for urban youth who live in concentrated pockets of poverty-stricken neighborhoods. The voices of urban youth who live at the edges of urban displacement yearn for a curriculum that will work with young people in how to emerge from the bottom of the metropolis, where

economic resources have dissipated and local jobs have disappeared. Subsequently, to truly create democratic practices and spaces in local urban communities, critical educators will need to think creatively about meeting local citizens where they are, understand how they process the world around them, find out what disappoints and empowers them, and mobilize teaching and learning practices that disrupt the traditional, curriculum boundaries in urban public schools. Situating hip-hop as a democratic practice is about taking political action in ways that create conditions upon which youth find their own imaginative creativity and individuality, democratic community, and democratic society (West, 2004). School leaders must work with students to figure out creative strategies of how education can help urban youth find their own way to resist repressive practices in society, and work toward critical-cultural citizenship. These values hold true the priorities of education as a democratic practice, concerned with matters of social justice for the downtrodden in society.

In the next section, I describe the current ways in which neoliberal reforms in urban schools threaten to snuff out all democratic possibility and hope for urban youth. According to West, democratic energies in America are threatened by free market fundamentalism, where the idol and fetish of the market take precedence in all matters of public policy and ways of living. In this context, the politics of corporate greed take precedence, while the needs of local citizens (e.g., health care, funding in public education, after-school programs, social security) are threatened. In schools, the logic of the corporate market drives the curriculum based on the business discourse of "objective standards," "measurements," and "data-driven," performance-based outcomes to define academic achievement. Urban youth are socially alienated from the policies and corporate logic of No Child Left Behind (NCLB); schools prepare students to become workers in an economy that has dissipated in the current economic downturn; and much of what is being taught in urban schools is based on a neoliberal, market logic that is not reflective of students' histories, identities, cultural contexts, or lived experiences and presumes a white norm (Leonardo, 2007). In addition, West suggests that neoliberalism also assumes an aggressive militaristic posture, where punishment and incarceration are the modus operandi rather than finding new,

compassionate ways of ameliorating problems related to social, political, economic, and racialized conditions. This has fueled obsessive policing and surveillance of Black and Brown subjects in the urban community. The surveillance and suspicion of urban male youth, often seen as criminals in public spaces of media, neighborhood street corners, or other public institutions, should be seen as problematic to the cultivation of citizenship and democracy in American public life. When students cannot be seen and understood in public space in the same way as other citizens this should be a problem and challenge to all educators who believe in the ideals and practices of democracy and social justice. Finally, there are those who adopt the idol and fetish of free market individualism and narcissism with material gain as the goal and ideal of success. Youth in market-driven forms of popular culture have become sedated with this kind of mentality. The sum total of emotional disinvestment in pedagogical relations between teachers and students in response to neoliberal reforms create the conditions upon which many youth turn toward market identities and relations circulated and produced in the corporate-driven market of the hip-hop industry. The aforementioned conditions are enough for any of us as critical educators to give up all hope. However, providing social critique of anti-democratic dogmas in corporate institutions that prevent real possibilities of democratic practices flourishing in the lives of urban youth is central to the language of social justice in urban education. West's notion of democracy, guided by a divine love of social justice, states that democratic practice is marked by uncompromising, prophetic truth telling—frank speech—in the face of lies and distortions of corporate interests to awaken the public. He states that new visions of democratic individuality, community, and society cannot take shape without critique of the American empire. This is where ordinary citizenry expose the lies and contradictions within the underside of American darkness that attempts to conceal itself within superficial ideals of American patriotism (West, 2004).

The future of hip-hop reclaiming its democratic possibilities is in local communities. The very best of the culture is tied to prophetic strands of hip-hop, which are an uncompromising truth telling, giving frank speech and social critique of the hypocrisies and men-

dacities of the imperialist, American empire. Artists within prophetic strands of hip-hop keep democratic practices of local urban communities alive by critically questioning issues of peace and justice, violence, inequitable health care, police brutality, disproportionate warehousing of Black and Brown peoples in the prison industrial complex, dilapidated housing, and unjust school systems. They are committed to democratic individuality, community, and society. The preservation of social and political discourses (prophetic hip-hop) is in constant tension with what I call gangsta and market-driven discourses of hip-hop culture that have been taken over and commodified by the dominant mainstream society. In addition to critiquing institutional practices of domination and suppression in society, prophetic voices in hip-hop culture undergo a critical self-examination and critique of market-driven elements of the hip-hop industry that impact the soul of urban youth. Without critical questioning between self and society, democratic individuality, community, and society cannot be maintained or sustained.

Neoliberal Contexts: Corporate Consumption of Schools, Streets, Work, and Market Identities

Under conditions of neoliberal hegemony in America over the past two decades or more, urban schooling increasingly has been restructured a technical-rational process of producing learning outcomes under highly disciplined and alienating conditions, with a basic skills curriculum and a test-preparation pedagogy that do not acknowledge or engage urban students' everyday lived experience, respect their culture and language, or involve them in struggles to construct empowering and self-affirming identities and to resist oppression. The technical control of the curriculum and the de-skilling of both teaching and learning in urban schools are the latest expressions of instrumentalism and social efficiency models of schooling that have a long history in urban districts, dating back to the early progressive era (Apple, 2001, p. 417). Dennis Carlson argues that the contemporary neoliberal reform discourse on urban educational renewal emerged in the 1980s as economic functionalism, and a standards discourse "began to assume a more active role in shaping urban school policy

and in overseeing school reform consistent with the 'bottom line' of test scores" (2005, p. 33). As teachers succumb to corporate imperatives of "banking models" in education and rote learning, how they critically engage with urban youth has become increasingly difficult. "As a result, a schism has grown between in-school and out-of-school culture, with unofficial curricula (e.g. rap music, film, etc.) and learning settings (e.g. community centers, churches, etc.) taking on increasing salience" (Dimitriadis, 2001, p. 7; Prier, 2006). In the new labor force, as the high school diploma in most urban schools has been aligned with the basic skill needs of the entrée labor, service industry working-class, Black, and Latina/o youth also begin to feel that the myth of upward mobility is just that, and that they are being oppressed and disempowered through the schooling process.

The economic and political rationale and logic of neoliberalism have become one of the major forces and back-end ways in which new racial projects have emerged. Neoliberal agendas adopt race-blind politics that speak about "free markets," "individual accountability," "meritocracy," and "achievement" ideologies that are business discourses which serve corporate interests to publicly promote a common sense about equal opportunity for all people. However, the needs of the common good, such as public education, workers' rights, health care, and social security for many working-class communities in urban centers, have been placed on the periphery in lieu of advancing the economic interests of corporations. As Cornel West states, there is callous indifference to the suffering of the dispossessed and the most vulnerable in society. Michael Apple suggests that the culture of neoliberalism has affected all aspects of social life, and has had particular racializing effects on minority communities. According to Henry Giroux, the culture, philosophy, ideology, and discourse of neoliberalism are predicated on the state giving a priori to commercial and profit motives of transnational and multinational corporate interests over the public good (August 2004). Neoliberalism attacks all noncommodified public spheres, such as public education, social security, noncommercial public airwaves, and fair labor laws that advocate for decent living wages of working-class communities (Giroux, August 2004). The economic and political imperatives of neoliberalism also stifle critical public spaces of dialogue where

marginalized communities can negotiate their own priorities as they relate to social responsibility, civic engagement, and democratic participation within their everyday lives (Giroux, August 2004). In this way, urban spaces and places where collective communities can politically engage in democratic dialogue shrink and dissipate under the corporate power and regulation of neoliberalism.

One of the outcomes of neoliberalism is economic restructuring that has changed the nature of work and production of manufacturing. During the 1960s and '70s, decent work and wages could be found through steel mills and other manufacturing centers across the country. However, today, the cultural shift toward a global economy has motivated many U.S. multinational corporations to seek the production of cheaper labor through foreign markets for the maximization of profit, while disinvestment in urban locales created devastating socioeconomic conditions for Black and Latino families (Lipman, 2004). One of the consequences of this disinvestment has been the dissipation of employment for urban youth and families of color (Lipman, 2004). For example, unemployment rates for African American communities soar at 16 percent. According to recent data from the U.S. Bureau of Labor Statistics, while these figures far exceed the national unemployment rates (9.7%), they pale in comparison to unemployment rates for African American youth at 49.3 percent, and 52 percent for African American male youth (Sanders, 2010, para 1). Inevitably, the economic consequence of neoliberalism's impact on unemployment has placed a financial strain on impoverished urban communities that fight for monetary resources for their daily survival in such circumstances. In this regard, as jobs take flight overseas and public education becomes less of a route to socioeconomic mobility, the proliferation of drug economies often flourishes. In these conditions, the vulnerabilities for local competition and violent conflict over urban street markets may take root. In many cases, the regulation over urban territory by rival gangs has been an outcome of competition over the political economy of street pharmacy. Consequently, many urban youth navigate limited options between the illicit, informal economy of the street versus legit forms of employment that have all but dissipated for urban youth. Students often negotiate the cultural politics of these matters as outcomes of corpo-

rate disinvestment in urban communities. Elijah Anderson has spoken at length about the trappings of informal economies of the street that become alluring to vulnerable youth in the low socioeconomic circumstances of local urban communities. In a neoliberal era of globalization, such critical, sociological insights have even stronger validity in the contemporary moment of economic disinvestment in concentrated ghettos across the nation.

Under neoliberalism, market-driven practices in schooling have confined curricular and pedagogical practices to corporate, technical efficiency models that are far removed from the everyday lived experiences of Black male youth. For example, President Obama's well-intentioned "Race to the Top" initiative inevitably continues the legacy of George W. Bush's NCLB policy through its funding incentives to push states to come up with a set of common "comprehensive standards" that "raise the bar" so that "all students succeed." In reality, these policies narrow democratic practices in urban education because they isolate knowledge as a technical, mechanical act; privilege market interests over the material and sociocultural contexts of persons of color (virtually rendered invisible); reproduce the discriminatory affects of institutionalized practices of racism; and nullify a more critical, diverse, pedagogy and curriculum in the current neoliberal structure of schools. In so doing, the racial politics of NCLB reinscribe what Zeus Leonardo calls white nationhood (2007). The discursive strategy and universal logic of "no child left behind" reaffirm whiteness in a way that presents an equal merit system, targets and exposes the supposed "cultural deficits" in learning and academic achievement of persons of color, and awards and penalizes disparities between affluent and nonaffluent school systems, already disproportionately segregated along racial and socioeconomic lines (Leonardo, 2007). This author describes the impact of neoliberal reforms in urban schools in relation to institutional practices of racism in this manner:

> NCLB does not make visible the structural obstacles that children of color and their families face, such as health disparities, labor market discrimination and the like, processes that a class analysis alone cannot unmask (Brown et al., 2003). This is vintage whiteness. In fact,

NCLB hides these dynamics even more efficiently, tucked away in the language of tough love and harsh sanctions. Employment discrimination disappears in the abstract individualism of NCLB, where the threat of laissez-faire market forces becomes the final stop for persistently failing schools that will finally succumb to privatization. (Leonardo, 2007, p. 269)

While the intent of Obama's Race to the Top Initiative is laudable, the premise of its aims continues the legacy of impotent, neoliberal, essentialist reforms first developed in the 1930s by scholars such as William Bagley, which gained resurgence in the 1980s with the Nation at Risk declaration, and of course, the most infamous No Child Left Behind Act of 2001 of the Bush administration. Each of these cultural movements in education narrowly privileged the basics (e.g., math, science) to meet the military's imperatives of national defense and the production and consumption of workers to fulfill the economic ends of the corporate market. The market-driven logic and priorities of these goals, in neoliberal contexts, discount altogether the public good for persons of color in urban schools. This approach to teaching and learning renders invisible the different sociocultural contexts that shape different lived experiences of diverse communities who may, in consequence, produce different—not inferior—kinds of knowledge. These reforms have ultimately led to a narrowing and disciplining of curriculum and pedagogy that preserve the status quo and cut off opportunities for schools to create conditions that can create and sustain democratic individuality, democratic community, and democratic society for urban youth and the teachers who educate them (West, 2004).

The race-blind logic and commercial order of neoliberalism do not advocate for diverse curricula and pedagogies, and maintain technical practices of instrumental efficiency within management systems of schools (Apple, 2001, p. 417). Neoliberal ideologies on the right attempt to erase the histories, identities, and lived experiences of persons of color in power struggles over the curriculum. For example, it was recently reported by April Castro of the Associated Press that the Texas State Board of Education recently voted to privilege and value far-right, conservative ideologies in the public school curricu-

lum over more progressive orientations. The motivation, importance, and expectations of the Civil Rights Movement were questioned; sociology students would not be expected to give reasoning and explanation of institutional racism in America; hip-hop was denied recognition and legitimacy as a cultural movement; and significant figures and events in the Latino community would also be denied and omitted from the history textbooks (2010). Given the large population of students in Texas, decisions over curriculum content in this state often influence how textbook publishers make decisions for school districts in other states across the country. In Arizona, the legislature recently voted to pass a bill (HB 2281), now signed into law by Governor Jan Brewer, that bans any teaching in public schools on matters related to race and ethnicity, as they are deemed to be racially divisive and seemingly challenge "the tradition of American values and culture." In a recent CNN interview with Anderson Cooper (5/12/2010), the superintendent of Arizona public schools, Tom Horne, suggested that students should not be taught exemplars of the race they were born into, that "race-obsessed" philosophy should be kept out of our schools; he further stated that students should be taught they are individuals, and that if they work hard, America is the land of opportunity. Finally, he stated that Freire's *Pedagogy of the Oppressed*, and books like it, should be taken out of the curriculum because it teaches students they are oppressed and that they should be "angry at their country." In 2008, Amy Goodman of *Democracy Now!: The War and Peace Report* states that a Los Angeles teacher's contract was not renewed because she was said to have taught a "biased view of the curriculum" when she incorporated texts such as excerpts from the *Autobiography of Malcolm X* (2008). Haroon Kharem observes that "to exclude the history and culture of people of color from the curricula implies that not only is Anglo Protestant history and culture all that is worth knowing, but the students who are being devalued, subjugated, and colonized have no history and culture, but also children of color themselves have nothing to offer at all" (2006, p. 33). In this regard, corporate-driven management models of educational reform have differential, racializing effects for students of color who interact within market-driven business models of education and public schooling (Apple, 2004, p. xi). "Current neo-liberal and neo-

conservative policies in almost every sphere of society— marketization, national curricula and national testing are representatives of these policies in education—have differential and racializing effects" (Apple, 2004, p. xi). Apple says that while these policies are often couched in the language of "helping the poor," increasing accountability, giving "choice," and so on, the racial structuring of their outcomes is painful to behold in terms of respectful jobs (or lack of them), in health care, in education, and in so much more" (Apple, 2004, p. xi).

As will be shown throughout this text, urban youth at the center provided some social critique of standardized testing in urban schools. Politically, they understand the economic and racially stratified consequences of standardized testing to their future opportunities for socioeconomic mobility. Standardized testing is not seen by the youth in my study as an initiative that gave them equal opportunity under equal conditions of "Ameritocracy." These students were politically savvy and knew that these tests determined whether or not they would graduate, which would then determine their status in the job market. The mandate of such a test for students who confront the sheer weight of poverty among other encumbrances on an everyday basis reproduces forms of social and racial inequality in urban society.

Neoliberal corporate imperatives also play a role in the hyperpolicing, surveillance, and control of Black male youth through disciplinary discursive economies that result in their disproportionate punishment in urban public schools (Carlson, 2005). "Currently that reality is that transnational capitalism plays an ever-increasing role in establishing the discursive parameters for educational policy and practice, and public schools (particularly urban public schools) are being called upon to assume a heightened role in the surveillance, policing and regulation of 'problem youth'" (Carlson, 2005, p. 22). Carlson suggests that disciplinary discourses, which circulate in and between microtechnologies of discipline, punishment, control, and surveillance, and between institutions such as school systems and prisons, are rooted in a racial politics of fear that resonated from corporate boardrooms to suburban bedroom communities in the 1990s (Carlson, 2005, p. 36). When Black youth "hung out" in downtown

shopping districts, waiting for buses or just meeting with friends, these public spaces also came under much tighter surveillance and policing in an effort to ease the fears of white shoppers who viewed a trip downtown as a trip into the "danger zone" (Carlson, 2005, p. 36). In his study of urban school reform in Cincinnati, Ohio, in the 1990s, Carlson found that racial unrest in the city helped forge "closer working relationships between the police, the juvenile system and the public schools as elements of disciplinary power" (Carlson, 2005, p. 36). Today, the disproportionate discipline and punishment practices exerted on urban youth in public schools have garnered national attention, and are being claimed as a civil rights issue in the U.S. Department of Education. It was reported by Mary Ann Zehr in *Education Week* that given the crisis of discipline and punishment of Black males in public schools, the Obama administration has agreed to conduct a "disparate-impact-analysis," which includes cases of intentional discrimination or enforcement of discipline policies with unintentional discrimination, but with differential impact for students of color (2010). In a recent conference (hosted by the U.S. Departments of Education and Justice, September 27 and 28, 2010) entitled, Civil Rights and School Discipline: Addressing Disparities to Ensure Equal Educational Opportunities Conference, Thomas Perez, the assistant attorney general for civil rights at the U.S. Department of Justice, stated:

> The numbers tell the story. While blacks make up 17 percent of the student population, they are 37 percent of the students penalized by out-of-school suspensions and 43 percent of the students expelled. Black boys account for 9 percent of the nation's student population, but comprise 24 percent of students suspended out of school and 30 percent of students expelled. A study written by participants in this room and released just two weeks ago by the Southern Poverty Law Center found that black male middle school students are suspended at three times the rate of their white counterparts. (2010, para 8)

Perez asserts that officials are concerned with harsher discipline and punishment practices and unfair enforcement of zero tolerance policies for subjective violations (e.g., dress code, schoolyard fights) that create conditions that facilitate a school-to-prison pipeline for vulnerable African American male youth. Students in urban schools

are very much aware of how they are perceived, feared, and as result, punished in society. This is due in no small part to the circulation of images produced in the media that inject fear into the hearts and minds of common citizens. Subsequently, old racial legacies are carried out under the new auspices of neoliberal politics in the production of militaristic discourses in media that view and punish youth as problems rather than seeking new empathetic measures to keep youth in schools. The tightening of security, surveillance of urban youth outside school walls by police, negative labeling practices, and unequal enforcement of discipline policy all serve as mutated expressions of fear of the Black male as a public enemy. The culmination of these activities threatens the ideals and practices of democracy in urban schools, and lessens the chances of education being a pathway to productive citizenship for these youth.

Finally, the commercial order of neoliberalism also advances economic, corporate interests through the global consolidation of media, and the promotion of consumerism as a way of life. That is, individuals are not encouraged in activities of civic engagement and cultural citizenship. They are encouraged to be consumers in the market as the demonstration of democracy. For example, after 9/11 George W. Bush publicly encouraged us all to go shopping to prove to the world that North America was still economically viable and strong. The idea of consumerism as a way of life has particular implications when we think of the lack of self-identification amongst urban youth with the breakdown in collective, emotional, bonds of caring and nurturing environments of urban public schools. The ways in which they have been displaced, alienated, and racially differentiated to punishment, detachment, objectification, and indifference in urban public schools facilitate alternative cultural ways of self-identification and identity making. Philip Wexler argues that these youth have developed compensatory reactions to institutional practices in schools that have emptied out any emotional investment to effective social interaction with them (1992). One of the ways in which they have compensated for the lack of emotional investment, nurturing, and care in urban public schools is through stylized forms of brand identification through market niches of product consumption (Carlson & Apple, 1998). "Each of these niches is defined according to a particular,

highly specialized consumer identity, so that more and more we define who we are by the products we consume and the images of self attached to them. The commodified self becomes emptied of any meaning other than the commercialized sign it embodies and the identity it represents" (Carlson & Apple, 1998, p. 18). Carlson and Apple argue that for all youth, the new consumerism organized around market niches suggests that "style and brand identification is becoming more important in defining who they are, which is to say what image they wish to project. In a society of consumerism, even class identity becomes as closely related to the products and images we consume and embody as the work we perform" (1998, p. 19). Wexler would argue that this is part of the social interactional labor that youth go through in the process of becoming somebody in schools that have removed themselves in connecting socially and emotionally with the students (1992; Carlson & Apple, 1998, p. 19). For urban youth, and Black males in particular, the commodified culture of the hip-hop industry, through its circulation and production of market-driven images of monetary opulence as the object of economic value and success, has become a primary mode of cultural production in their identity making. The emptied emotional and social investments of urban public schools become spaces and places by which these youth construct their identity through the consumption of hyper-sensationalized products and images of hip-hop artists, as seen in mass media culture of videos, and certain commercial discourses in rap lyrics. In this way, they become somebody through the market-driven culture of the hip-hop industry. This too cuts off the possibilities of democratic citizenship when urban youths' cultural investments in a commodified and exploited culture, void of authentic meaning, do not live up to the hype of the American dream; it also engenders conflict and competition for masculine forms of respect that celebrate free market ideologies of individualism over local communal bonds of caring and collectivity that can sustain buffers for democratic individuality, community, and society.

When the racial politics and commercial order of neoliberalism invade the public space of local urban communities, it nearly shatters all pedagogical possibilities for democratic practices in education to take shape and flourish. Technical, business, management models in

public education are not concerned with creative, pedagogical conditions that might have the capacity to produce in young people some hope and possibility toward critical citizenship in society. Students are not valued by their name, identity, or the strengths they might contribute as knowledge brokers in a democratic society. However, they are valued and tracked by the numeric outcomes of what they can produce on a test, which will then determine which students the free market can promote and invest in, and which students will be rendered disposable when they don't meet the benchmarks, assessments, and performance outcomes of their "business portfolios." In neoliberal contexts, the actions, attitudes, and choices of urban youth in their day-to-day struggles on the margins are frequently seen by schools as problems to be punished, rather than challenges and teachable moments that encourage the possession of critical reflection and consciousness toward social change. Neoliberal reforms in education don't encourage what Peter McLaren calls a critical multiculturalism, which would enable youth to question the hypocrisy, mendacity, contradictions, and lies of a distorted curriculum and pedagogy of whiteness that enacts social and cultural practices against persons of color (2003, p. 260; West, 2004). Fortunately, citizens are organizing their own local, public spaces of resistance to the brutal and harsh conditions of neoliberalism. In matters of life, death, and poverty, they do not have time to wait with "deliberate speed" for public institutions to hold true the ideals and promises of a democratic society. Subsequently, young people are developing cultural movements through subcultures such as hip-hop that redefine the boundaries of democracy and citizenship that are not relegated and confined to the political machinery of voting. While voting is still vital and crucial to keeping the hope of democracy alive, history has shown that we cannot always trust what the majority of citizens think, especially in situations where others are oppressed by majoritarian ideologies of the dominant culture. Subsequently, urban youth are rejecting the status quo, and creating their own visions and democratic practices through cultural works that validate who they are as cultural citizens. They are creating their own spaces and places where they are not treated as objects of the state, but as subjects and authors of their own knowledge through popular cultural texts. I now

turn toward a discussion on hip-hop in academia and the pedagogical possibilities of cultural citizenship in hip-hop culture.

Hip-Hop-Based Education and the Pedagogical Possibilities of Cultural Citizenship

Scholars in the fields of cultural studies, popular culture, and critical and culturally relevant pedagogies suggest that youth are increasingly affirming and negotiating notions of self and identity through popular culture. As such, it has been suggested that in these postmodern times youth no longer affirm their identities through the traditional culture of education and schooling (Giroux, 1996), and look toward subcultures such as hip-hop to deal with their most pressing issues and concerns of the day (Dimitriadis, 2001). Hip-hop culture is the most explosive, engaging, and controversial form of American popular culture to find global circulation and acclaim in the past quarter century, and is "worthy of serious critique and investigation" (Dyson, 2004, p. 399). How youth subcultures are affirming notions of self and identity through hip-hop in relationship to their performative, socially constructed, or everyday lived reality becomes an important site of investigation. Subsequently, this study considers the changing meanings of youth in various historical, social, racial, and political contexts, and is the product of an ongoing dialogue between the institution of education and schooling, the social justice system, mass media, and the youth-produced subculture of hip-hop.

In the postmodern era, there have been a number of recent cultural critics and scholars who have attempted to enumerate the plight and predicament of urban youth through hip-hop culture. While they have not focused exclusively on the cultural intersections between Black male youth identity, hip-hop, and urban education, they have laid the groundwork in explaining how hip-hop culture has been shaped by urban and political contexts in society. For example, cultural critic and scholar Tricia Rose has been a pioneer toward these efforts. In her 1994 work *Black Noise*, Rose posits that the culture of hip-hop, its language, attitude, and artistic expression, emerges out of postindustrial America. She underscores the formation of hip-hop's cultural practices within urban contexts, the prioritization and politi-

cal utility of the Black voice in rap music, the corporate influence of technology and media in hip-hop, and the cultural tensions of sexual politics of the culture. This work is considered to be a classic text in cultural studies texts on hip-hop culture.

Michael Eric Dyson, who many have called the "hip-hop intellectual," also has done extensive cultural criticism on urban youth and hip-hop culture. His work on the Culture of Hip-Hop in *The Michael Eric Dyson Reader* (one of the first academic publications on hip-hop in the academy) (2004), his bio-sketch of Tupac Shakur entitled *Holler If You Hear Me* (2001), and his latest work, *Know What I Mean?* (2007), explore the cultural intersections between hip-hop as a cultural production and intellectual discourse alongside traditional philosophies and theories in the academy. Dyson has been an advocate in underscoring the value and importance of hip-hop as a cultural production that allows us to complicate and challenge our commonsense ways of understanding urban youth. He often notes that the contradiction and tensions within hip-hop are reflective of the tensions and contradictions of the larger society.

In *Can't Stop Won't Stop: A History of the Hip-Hop Generation* (2005), historian Jeff Chang captures the social, political, and economic conditions that forged and shaped the emergence of hip-hop culture. He states that politics and music, between Jamaican and South Bronx communities, have always foregrounded the convergence of what we know today as hip-hop culture (2005). The politics of urban decay from the Robert Moses expressway project created the isolation of high tower projects that clustered Black and Brown peoples in less than adequate living conditions in the Bronx (2005). Chang states that internal struggles between gangs of abandoned youth in urban communities, and the disparities in health care, jobs, education, and basic living conditions for Black and Brown youth, fueled an ethos of youth activism among gangs (along with youth service agencies) whose neighborhoods and difficult life circumstances had long been rendered invisible (2005). The conditions in Kingston, Jamaica, and South Bronx, New York, in the late sixties and early seventies forged the birthing of hip-hop with DJ Kool Herc, a Jamaican-born immigrant who lived in the Bronx and heightened the presence of block parties led by the deejay (2005). Given the creativity of Herc's break

beat, aesthetic innovations created new energies of youth that became the center of youth activity, rather than earlier heightened gang presence. Later, cultivators of the culture, such as Africa Bambaata, began to articulate what Chang calls a polycultural worldview of multiculturalism that expanded in global terms (2005). Music became a strong antidote to curb the violence among youth gangs throughout the boroughs of New York.

In *That's the Joint!* (2004), Murray Forman and Mark Anthony Neal have put together a "hip-hop canon" of scholars who speak to the geographic origins of hip-hop, historical contexts, its cultural practices and artistic formations, politics of resistance, the commodification of the culture industry, along with confronting issues of identity and difference of urban youth along race, class, and gendered lines. This work is now being used in cultural studies classes across the academy. In addition, Bakari Kitwana and Yvonne Bynoe have spoken to the possibilities and tensions with mobilizing hip-hop as a political movement (2002; 2004). In *Who's Gonna Take the Weight?* (2003), Kevin Powell gives a semi-autobiographical account of his experiences with hip-hop to explore issues of Black masculinity in the larger society.

In the field of public education, there has been a small collective of emerging cultural and critical scholars and researchers who present the diverse ways in which hip-hop can be used inside or outside the traditional culture of urban education and public schooling. Many of them have argued that the ways in which urban youth significantly negotiate and self-fashion their identities in hip-hop can foreground alternative curricular and pedagogical practices in critical and culturally relevant pedagogies. Gloria Ladson-Billings and Jamel Donner suggest that scholars and educators who ignore the significance of hip-hop culture will increasingly be out of touch with the contemporary concerns of urban youth (2005; Prier & Beachum, 2008). For example, Greg Dimitriadis provides one of the first long-term, critical, performative, ethnographic approaches of rap music in the lives of Black youth (2001, p. 9). In *Performing Identity/Performing Culture: Hip-Hop as Text, Pedagogy, and Lived Practice* (2001, 2009), Dimitriadis not only provides an understanding of youths' unpredictable cultural practices and meanings generated from hip-hop and popular cultural texts, he relates their reception of textual analysis to their everyday

lived experiences and cultural realities. Dimitriadis argues that we cannot conduct textual analysis removed from the lived experiences of the students who are receptors of the texts. As it relates to hip-hop, he traces the genre's production and consumption practices from local, live spaces of public performance to a global, privatized commodity; he underscores the different uses of popular cultural texts of rap music for the construction of place in relationship to biographical narratives and geographical locations; Dimitriadis also locates the discursive events among urban youth around the life, death, and "rebirth" of Tupac Shakur (Dimitriadis, 2001). His central argument is that increasingly urban youth are using popular cultural texts in ways that previous generations did not account for or predict. Hence, if we as educators can better understand the multiple ways in which these youth make use of culture to construct their performative identities, and the ways in which these uses are reflective of larger lived realities, educational institutions can more effectively institute policies and pedagogical practices that reflect the official and unofficial curricula for Black youth inside and outside schools (Dimitriadis, 2001, p. 122).

In *The Art of Critical Pedagogy* (2008), Jeffrey Duncan-Andrade and Ernest Morrell teach a secondary English class, using traditional canonical poetry against hip-hop/rap music. They wanted the students to understand that much of the poetic forms and devices used in traditional poetry are similar to the poetic forms and devices in rap music. In this way, urban youth were able to see the educative importance and value of popular cultural texts of rap music that they invest in alongside "classic" poetry within the traditional curriculum of schools. According to the authors, by tapping into popular cultural knowledge of the students, they gained a deeper understanding of school-based poetry. Through youth participatory action research, they also employed hip-hop and popular culture in an urban sociology class for high school students. In this instance, students used their understanding of sociological terms learned in class, and applied this knowledge in analyzing sociological phenomena in popular cultural texts, and engaged in community activist research.

Marc Lamont Hill co-taught a hip-hop literature course in a northeastern, urban high school. He incorporates the reading and reception of hip-hop texts through the discipline of an English class for adult

students who attend evening classes and have come back to school to get their high school diploma. The evening class was also for teen mothers and students with "challenges with conduct" and excessive lateness in day school classes, students having experienced entanglements with school violence, students having obligations of work due to financial constraints, and other students who were deemed not a fit for the day school environment (Hill, 2009). Hill advocates the incorporation of hip-hop texts in the classroom as culturally relevant and critical pedagogy that is reflective of students lived experiences, and allows them to deal with their suffering, pain, and identity through personal self-disclosure to allow what he calls wounded healing. While the texts can become almost autobiographical to the lives of students reading the texts, he states that we must be attentive to the power relations and sociocultural contexts between teachers and students when entering critical dialogue on sensitive matters that evoke pain and suffering of marginalized communities.

Curry Mallott and Brad Porfilio advocate the use of hip-hop (along with punk rock) as a form of critical media literacy that teacher educators and public school teachers can apply to their classrooms for social studies curricula (2007). Although they focus on both of these important genres of youth subculture, their critique and use of hip-hop in the reconstituting of a more radical social studies curricula are of interest for the purposes of this project. For these authors, hip-hop is a way in which teacher educators and in-service and pre-service teachers can understand the larger social, historical, political, and economic inequalities that students' lives are situated in. They argue that the way in which we can understand these contexts as educators is by critically reading the world and the word of hip-hop texts through artists such as Public Enemy and Dead Prez, who articulate Afrocentric pedagogies of resistance to the economic state of transnational capitalist relations. They have used artists such as these to stimulate critical awareness in students that they have the capacity to be agents for social change and transformation.

Building upon the extant literature of what Hill calls hip-hop based education, I argue that Black male youth face a series of disruptions and contradictions within and between hip-hop culture and schools that threaten the cultivation of democratic spaces and places

for cultural citizenship. The study of urban youth and hip-hop is about "identifying spaces where youth's popular culture practices contribute to shifts in the public sphere, in the creation of knowledge, and ultimately to the practice of democracy" (Dolby, 2003, p. 272). Nadine Dolby, for example, talks about cultural citizenship as a term that redefines how we can think about what democratic practice is and can be. That is, for Dolby, democratic practice is not limited to liberal democracy, where citizens engage merely in electoral politics. While this form of participation in the public sphere can assist with the project of democracy, most see it as a slow process that hinders progressive action for social and political change. She states that as education as a public sphere has contracted over the past two decades, the world of popular culture has become a significant pedagogical site where we understand how youths' cultural investments and desires can re-shape and re-form the politics of the public sphere (Dolby, 2003, p. 276). The different ways in which youth politically mobilize popular culture open up alternative spaces where private cultural practices of youth can politically disrupt, transcend, and transform the public sphere (Dolby, 2003). In this way, we need to think about the significance of popular culture as a new site of democratic action and practice that is a significant pedagogical space and place where youth not only negotiate their identity but politically mobilize their sense of agency. Dolby boldly proclaims that educational researchers who are concerned about the project of democracy will have to look beyond just the schoolhouse in their inquiries (2003, p. 276).

Hip-hop, then, is not only worthy of serious critique and investigation, but is part and parcel of reshaping a more democratic and "public" education that is more just in its pursuit of including diverse curricula and pedagogies that advance, rather than confine, the terms of knowledge construction. I see hip-hop as a site of nontraditional curriculum and pedagogy that can alternatively be considered a democratic practice in education. That is, I see hip-hop as a former private cultural practice that now transcends, disrupts, and transforms the public sphere, and which has political implications for radical democracy. It is a cultural movement that urban youth participate in that develops their political sense of agency. As cultural

citizens in hip-hop, they take action and engage in everyday practices that reveal concerns about the constraints of democratic possibilities that are of consequence to their lived realities. For example, some youth have mobilized a political discourse within the music to talk about issues such as 9/11 and the war in Iraq, Hurricane Katrina, poverty in the inner city, joblessness, and education and schooling, among other issues that confront inequality in the public sphere. Other artists/hip-hop aficionados have used it as a cultural movement to galvanize youths' public opinion about traditional practices in liberal democracy of electoral politics. Although my work in this study draws from a more expansive definition of democratic practice as cultural citizenship, hip-hop figures such as Kevin Powell have reclaimed some hope and possibility in traditional electoral politics by running for Congress in Brooklyn's Tenth Congressional District in 2008, and then in 2010. What's interesting here is that in his 2008 campaign Powell mobilized the cultural practices of hip-hop via politically oriented mix-tapes, hip-hop graphic designs on his campaign literature, and stump speech appearances at hip-hop venues in urban communities of New York City. In this regard, cultural modes of citizenship were politically mobilized through critically conscious hip-hop discourses, which in turn served as an alternative democratic practice. This form of cultural citizenship helped Powell galvanize a hip-hop grassroots movement seeking progressive change in the traditional sense of citizens engaging in participatory democracy. Subsequently, it was through the cultural practices of hip-hop that Powell developed a policy agenda that energized and informed young people to vote on public policies that affected their everyday lives in the communities in which they live. This is perhaps an example of a new revolutionary model that ruptures lines between traditional and cultural modes of citizenship for young people.

In my view, it is the cultural and pedagogical space of hip-hop, beyond the schoolhouse, that expands our traditional notions of democratic practice in the public sphere of education. As bureaucrats in Washington and corporations in an age of neoliberalism politically regulate the "business" of education, focus on global competition, and limit learning to some "objective" standard, many youth have opted for alternative cultural sites such as hip-hop. For many urban Black

male youth, it has been a pedagogical and social site in which they construct identities that enable them to question status quo knowledge produced in schools; critique Taylorist forms of curricula that no longer speak to who they are in urban, social, and political contexts; and develop cultural and symbolic creativity (Willis, 2003) that affirms the humanity of who they are as people. It is in this sense that cultural citizens within non-market-driven hip-hop attempt to wage a counter-hegemonic struggle to break the pedagogical and curricular limitations imposed by the current No Child Left Behind era. Cultural citizens in hip-hop take very seriously the idea that true democratic practice means opening up multiple spaces and places for new youth-generated activities (Dolby, 2003).

As a critical educator, I have taken part in cultural movements in hip-hop over the years, as I see them as vital to social justice movements in urban education. Most recently, I assisted with the curriculum development of an after-school program that used critical texts and cultural practices of hip-hop as a method and means of co-constructing critical knowledge with urban African American male youth in at-risk circumstances in schools and their communities. The intervention of these practices provides the pedagogical conditions for students to resist social, economic, racialized pressures of domination at work in their lives. The space and place of what I term the hip-hop community center allow these students, as Freire would suggest in "The Importance of the Act of Reading," to read the world and the word (Freire & Macedo, 1987, p. 29) of their everyday lived experiences through the cultural practice (e.g., emcee, b-boy, graffiti, DJ) and alternative literacy of hip-hop texts in ways that give them some sense of agency. Through investigating the curriculum and pedagogy of hip-hop we can gain an understanding of how youth participate in, produce, and consume this particular culture, and how youths' subjectivities are socially constructed, performed, and made meaning of in relation to constitutive elements of this culture, broadly defined. Given that culture is constituted by relations of power, in situating hip-hop as a subculture one can locate how an identity politics of race, class, and gender constructs the identity formation of youth, and how certain ideological presuppositions emerge out of dominant-subordinate relationships between larger societal and institutional

contexts of meaning. In the postmodern sense, we can also learn what it means to be on the margins of a subculture that has become mainstream popular culture, and the particular contexts that shape different identities within and between the culture *industry* of hip-hop and hip-hop *culture* as a way of life. Within the dialectic of social, political, and cultural configurations of hip-hop, this work is about exploring what life means to the identity of youth whose subjectivities are and have been shaped, formed, and represented within the culture, and how they construct hip-hop as a form of agency. This work is also about understanding what hip-hop can teach us pedagogically as public educators. It is in these contexts that I situate and advance hip-hop as a site of pedagogy, curriculum, and democratic practice.

Chapter 2
The Rhyme and Reason of Lines,
Bars, and Hip-Hop Texts

Hip-hop culture in the United States has been shaped by three differ-
ent genres of rap music: postmodern Black aesthetic of social-
ly/politically conscious rap, gangsta rap, and mass-marketed
commercialized rap. I mean these to be useful categories for analysis,
bearing in mind at the same time that each "genre" has in part been
shaped by the others, has developed in relation to the others, and has
developed and changed historically. As Rose states, "an examination
of how and why hip-hop arises helps us understand the logic of rap's
development and links the intertextual and dialogic qualities in rap to
the diverse cultural and social context within which it emerges" (1994,
p. 26). What is consistent across the formation of all three discursive
genres is that these texts have been produced within asymmetrical
relations of power between dominant and subordinate communities.
In this regard, the identities that youth perform, the different modes
of communication signified amongst different networks and commu-
nities in hip-hop culture, and the actions, choices, and decisions made
on an everyday basis are understood as responses to and outcomes of
local urban communities struggling against institutional structures of
power and domination.

Reading and interpreting the sociocultural contexts of hip-hop
texts are central to understanding new forms of social knowledge
produced by urban youth within the subculture. Epstein suggests,
using Weinstein's assertion, that the bricolage of youth subcultures is
often held together by musical preference; and identifying and
understanding a subculture's musical preference are central to the
understanding of that subculture (Epstein, 1998, p. 18). Dimitriadis
argues that a segment of vulnerable Black youth often construct their
sense of self through popular cultural texts, such as hip-hop (2001, p. 6).
Giroux states that youth are moving to alternative knowledge forms
other than just the book to affirm their identities (1996, p. 51). He insists

that given the radical shift in knowledge construction and youth identity formation in popular culture and mass media, studying the production, reception, and use of various texts, and how they are used to define diverse notions of self, values, community, social relations, and the future, becomes increasingly important (1996, p. 50).Thus, it is not only important to acknowledge the radical shift in knowledge construction, but to acknowledge the ways in which audio, visual, and electronically mediated forms of knowledge are read, received, and consumed (Giroux, 1996, p. 50). Subsequently, I draw upon hip-hop as a form of popular culture and rap music to understand Black male youth identity formation in relation to larger institutional and societal contexts of education and schooling. This is necessary to critical youth research, where researchers are interested in the intersection between youth and hip-hop culture, and resituating these youth as active agents in the continual process of remaking democracy (Dolby, 2003, p. 267). Such an approach focuses on how Black male youth relate the meanings of these cultural processes to their everyday lives, and the meanings they make and receive from texts of popular culture (Dolby, 2003, p. 267). Hence, this methodological research approach functions as a bricolage, emerging within and between different disciplines or fields of study; and the choice of practice is pragmatic, strategic, and self-reflective (Carlson & Dimitriadis, 2003, p. 25).

The chart below outlines key tenets within each discourse that are most prevalent in hip-hop (see Table 1). These discourses outline the social, political, economic, and historical contexts that have played a significant role in shaping each genre; present major themes emphasized within each discourse; and locate how youth view government, schools, and the larger society within each discourse. Also, each discourse articulates youth identity formation processes that emerge in response to the aforementioned contexts that shape each mode of communication within hip-hop culture. These discourses are instructive in that they clarify and give understanding to youths' voices and processes of identity making in relationship to the roles of power, culture, and ideology shaping the different hip-hop texts that circulate within and between media, government, schools, and society.

Table 1

DISCURSIVE GENRES OF HIP-HOP TEXTS IN SOCIOCULTURAL CONTEXT

Discursive Text Types	Socially/Politically Conscious Discourse	Gangsta Discourse	Market-Driven Commercial Discourse
Key Tenets	Critically conscious discourse. Provides social critique of cultural and political issues in society. Interrogates and challenges asymmetrical relations of power within the public sphere of society. Some discourses merge into concrete social action.	Discourse is defiantly resistant, radically rebellious, and obstinate; yet, this genre also possesses moments of critical consciousness. There is great frustration with socioeconomic, political, racial, and social conditions not being met. Some youth and young adults feel they have no other option than to take the law into their own hands.	Market values predominate over nonmarket values within the production of commercial discourses in hip-hop. Music and cultural practice are commodified representations of self and identity, which privilege profit over critical needs of local community.
Historical, Social, Political, and Economic Contexts	Hip-hop birthed on the heels of the Civil Rights Movement. During that period, unemployment greatest source of poverty for Black males. Emergence of neoliberalism (Reagan administration, 1981–1989). Retrenchment of hard fought civil rights legislation. Social conditions marked by postindustrialization, disinvestment in urban neighborhoods, collapse of steel mills and changing production of manufacturing with exportation of jobs to foreign markets— globalization; surveillance, discipline, and punishment of urban space. African American youth unemployment at 42 percent; shutting down and reducing funding of social services and after-school youth programs (e.g., arts, recreation). Pivotal Period of Emergence: 1987 to mid-1990s.	Gangsta discourses emerged around the same time as socially/politically conscious discourses. However, the political orientation of the music was shaped in radical, defiant ways. There is strong opposition to the nation-state due to extreme levels of poverty, underemployment, and police brutality. Couple these circumstances with the influx of the crack economy (latter part of '80s), and substance abuse and crime became a part of coping with profane conditions. High levels of anger, rage, and disappointment predominate and are reflected in the music. Reflects gang violence that erupts in local urban ghettos of genocidal proportions, particularly in 1987. Violence and Black on Black homicide are aftermath effects of drug market economies and socioeconomic erosion of neighborhoods. Pivotal Period of Emergence: 1987 to mid-1990s.	In the 21st century, the culture industry of hip-hop is now a billion dollar business, owned and consolidated by five major corporations within the dominant culture. The production of the music is no longer owned by local African American and Latino communities who created it. Much of the cultural practice is no longer performed in local urban neighborhood communities. In many ways, urban life is sold as a commodity. In addition, the culture has transcended music and entered multiple industries, including, but not limited to, film, fashion, reality shows, advertising, and marketing, which has had positive and negative effects. Pivotal Period of Emergence: Mid-1990s to the present.

Table 1 (continued)
DISCURSIVE GENRES OF HIP-HOP TEXTS IN SOCIOCULTURAL CONTEXT

Discursive Text Types	Socially/Politically Conscious Discourse	Gangsta Discourse	Market-Driven Commercial Discourse
Major Themes	Historical references to the various cultural contexts to ethnic communities' country/continent of origin (e.g., Africa, Latin America). Strong social critiques of disproportionate warehousing of Black and Brown bodies in prison industrial complex, police brutality, homelessness, dilapidated housing, miseducation in schools, Black on Black violence, and homicide, poverty, and unemployment. Promotes ethic of love, peace, and community.	Police brutality, critique of prison industrial complex; at certain moment's crime, violence, and drug market economy celebrated; at other moments, crime, violence, and drug market economy critiqued; sexism, misogyny, capitalism, and street life celebrated.	Think of Raekwon's *Cash Rules Everything Around Me*, 50 Cent's *Get Rich or Die Tryin'*, or Cash Money's popular phrase "Bling Bling." Excessive preoccupation with material wealth—money, mansions, clothes, cars, jewelry—and frequent sexist and misogynistic attitudes toward women.
View of Gov't, Schools, and Society	Government should provide for public welfare in society. Redistribution of wealth inequality to local communities. Government should also provide decent education and job opportunities. Schools and larger society should educate for critical consciousness, freedom, and liberation. These ideas align with critical, progressivism.	Youth consider themselves outlaws, moving outside the government. Rules are governed by what Elijah Anderson calls a "street orientation," and what Michael Eric Dyson calls "juvenocracy," the regulation and control of the street through unlawful means. The knowledge of the streets is valued over knowledge from schools. It informs the terms of survival.	Neoliberal ethic toward the nation-state. Private, corporate sector of business predominates over local public sphere of community. Youth subcultures emerge out of emotional disinvestment between teachers and students in schools from technocratic practices of standardization and disciplinary apparatus. Students consume popular cultural image and brand identification.
Youth Identity Formation	Great sense of agency for self-determination and empowerment. Possesses critical knowledge. Often reclaims popular memories and historical narratives of ethnic groups (e.g., African American history) as social referent for identity making. Seeks social transformation in society.	Strong tendency toward self-destruction and nihilism; however, this discourse also expresses far-left political viewpoints. Racialized masculinity in relationship to capitalistic patriarchy also prevalent—money, power, and respect at all costs are valued most. Hardened attitude and outlook on social world.	Market relations and market identities, which mean that money and material wealth are the object of success. Authentic representations of self and lived experience detached from original meaning. The self is commodified by spectacular consumption of the mass market media. Value and self-worth of personhood are determined by popular cultural consumption.

To some genres, such as the more socially and politically con-
scious discourses, youth respond in a more critical manner to their
conditions of circumstance. That is, they often give social critique to
injustice in society. However, a sense of history, culture, and equity
often motivate the ways in which they become empowered to give
voice and campaign to transform their conditions of struggle. Free-
dom fighters of the critical Black history tradition become historical
references to present-day struggles. Violence becomes the condition of
advocating for peace. Postindustrialization, wealth inequality, job-
lessness, dilapidated schools and housing, disinvestment in public
social services, and imprisonment and police brutality serve as
specific material conditions upon which socially and politically
conscious artists and activists shape critical discourses and activate
urban movements for social justice in their communities. For these
artists and activists it is about raising consciousness and awareness
about the world in which one lives, giving voice to those circumstanc-
es and conditions, and organizing ways in which to alleviate the
realities of human suffering. It is also about privileging knowledge of
self, a love for one's community, and providing organized ways in
which to resist structures of domination.

Other genres, such as gangsta discourses, are fed up with the
failed promises of social justice and democracy in a society of persis-
tent social inequality. It some ways, gangsta rap can represent the
very worst expression of socially constructed, Black masculine identi-
ty. In this regard, external forms of oppression are internalized in
such a way where the violence and brutality committed on urban
populations from larger public institutions begin to turn inward
amongst disenfranchised communities. These discourses have the
potential to produce a form of self-inflicted nihilism in action, image,
and representation that becomes self-destructive with little to no
intent of combating social ills of the day. They adopt what Elijah
Anderson calls a street orientation, countering dominant mainstream,
American values of "decency and civility." However, the anger,
frustration, and rage exhibited in the lyrics of these artists are signifi-
cant expressions of pain and disappointment from urban social
neglect. While controversial, these narrative discourses are often
meant to jolt and wake up America's sensibilities to its seemingly

race-blind ignorance of conditions it has created, which subjugate, oppress, marginalize, and repress urban youth. The sexism, misogyny, violence, and capitalist patriarchy along with political rhetoric against the injustice of the nation-state complicate and outline the double conscious sensibilities of gangsta discourses.

Market-driven, commercial discourses of the hip-hop industry currently dominate the trajectory of the music and culture. While there are socially and politically conscious discourses that have gained mainstream success, they are no longer as integral to what drives the market-driven culture of the hip-hop industry. While the local material conditions of urban youth have not changed much since the latter part of the '60s, early '70s, the perception of access and opportunity that urban youth have to unprecedented levels of monetary gain in a now billion dollar industry has. We are in an era where a record contract can turn into a movie deal, reality show, or clothing line, seemingly overnight. Many urban youth have the idea that the hip-hop industry is their way out of the hood to achieve the American dream. Images of Bentleys, Benzes, and Beamers (BMWs) in the videos, money raining from the sky, women draping all over the mansion, and ice (aka diamonds) accessories on the wrist give the illusion that the culture is the gateway to what Kanye West says is the "good life." As urban youth have been disaffected, alienated, and displaced from schools, many have turned toward subcultures such as hip-hop, where the consumption of market identities, values, and representations tend to predominate in the contemporary moment.

The explanation of each of the discursive genres in the following section are meant to be helpful interpretive devices for educators who seek to understand the complex, performative identities that many urban youth take up in their daily lives, given the conditions in which they live. Schools are cultural sites where these identities play out with their peers, teachers, public school officials, and other authority figures. Therefore, having some sense about the varying contexts upon which these identities emerge, and how they view government, schools, media, and society, might assist public schools in how to respond and restructure the cultural contexts upon which schools are situated. The insights gained from these discourses might be useful in producing nontraditional curriculum and pedagogy, and reexamining

pedagogical relationships and social interactions with students that might be more effective in the teaching and learning process. These discourses may also serve as interpretive guides useful to critical and culturally relevant pedagogies that are implemented in after-school youth programs, community centers, progressive public schools, or other school-community partnerships that see the pedagogical value of hip-hop in urban communities. Finally, in my own experience as a critical educator, these discourses can be helpful in pre-service teacher education programs for students familiarizing themselves with urban youth culture in educational settings. This is particularly applicable to pre-service teacher education programs that use a cultural studies approach to social foundations of education when studying varying aspects of urban youth culture. In the conclusion to this study, chapter 7, I will address these matters in more detail. However, it is my hope that the textual framework I have constructed below will at least give pre-service and in-service teachers, school administrators, other public school officials, and scholars a working discussion and insight into the varying lenses by which we can understand and make use of hip-hop in urban education for the larger purpose of social justice.

In what follows, these text types or discourses provide the reader with some historical and present context to the cultural and material conditions that have shaped hip-hop as an urban youth subculture. The three different discourses that I outline can serve as a working framework by which readers can work alongside, across, and against the student narratives that will be discussed throughout this book. This section serves as a textual framework about the meaning of rap music and hip-hop culture to the lives of urban youth within the cultural politics of the larger society. Keep in mind that this framework is an interpretive framework by which I focus on the youth identity formation processes of urban male youth, as opposed to urban female youth. It is in this context that I readily acknowledge the incompleteness and gender imbalance of the contexts presented here. However, this void does not represent a dismissal of female concerns in hip-hop. I developed this discursive framework in practical application to the population that was served at the hip-hop community center, which focused specifically on the needs and concerns of urban male youth in "at-risk" circumstances in the surrounding local

neighborhoods. The targeted population under study was developed in relationship to the specific mission, goals, objectives, and outcomes of the grant that provided funding for the program. Subsequently, this is the context upon which the discourses were developed and constructed, and not an intentional omission of the concerns of females. These issues notwithstanding, it is my hope the reader will come away with a better understanding of the constant interplay of heterogeneous identities urban youth put to work through the different discursive formations produced within the culture of hip-hop. These texts serve as alternative forms of social knowledge in how urban youth negotiate notions of self and agency in relation to sociocultural relations of change and structure in society.

Discursive Genres of Hip-Hop in Context

It is widely known that socially and politically conscious rap music was birthed on the heels of the Civil Rights Movement at a time when unemployment was the greatest source of poverty for Black males in the 1960s (Powell, 2003; Wilson, Quane, & Rankin, 1998, p. 57). Socially and politically conscious rap that shaped the genre's counter-narratives of rhetorical resistance and opposition was largely in response to President Ronald Reagan's retrenchment of hard-fought civil rights legislation in the 1980s that affected high unemployment rates for Black families as well as for Black youth, a shortage in public funding for schools and community youth programs, and policies that heightened forms of surveillance, hyper-policing, discipline, control, punishment, and repression of urban youth in urban inner cities. During the two-term presidency, 1981–1989, Reagan ushered in the neoliberal conservative era known as "Reaganomics," which resulted in cutting back a range of public social services that exacerbated long held, existing tensions between the urban Black working class and a state politics of economizing the public welfare. "By Reagan's second term, over one-third of Black families earned incomes below the poverty line. For black teenagers, the unemployment rate increased from 38.9 to 43.6 percent under Reagan" (Kelley, 1997, p. 47). Robin Kelley states further that "in Midwestern cities—once the industrial heartland—black teenage unemployment rates ranged

from 50 to 70 percent in 1985. Federal and state job programs for inner city youth were also wiped out at an alarming rate" (Kelley, 1997, p. 47). In addition, Reagan's "get tough on crime" policies reinforced intensive disciplinary practices that came to a climax with the beatings of Michael Stewart and Michael Griffith (Chang, 2005). The aforementioned events and circumstances, among several others, shaped hip-hop's visceral reactions and critical consciousness about social injustices that affected Black and Brown peoples in urban communities.

While persons/groups such as the Watts-Prophets, Last Poets, Amiri Baraka, Gil Scott-Heron and Sonia Sonchez of the Black Arts Movement (1965–1975) set the stage for rap's social and political commentary, the 1980s marked hip-hop's most powerful emergence for its uncompromising truth telling (Dyson, 2007, p. 62). Urban youth were frustrated with the old guard of civil rights leadership, and adopted a politics of confrontation and resistance to white mainstream society, who they felt had abandoned, neglected, and mistreated them socially, politically, and economically. Between 1987 and 1990, artists such as Grandmaster Flash and the Furious Five, Public Enemy, and KRS-One rendered social and political critique on the East Coast in New York, while Ice-T and N.W.A., and later solo artists of the N.W.A. movement, Ice Cube and Dr. Dre, mapped out a more gangsta ethic on the West Coast.

In terms of rap's social/political discourses, Grandmaster Flash and Furious Five's classic "The Message," in 1982, was the first rap song to be promoted on MTV that spoke about the politics of ghettoized poverty and social neglect in urban America in response to deindustrialization. For example, in their most famous phrase in that song, "It's like a jungle sometimes, it makes me wonder how I keep from going under," the jungle signified oppressive conditions within the postindustrial center of urban life. Soon thereafter, Public Enemy, also known as the "Black Panthers of Rap," referencing a more Black nationalist tone, came up with a name and symbol that signified the Black male as targeted under a gun stethoscope as an "enemy of the public." Two of their most monumental albums, *It Takes a Nation of Millions to Hold Us Back* in 1988, and *Fear of a Black Planet* in 1990, completely changed the sonic and linguistic landscape of social and

political discourses in rap music. Public Enemy's rhetorical politics of resistance involved using language as a verbal assault weapon to speak truth to power.

KRS-One is widely considered to be an organic intellectual who has not only attempted to preserve the cultural practices of hip-hop, but has centered the elements of knowledge, critical consciousness, and political advocacy in hip-hop culture. He was particularly inspired by former gang member, and one of the forefathers of hip-hop, Afrika Bambaata, who called for a meeting in 1987 at the Latin Quarter club, stating that hip-hop needed to make a commitment to stop the violence and shift toward more political advocacy in urban communities (Chang, 2005). This call from Bambaata was important in 1987 as there were "more young black men killed within the United States in a single year than had been killed abroad in the entire nine years of the Vietnam War" (Dyson, 2004, p. 139). In 1989, KRS-One responded to Bambaata's call and mobilized several hip-hop artists and came out with a song entitled "Self Destruction." The song was a rallying cry and a call for peace in the Black community. As indicated by the title, it was a warning and rejection to self-inflicted forms of nihilism that threatened to wipe out the Black community in genocidal proportions. In the spirit of self accountability, the song was a call for the urban community to think about the choices and decisions of their actions, the political consequences of their actions, and to challenge and reject the stereotype that Blacks were inherently violent people. The song also attempted to challenge dominant mainstream racial scripts that stereotypically associated the cause of violence in urban communities with Black people and rap music. The central themes of love, peace, and collective community predominate throughout the text of this song. Since that time, there have been a number of visible socially and politically conscious artists, such as Nas, Talib Kweli, Dead Prez, the Roots, Common, Immortal Technique, Lupe Fiasco, and Mos Def, who articulate critical discourses and have addressed issues of systemic injustice related to matters such as education and schooling, health care, joblessness, police brutality, reparations, foreign policy, family matters, voting rights, the overrepresentation of Black males in the prison industrial complex, and the overall politics that confront life lived at the margins of urban

communities (Dyson, 2004; Kitwana, 2002). Dead Prez, for example, is generally recognized as one of the major contemporary political forces in hip-hop since Public Enemy. The song "They Schools" on their classic 2000 album, *Let's Get Free*, is perhaps one of the most potent critiques on the neoliberal culture of education and schooling from an urban Black male perspective. For example in one stanza Dead Prez implicates the regulation, control, and power between business and government over social systems of prisons and schools. According to these artists, the power, culture, and ideology of these institutions map out new forms of enslavement and repression through new disciplinary apparatuses of prisons and schools. Dead Prez also presents us with a postmodern urban landscape marked by an aggressive militarization of ghettoized space, and by public schools that are "out of touch." In a world of institutional abandonment and social neglect, it is as if hip-hop artists are crying out that public schools should exist to serve young people, to be spaces in which they can turn to not only understand the social world around them, but engage in critical practices that make their lives more livable. Talib Kweli recently critiqued neoliberal state politics of the Bush administration on a track entitled "Bushonomics" (2007) on the Cornel West & BMWMB album, *Never Forget: A Journey of Revelations.* Talib Kweli opens up the track stating that in order for social and political change to occur the common people must be willing to participate and be active citizens for democracy and social justice to take shape. In addition, he states that the government "must respect the will of the people" and should serve the people as opposed the people serving the interests of the government. In this context Kweli suggests that the politics of social change and transformation must emerge from below, and that the government must be held accountable to the interests of the public welfare state. He then addresses questions of equitable participatory citizenship in relationship to education; and he demystifies the traditional political lines between ideologies on the left and the right, suggesting the need for changing the U.S.-embedded neoliberal agenda.

Many artists within and outside the social and political discourse have begun to translate their critical discourses into movements for social change. For example, David Banner and Master P have testified

before Congress, defending hip-hop culture's free speech rights and challenged the government to be more attentive to the urban conditions of disposability that rap artists speak about, and understand how the profane language often reflects those realities. Both (along with artists such as Jay-Z and P. Diddy) have also raised millions of dollars to help clean up and rebuild New Orleans after the Hurricane Katrina disaster. Common has been a longtime advocate for HIV and AIDS awareness in the urban community. In 2007, Mos Def led a protest that addressed the Jena Six crisis that happened in Louisiana in 2006. He ignited a movement by sending out a viral video, which called all students to walk out of the nation's classrooms in response to the prosecution of six Black male teens that were entangled in a racial brawl with white students over a noose hanging from a tree (Sims, 2007, para 2)

Toward the latter part of the '80s and into the 1990s, Ice-T, followed by Ice Cube and N.W.A., ushered in gangsta rap's discourses that articulated a defiant attitude and, frequently, nihilistic reactions that were outgrowths of major injustices related to police brutality, low socioeconomic conditions with limited options for employment that proliferated the underground market of the crack economy, and the effects of crime on the urban scene. Themes of violence, sexism and misogyny, police brutality, and other long-standing political critiques of urban society complicate and shape discourses within gangsta rap music. The rhetorical discourse of gangsta rap often uses metaphors and tropes of urban street life of real and mythic proportions, ultimately rooted in vulnerable responses to a system of white patriarchal dominance that is well chronicled in the history of North American society. For example, Ice-T best captured gangsta rap's market discourses, predicated on a rugged individualism that invoked a patriarchal misogyny in his 1990 classic hit "New Jack Hustler." This song was the opening track to the movie *New Jack City*, a tale (set in the time period of 1986) about the proliferation of underground, drug market economies that flourished during times of high unemployment and poverty rates in inner cities during the Reagan era. Gangsta discourses in hip-hop reflected a deep sense of disappointment, rage, and anger to social, political, and economic neglect in urban inner cities across Black and Brown America. As Nino

Brown, drug kingpin in *New Jack City* played by Wesley Snipes, states "You gotta' rob to get rich in the Reagan era." Subsequently, the narrative of "New Jack Hustler" sought to describe outlaw, patriarchal, market mentality of capitalist consumption practices with such phrases as "I got a capitalist migraine" and "I gotta get paid tonight you muthaf____n' right." "B____s" also had to get "checked." Although the hustler didn't have much education he had "long dough," and his Uzi was his best friend. Ice-T also likens the empty emotions of the hustler to dispositions of a mortician. This artist gives a ruthless exposé of a cold, calculating hustler who regulates his power and respect through monetary acquisition, while claiming his phallocentric space of male dominance over his female conquest. According to the New Jack Hustler, an inadequate education through presumably inequitable schooling practices further gives credence to the hustler's capitalist ambitions to achieve illicit cash flow of the underground street market economy. The hustler's relationship with the Uzi signifies that he is ready for war and violence on urban turf if necessary. The gun, a symbolic text often used in the discourse of gangsta rap, is frequently understood, according to rap artist Killer Mike, to be that "equalizer of that feeling and not being able to exert change around them" (Matthews, 2006, p. 66).

Gangsta rap often reflects the subject positions of outlaw ideologies of urban Black male youth who feel a suffocating marginality to the larger contradictions of equality and justice in U.S. democracy. Given the history of political and social neglect in the past, they no longer believe in the good faith capacity of public institutions to serve all of its citizens in equitable ways. Subsequently, communities that have been destabilized, that suffer the weight of oppression, often internalize it and respond inwardly (psychically) in complicated ways, which can result in social worlds that are life denying and give consequence to the unfortunate realities of violence. However, Kelley notes that much of what gangsta rap is trying to accomplish for the audience is not advocacy but description (1996, p. 190). He states that gangsta rap is a loosely based form of street ethnography; however, the rappers who play the role of researchers are not detached observers from the scene (1996, p. 190). For example, Dr. Dre, who was formerly a part of the N.W.A. movement that significantly fomented

and shaped the genre of gangsta rap in 1987, produced a track enti-
tled "Lil Ghetto Boy" on his 1992 classic album, *The Chronic*. The track
reflects the description of attitudes in the street life of a gangsta, and
the immediacy and consequences of choices, decisions, and actions
taken in street life. Notice the title of the track signifies descriptive
experiences of urban life for African American males in ghetto com-
munities. On the beginning of this track Snoop talks about a murder
case he faces at the young age of eighteen. In a final state of near
hopelessness, he prays to God for his salvation from his violent
struggles of the streets that, in his mind, have characterized his reality
of survival. In this context, Snoop states that this is the life "of a G."
Snoop captures both the mentality and consequences of a society that
has left him with one option: to bang, scrap, and fight to a violent end
if one must. According to this narrative, there is no other option or
choice if one is to survive life as a gangsta. In a later stanza it appears
the life of a G has taken a hold of his immediate conscience as the best
terms of survival. It is almost as if one is in a mind field of violence,
death, and destruction, where, as Snoop states on this track, "brothers
is droppin' quicker." According to Snoop, if one is to survive as a G,
he has to get a rep (reputation) and one must engage in physical
altercation, be "strapped" with artillery and "handle his," taking
violent, assertive action to maintain respect and status in the street
life. In recognition of this street life of a gangsta, Snoop acknowledges
the realities and consequences of doing time in the penitentiary.
What is being reflected here is what Freire calls a horizontal violence
that is often enacted and committed amongst oppressed and subordi-
nated groups who adopt the consciousness and mind-set of the
oppressor and that has informed (through violent actions against
marginalized groups) certain mentalities about violence and repres-
sion (2004, p. 62). This horizontal violence has contributed to the
deaths of rap icons such as Biggie and Tupac, Jam Master Jay, Big L,
T.I.'s assistant Philant Johnson, Busta Ryhmes's bodyguard Israel
Ramirez, Eminem's fellow crew member and rap artist Proof, and a
host of other unfortunate tragedies in hip-hop. These incidents were
predicated on a street orientation that is rooted in an aggressive
determination for respect at all costs (Anderson, 1994).

Rap music, and gangsta rap in particular, cannot always be understood as literal interpretations of reality; rather as art forms they use rhetorical metaphors, similes, and tropes about committing "violence" as competitive battle expressions in the artists' performance. Phrases such as "murder all sucka' emcee's," to destroy fellow rap artists through verbal competition, microphones that become symbolic as guns, and "murdering lyrics on a track" to boast one's verbal prowess and lyrical skills are but a few of these examples (Kelley, 1996).

Sexism and misogyny have been problematic and pervasive central themes in the discourse of gangsta rap. Women in rap videos and lyrics are often symbolized as trophies and objects to be possessed by "players" in the pimp game of sexual conquest, domination, and control. Snoop Dogg, whose debut album in 1993 was entitled *Doggy Style*, displayed this most vividly at the 2003 MTV music awards when he appeared with a woman on each of his arms, attached to him on leashes. He has been one of the key figures that made pimp narratives in gangsta rap go mainstream in popular culture. For example, on the track "Ain't No Fun" from the *Doggy Style* album (1993), Snoop poses a rhetorical question to how many "b_____s" want to "f__k" him; yet, he does not want to get too caught up or spend too much time with them "h__s." This narrative suggests it is already assumed that women are of sexual use at his disposal, expendable for his pleasure, and on his time.

Although not considered a gangsta rap artist, Nelly's video *Tip Drill* perhaps served as a key tipping point in agitating a protest at Spelman College for rap's sexism and misogyny. The video showed a man swiping a credit card between a woman's buttocks. In response, women from Spelman College boycotted and protested his visit to their college when he was trying to raise funds and awareness for his now late sister's bone marrow cancer. On the critique of sexism and misogyny in rap, Rose makes a valid and poignant point. "Perhaps these stories serve to protect young men from the reality of female rejection; maybe and more likely, tales of sexual domination falsely relieve their lack of self-worth and limited access to economic and social markers for heterosexual masculine power" (1994, p. 15).

Another major theme prominent in gangsta rap is police brutality. Gangsta rap artists' attitudes are reflexive of many urban youths' attitudes toward incidents between police officers and urban youth. For example, N.W.A.'s song "F__k Tha Police" (1989) shows clearly the damaging impact that emanates from the state over-policing urban communities and criminalizing urban youth as a matter of routine. In the introduction skit of this song they position themselves prosecuting the police department in a court room. Witnesses, the rap artists, will take the stand to the tell the truth about police brutality in the Black community. Ice Cube then enters the track, screaming "F__k the Police," and that brothers have hard times with the police because they are Black and Brown. He then speaks to the police department's corrupt, abuse of power, using their authority "to kill a minority," "to be beaten on" and "thrown in jail." The song was politically explicit in responding to the historical practice and injustice of racial profiling and police brutality that have disproportionately targeted African American males within the criminal justice system. For example, the LAPD beating of Rodney King in 1991; the sodomization of Haitian immigrant, Abner Louima in 1997; the shootings of unarmed men Amadou Diallo (1999), Patrick Dorismond (2000) in New York and Oscar Grant in California (2009) are but some of the examples that reflect why attitudes of anger and resentment surfaces in many African American male youth toward the criminal justice system. Addressing the controversy on gangsta rap, Cube states in a 2006 issue of *The Source*, "We was getting attacked in the media, and I wanted to understand where everybody was coming from. Because of how we grew up and how we wanted to rhyme, we felt that was the only way to go. I didn't understand how people who never lived that could comment on anything" (Ford, 2006). Rap artists of the gangsta genre reflect sentiments of police departments that have generated unfair punishment practices, which collectively give consequence to racial profiling, disproportionately unjust sentencing practices in the prison industrial complex, and widespread police brutality exerted on Black males in urban society.

Given the imbalance of power for dominance and control in a white patriarchal society, many Black male youths' search for power through gangsta rap has often given way to discourses in popular

culture most noted for violence, sexism, and misogyny; however, as seen here, the artists at the same time evoked similar political ruminations about tense relationships with the legal and criminal justice systems. While I agree with understanding the cultural and artistic contexts that shape the complexities and symbolic nuances of gangsta rap, I also agree with Michael Eric Dyson when he states that the stakes are too high for moral neutrality in gangsta rap, particularly when speaking about the lives of urban youth.

Toward the latter part of the 1990s and into the 21st century, we have the market-driven economy of commercialized rap music, which speaks more to the corporate industry of hip-hop. The music has unexpectedly become big business, removed, in many ways, from the social and political concerns that emerged in the seventies and early eighties from local voices, experiences, and practices of urban working-class communities. That is, the culture of hip-hop has become the commodity of capital that drives corporate consumption of urban youth culture. Under the neoliberal commercial order, the culture of hip-hop is now dominated by a few media market technologies that have commodified the local practices of collective communities in urban locales. Part of this shift happened under the Telecommunications Act of 1996, which deregulated privatization of local public radio airwaves (Chang, 2005, p. 441). While the act proposed to fuel innovation and competition, it did the exact opposite. This act effectively destroyed local community programming and standardized playlists, reduced running time for listeners, and consolidated the public airwaves under a handful of companies, namely, Clear Channel, Cumulus, Citadel, and Viacom (Chang, 2005, p. 441). According to Chang, since the dawn of the new millennium, five companies (Vivendi Universal, Sony, AOL Time Warner, Bertelsmann, and EMI), which are mainly owned by white corporate executives, control 80 percent of the U.S. media landscape. Their ownership includes the music industry, movies, television, Internet, video games, and magazines (Chang, 2005, p. 443). Such an act allowed corporate interests to pursue global consolidation of media, while concomitantly maximizing their profit margins.

As hip-hop became more privatized through select multinational corporations, the circulation, production, and consumption of the

music's discursive texts and images became increasingly associated with constructed notions of Black masculinity. As Chuck D of Public Enemy states in Byron Hurt's documentary *Hip-Hop: Beyond Beats and Rhymes*, corporate interests of the hip-hop industry have resulted in "selling Black masculinity in a bottle." Concomitantly, the voices, images, and representations of female rappers became increasingly silenced. Even for those females in the past who had been successful, such as Missy Elliot, Raw Digga, Remi Ma, and Lady of Rage, many had to project a more masculine edge in the performance of their work. While artists such as Lil Kim and Foxy Brown projected a sexier image, they still had to prove that they were just as raw and aggressive, lyrically, as their male counterparts in their all-male crews of Junior Mafia and The Firm.

Under this consolidation, performative constructions of "ghetto life" of the Black male is being sold as a commodity for global circulation. This means that much of the production of the music is being driven by record sales and profits of a few major distribution companies, rather than valuing any political or socially redeeming messages by artists who articulate more empowering discourses in hip-hop. In this regard, the commodification of the hip-hop industry's regulated and mass production of "gangsta" — "bling bling" — identities and rap's rhetorical discourse detach "authentic meaning of the image" and inspire market ways of living (West, 2004). Subsequently, patriarchal (hooks, 1992) performance, representations, and social constructions of "Black manhood" play out "inner-city" (urban centers blighted with poverty) Black male youths' desires for the maintenance of money, power, and respect to obtain self-worth (Watts, 2004, p. 595).

As hip-hop has become a billion dollar industry, the culture's influence extends beyond the local and communal discourse of the art form into the corporate branding and media interests of multinational companies. Russell Simmons (Chairman, Def Jam Records), for example, successfully translated a blueprint for the packaging of hip-hop to mainstream American popular culture in a consumable and commodifiable form. For instance, he has played a major role in brokering the hip-hop industry into a conglomerate enterprise that includes, but is not limited to, movies (e.g., Nutty Professor), fashion

(e.g., Phat Farm), music (e.g., Def Jam), soft drinks (e.g., DefCon3), and finance (e.g., RushCard). The influence of clothing lines such as Sean Jean, Roca Wear, and P. Miller, headed by hip-hop icons P. Diddy, Jay-Z, and Master P, can be traced directly back to the pioneering efforts of Simmons's shrewd business acumen. He has also been successful in facilitating the marriage between hip-hop and reality TV with the production of *Run's House* (starring Run of Run DMC), which has influenced the development of other hip-hop reality shows. Programs such as *The Flavor of Love* (starring Flavor Flav of Public Enemy), *50 Cent: The Money and the Power*, P. Diddy's *Making of the Band* and *Work for Diddy*, Snoop Dogg's *Fatherhood*, Coolio's *Rules*, and Fat Man Scoop's *Man and Wife* are examples of how the commercial discourse of hip-hop has transcended rap music, and has circulated urban culture into popular culture.

In a neoliberal commercial order, the branding in corporate America promotes spectacular images and discourses around urban life to sell a product. Corporate conglomerates have harnessed "popular" representations of urban street life and made them commodifiable to many urban Black male youths. They are social actors who most identify with these discourses and images because they come from the same lived experiences as the artists. On the one hand, these artists represent to many urban youths the powerful signifiers related to entrepreneurship and economic success without the assistance and negligence of a corporate, technical, efficiency-based education. For example, iconic rap artists such as Jay-Z, Biggie Smalls, Tupac Shakur, and Nas were all high school dropouts (Nas dropped out in 8th grade), whose identities were invisible to the structures of schooling at the time. Ironically, the work of these artists is now being studied in colleges and universities around the globe. This says something about the dialectical contradictions between knowledge rooted in urban struggle, and knowledge that has been privileged, legitimated, and valued by neoliberal corporate interests of schooling. On the other hand, absent from these texts is the myth of overnight success. The fact is that these artists' corporate success represents the exception, rather than the contrived "rags to riches" story portrayed of the hip-hop world in dominant forms of media.

In a postmodern period, where Black males who come from low socioeconomic conditions are searching for new identities outside of school, race and class identity are closely related to the products and images that these youth consume and embody the work they perform (Carlson & Apple, 1998, p. 19). These youth consume these images at a time where joblessness remains at 50 percent for Black males, irrespective of having a high school diploma; poverty rates for Black families are double the national average (Giroux, February 2004; Street, 2003), and are the same as when King died in 1968 (Gates, 2004); and the standardization of education is not speaking to the most pressing issues that are relevant and relational to affirming the identity of Black male youths (Dimitriadis, 2001). Subsequently, there is an ongoing negotiation between the consumption of image in relationship to everyday lived realities, where Black male youths are bereft of political and economic resource acquisition, and the contradiction between education and social mobility is apparent. As it relates to school, Paul Willis would suggest that consumption and popular culture are relevant to existing themes of school conformism, resistance, disaffection, and variations and points in between (2003, p. 405).

Implications of Reading Hip-Hop Texts for Urban Schools

The genres between the social/political, gangsta, and commercial discourses offer compelling insights into the competing and contested identities that shape the way many urban Black male youths construct their social world through the consumption of hip-hop under the neoliberal commercial order. Their identities and sense of agency in relationship to these competing discourses are constantly being challenged and contested. In order to fully understand the complexity of youths' identity formation processes within the sociocultural contexts of the three different discourses produced in hip-hop, we need to know how urban youth make sense of these discourses, how they take on certain identities, and how these discourses circulate and are produced and distributed in and between media, schools, government, education, and the streets. Subsequently, the framework presented above will be useful in analyzing how discourses are

produced, circulated, received, and consumed between the larger society and the youth themselves. I am particularly interested in the production and reception of these discourses in relationship to the everyday lived experiences of urban youth within asymmetrical relations of power of the dominant culture. These discourses give us some context into how identity formation processes of urban youth are characterized and shaped in the public sphere of urban society within sociocultural contexts in open, contested, and heterogeneous ways.

The students in my study were high school students and hip-hop artists. Subsequently, the discursive genre's hip-hop texts can also help the reader understand the context of their experiences with hip-hop, how they read and practice the culture, and their perceptions of how society judges them as participants of this subculture. The discursive genres in hip-hop help us make sense of the cultural context of the lyrics they were producing, and their motivations for participating at the hip-hop community center. These discourses are also useful in giving some context to the students' readings of hip-hop texts. For example, much of the curriculum I developed for the students was based around the life of hip-hop icon Tupac Shakur. While there are several other contemporary hip-hop artists I could have chosen, I would argue that Shakur has the largest body of work to date that invites critical cultural analysis of urban life. This is particularly true with respect to matters related to social activism, racism, violence, homelessness, poverty, education, police brutality, the family unit, unemployment, masculinity, etc. At particular historical moments of his youth and young adult life and career, Shakur spoke about "his views on schools, education, a curriculum rooted in real-world needs, poverty, and his difficult but rewarding upbringing" (Dyson, 2001, p. 76). The text of Tupac is also a crucial link and axis between the Civil Rights Generation, the Black Panther Movement, and the hip-hop generation. He was born in 1971. This was the same year the infamous New York Twenty-one of the Black Panther Movement (his mother was a member) were acquitted of charges for allegedly attempting to kill police and blow up several buildings (Bynoe, 2004, p. 62). This date of birth was also five years after the founding of the Black Panther movement, three years after the death

of Martin Luther King Jr., and when hip-hop was just emerging. In this regard, Shakur is a crucial intertextual, cultural bridge between these three different movements and generations in Black history. This presents broad opportunities for critical study in urban education and popular culture.

In focus group sessions I had students read and make sense of certain sections of Tupac's visual, oral, and written texts. Visual texts included a particular photo of him in a straight jacket in *Vibe* magazine and a documentary film, *Tupac's Resurrection*, produced by his mother, Afeni Shakur. Oral texts included the students' reading of a speech he wrote for the Black Panther Party at the age of 21. Written texts included students' critical analysis of his lyrics in various rap songs. The combination of visual and written texts was analyzed through a music video, along with transcription of his lyrics that went along with the video to a song called "Trapped." Each of the texts I selected for students to read and analyze within the curriculum of Tupac Shakur were produced within the genre of social and political discourses. However, the ways in which they generated meaning of these texts extended within and beyond the location of social and political discourses to interpret the social world of their lived realities. In some instances, the youth responded to his texts in ways that diverged from the original intent of Tupac. In other instances, the texts were reflective of their own lives and the painful realities they cope with on a day-to-day basis. In all cases, the students' readings of the texts reflected the different ways in which they see the contemporary world of popular culture, and the political and sociocultural contexts that shape it. What I gathered from the conversations, interviews, and focus group discussions is how students made sense of their identities between socially/politically conscious and market-driven discourses. These discourses circulate within and between the culture and industry of hip-hop. The culture of hip-hop refers to urban youth from conditions of urban struggle from working-class conditions who see the culture as a way of life. The hip-hop industry refers to institutions tied to market-driven practices, whose principles are guided by the maximization of profit and corporate interests, and the celebration of market relations and market identities. However, the students also felt the dominant culture of society criminalized

their identities in ways that I would suggest reflect gangsta discourses, often produced and sensationalized in mainstream media of film and gangsta rap.

In doing critical discourse analysis, I also read the community center as a kind of hip-hop text. That is, the building was specifically designed as a center for the critical education and practice of hip-hop culture. In this regard, I could get some sense of the kinds of readings students were engaged in, could see how the imagery and articles posted on the wall situated hip-hop in its historical context, and had the opportunity to listen briefly to some of the lyrics one of the students had produced. Many of the hip-hop texts produced at the center reflected socially and politically conscious discourses in hip-hop, which helped me understand the political motivation in how the center is using the pedagogy of hip-hop in culturally relevant ways with the students. Subsequently, the discourses produced by the center, shaped within socially and politically conscious discourses, in some sense, were structured as what many critical race studies scholars would term counter narratives. That is, the production of these texts centered the lives, histories, experiences, and identities of the urban community in contemporary Black popular culture. The production and circulation of these texts at the center could be seen as a subversive, political act of resistance to dominant, Eurocentric curriculums that deny their identities within the traditional culture of schools. That is, the production of these texts served the purpose of providing critical and relevant pedagogies that center the Black experience through hip-hop culture. Students read the production of these texts in meaningful ways that connect with common experiences in their lives. As students read various hip-hop texts, and produce their own texts, the center is providing a democratic or counter public space meant to heal inward oppression of urban youth, shaped by external, racist practices of exclusion in the urban community.

In the next three chapters, I explore the constant interplay of urban youths' self-identification processes, given hip-hop's influence on their lives, and the prominence the culture and industry plays in mainstream popular culture. In some cases, as in chapter 3, the production and circulation of hip-hop's imagery in dominant, mainstream culture become the reason and rational that public institutions

scapegoat urban youth as problems and gangstas in urban schools and neighborhoods. For example, sagging jeans and a "hoodie" worn over one's head, fashion statements and styles associated with hip-hop culture, become narrowly read by the ideology of white main-stream society as symbolic texts of criminality when interacting with urban youth who adopt those styles. The challenge hear is that multinational corporations and a few mainstream artists who cele-brate gangsta and market-driven discourses have been complicit in reproducing a set of images and discourses that wrongly instigate a set of messages in the public consciousness of America that Black males should be feared, as if they are indeed a violent threat and public enemy to the social order of society. Based on the narratives of urban youth in chapter 3, the production of these gangsta discourses resurrects old racist tropes of dehumanization toward the Black male, during the institution of slavery. It is in this context, between the past and the present of neoliberal, racial politics, that urban youth enter the social imaginary and surveillance of what I term the hip-hop gaze. The hip-hop gaze involves a set of signs, symbols, and texts in hip-hop that are read by racist ideologies of the dominant culture in pejorative ways that criminalize the identities of urban youth as dangerous in urban society. In consequence, students in this study felt that police departments and schools take aggressive, militaristic stances that focus on regulation, surveillance, order, and discipline of urban youth. Consistent with the cultural politics of neoliberal re-forms, punishment rather than nurturing more caring pedagogical relationships with students tends to be the focus of urban schools.

In other cases, as in chapter 4, the students read socially and polit-ically conscious hip-hop discourses against the traditional culture of urban schools and the cultural politics of the larger society. For example, in one of my lesson units I had students read the lyrics of Shakur's 1991 song "Trapped" as a pedagogical method to shape students' critical awareness and consciousness of oppression and marginalization that might be at work in their own lives. I asked them to critically reflect on ways in which they might relate Shakur's notion of being trapped to the ways in which they might have felt trapped in society. They not only read trapped to mean you are not "free in this world" and "you have no power," but also related this confinement to

what they called the trap of standardized testing. In this way, these students in the 9th and 10th grades provided critical insights about how the political consequences of standardized tests, predicated on the "objective" quantification of learning outcomes in academic proficiency, prevent students who are not good test takers from graduating because they didn't make the numerical score necessary to pass. Some students spoke about the fact they get nervous before taking the test. Other students mentioned they were constantly pressured to do as good as the white students from other schools in performing well on the test. And yet others mentioned severe conditions of poverty, of being worried about eating on a day-to-day basis, that far outweighed their concerns with taking a test. Students also stated that in some ways their neighborhoods could be seen as a trap, given the ongoing vulnerabilities of violence produced out of juvenocracies of gang activity, where youth and young adults between the ages of 16 and 25 fight for control and regulation of urban territory (Dyson, 2004). The collusion of these events can best be understood in response to the aftermath and effects of neoliberal practices in governance that disinvest in local communities. Neoliberal reforms deplete urban neighborhoods of socioeconomic, political, and public social services necessary for impoverished families to survive. These are some of the ways in which students used the socially and politically conscious language of hip-hop to provide social critique of their experiences with social inequality through their critical reading of Shakur's lyrics, and subsequently stated that "some people feel trapped by that." In this way, the students took ownership in developing themselves as critical intellectuals, providing their discussion of how power within neoliberal contexts of the dominant culture in schools and larger societal contexts limits the ways in which knowledge, teaching, and learning are produced; they also speak of a series of other ideological, material, and discursive conditions that operate to confine rather than open up democratic possibility for disadvantaged urban youth. It is important to note that they made these connections through the reading of "Trapped" as a sociopolitical and critical hip-hop text.

In chapter 5, I discuss urban youths' consumption practices of market-driven, commercial discourses in the hip-hop industry. The

commercial order of neoliberalism inspires market mentalities, market relations, and market ways of living (West, 2004). Consequently, market-driven commercial discourses of the hip-hop industry play a significant role in how students critically contextualized their generation's greatest struggle to construct an identity of what they term "being that dude." As evidenced by the term, "that dude" is a masculine, constructed phrase the students in my study came up with to describe contemporary, capitalist, patriarchal notions of manhood that urban youth adopt, measured by the influence of commercial discourses in the hip-hop industry. This idea is based on a set of masculine and market-oriented values, heavily celebrated in the culture industry of hip-hop. According to the students, being that dude is predicated on a toughness, of being "hard," along with a style and aesthetic of dress and fashion, reflective of the latest apparel in the hip-hop industry. In addition, market relations and market mentalities of being that dude are defined by the material possessions one acquires, which signifies a man who can make his own money. According to the students, possession of these characteristics allows one to be noticed, popular, and recognized to obtain power and respect at school. They suggest that urban youths' consumption practices of being that dude are drawn from their peers' desires to be like iconic rap artists who are visual representations of market identities and lifestyles in the media they seek to emulate. The investments that urban youth make within the commercial discourse of the hip-hop industry, which often takes center stage in schools, are both symptomatic and reflective of the breakdown and emotional detachment that occur within neoliberal reforms of schools. Wexler (1992) suggests that such policies have wiped out caring and nurturing relationships between teachers and students that could otherwise sustain emotional bonds that are necessary for effective and successful pedagogical relations. It is these particular contexts that youth subcultures, such as hip-hop, form their own collective, communal bonds of identity making and develop a set of compensatory reactions through market niches of the hip-hop industry. It is important to note that students in the study who spoke about these matters were not passive objects who accept consumer market identities that have become a pervasive influence on many urban youth in the hip-hop

industry. They challenged these discourses as destructive to alternative forms of healthy identity making. In this context, students were critical ethnographers of their own subculture, describing the cultural investments their peers make to obtain masculine forms of power, validation, self-worth, recognition, and visibility in a society that has rendered them invisible. These are compensatory reactions in which they seek to become somebody in school (Wexler, 1992).

The different discourses produced and circulated in hip-hop emerge out of societal neglect and callous indifference to the suffering of young people, and have narrowed democratic, public spheres of public life in urban communities. The language and logic of neoliberal reforms adopt aggressive forms of militarism that seek to punish rather than nurture urban youth; neoliberal reforms privilege corporate models in education, absent of the identities, histories, and experiences of urban youth; neoliberalism also privileges profit over people, leaving many local urban communities economically bankrupt, due to globalization and outsourcing of jobs; and neoliberalism inspires consumerist practices and market ways of living in cultural processes of identity making. Collectively, these particular cultural contexts reveal institutional conditions that displace and detach urban youth in the public sphere of society. Subsequently, what is at stake in the present moment, it seems, is how we, as critical educators, can help co-construct with students counter public spaces of resistance to a neoliberal culture of urban displacement that threatens the advancement of more democratic forms of education. Subsequently, given the displacement, detachment, and alienation that confront many urban youth within the neoliberal culture of urban life, radical educators will need to develop and locate counter public spaces of resistance to reclaim democratic spaces and practices for urban youth. I take up these matters in chapter 6.

In what follows in the next chapter, I discuss the construction of the Black male as a public enemy in urban schools. In an attempt to subvert the neoliberal commercial order of urban life alongside Black male youths, we must engage in forms of critical media literacy as a way to critique commodified texts that convey hegemonic representations and performances of Black masculinity (which are both misogynistic and heterosexist) and counter-hegemonic representations and

practices that are more consistent with discourses and practices of freedom and empowerment. This demands that we challenge discourses that blame youths for the social ills they encumber, and demystify the ideological asymmetrical relations of power at work in such deficit theories of the student and the students' cultural background. It also demands that we recognize that youths have a sense of agency, and resist dominant, constructed narratives that couch their identities in pejorative ways. Urban schools must become aware of the narrow and dehumanizing ways in which the public consciousness of America has been educated about the identity of Black male youth. How we socially construct the identity of students impacts how we socially interact with them on an everyday basis in urban schools. These constructions have been heavily shaped by neoliberal ideologies in the media that cast them more as problems and public enemies to be punished, rather than more compassionate representations. Addressing the cultural politics of these matters is crucial to reaffirming more caring and nurturing pedagogical relationships with students.

Chapter 3
Public Enemies: Constructing the "Problem"
of Black Masculinity in Urban Public Schools

And yet, being a problem is a strange experience, – peculiar even for one who has never been anything else...

<div align="right">

W. E. B. Du Bois (1903)
Souls of Black Folk (2003, p. 8)

</div>

The image of a Black man, marked under the target of a rifle, was a profound statement by the political rap group Public Enemy. The symbol was a statement about how society has both treated and viewed the Black male as the "public enemy" in America. In being a part of the hip-hop generation, we all understood the moniker and metaphor immediately. In some ways, Public Enemy was revisiting the rhetorical question asked by W. E. B. Du Bois in his 1903 classic, *The Souls of Black Folk*: "How does it feel to be a problem?" Literally and figuratively, too often the Black male has been both targeted and objectified as a problem to be feared, disciplined, contained, and punished in society. The recent death of Oscar Grant, gunned down and killed by police officer James Mesherle in San Francisco, California, reminds us of how often urban youth are targeted as an enemy of the public. Even renowned scholar Henry Louis Gates Jr., of Harvard University, found out he too could be viewed as a public enemy when he was arrested at his own house, mistaken for a burglar.

In reflecting on the image and symbol created by Public Enemy and the question posed by Du Bois, I think about a troubling conversation I had with a teacher some years ago when visiting an urban public school. As she looked toward a group of African American male students innocently congregating in the cafeteria, she stated to me, "Darius, I don't know what to do with them. They are a bunch of thugs." In this context, the term "thug" was meant to be associated with an identity and behavior of violent, dangerous, criminality. Implicitly, she expressed a desire to take some kind of punitive action of "disposing" of these youth, if you will, from the "normal" popula-

tion of the school. As one youth advocate once told me, there is a tendency for schools to adopt the attitude toward African American male youth of "let's get rid of the hard ones so we can deal with these others." Consequently, these students are often labeled and marked as troublemakers or menaces to society with inherent behavioral dysfunction who suffer the consequences and perils of their own self-destruction. Subsequently, when urban youth are framed as public enemies, the infractions and "offenses" committed in schools and the larger society are seen as no one's fault or blame but the students themselves. Framing urban youth in public conversation *as* inherently deviant, dangerous, social problems relieves *public* institutions, which are to be *in service to youth,* of their moral and civic responsibility in developing transformative structures of hope and possibility to meet the needs of these students. Unlike any other population, these youth are often targeted and produced as the objects of fear, scorn, and contempt; and they are too often read as violent and dangerous in society.

Students in my pre-service teacher education programs are often unaware of the historical production and custody of meanings inscribed on the canvas of the Black male body that impact how urban public schools view and treat this population. The majority of these students are honest and courageous enough to admit that much of their perceptions about the life and identity of African American males, and African Americans in general, have been informed by what they consume on television and music. In addition, most of these students have lived in affluent, all-white communities, and attended schools where multicultural education was absent, as is true for the curriculum of most U.S. public schools. Many of these students grew up in homes with socially conservative values and ideologies where Blackness was treated as an aberration. Much of their lives have been sheltered from the actual, everyday lived experiences of persons of color. This was evident when many of them were told by their parents that you don't go into downtown, inner-city, neighborhood, communities out of fears associated with the "public face" of these communities, "violent" African American males on street corners. Other students had certain fears about being in close proximity to African American males in certain situations, but had difficulty

explaining or understanding where these fears originated. Even my masters' students in principal certification programs reveal that discourses around the Black male as violent and disruptive in urban schools have been kept firmly in place. All of these students were courageous and honest in that for the first time they had to critically grapple with a series of difficult questions they never had to think about before, regarding a population their lives never had to come in contact with before.

Early on, public schools tended to adopt a set of attitudes toward Black male youth based on a set of ideas, beliefs, and stereotypes rooted in a racial politics of the past between slavery and Jim Crow eras. It was during these eras where the Black male was constructed as animalistic, aggressive, violent, dangerous, and a sexual predator toward white women. The institutionalization of these discourses circulated in churches, schools, and academic journals, and the government itself played a significant role in the institutionalization of these discourses. It is significant to note that Blacks have been the only population in the U.S. Constitution to have been legislated as three-fifths of a human being, which negated their full rights to citizenship status. In fact, most U.S. presidents, up until Lincoln, had been slaveholders themselves and helped shape the national public consciousness about Blacks and Black male identity (Kharem, 2006). Immediately after the integration of public schools, white communities did not want their daughters in close contact with Black boys. White teachers tended to see these students as rough, aggressive, and hostile. In the possible threat of Black male miscegenation with white women in the U.S. society, discipline and punishment were often inflicted out of fear, hatred, and sheer white rage (Kharem, 2006). Subsequently, the racial politics of this ideology played out in the classroom because "the main reasons against school desegregation [were] to keep little white girls away from young black males" (Kharem, 2006, p. 39; Davis & Clark, 1992, p. 184; Day, 1974). bell hooks argues that white teachers were reticent to teach Black boys when the racial politics of desegregation emerged. She states, "White teachers were not eager to teach black boys and white parents were not eager to have black boys sitting next to their sons and daughters" (2004, p. 39). After *Brown v. Board of Education* in 1954, there was

nervousness and racist, xenophobic fear amongst white communities having to legally share public space with the Black community in public schools. Subsequently, during the period of what was called white flight, many whites moved to the suburbs to avoid physical interaction and contact with Blacks in the urban public space of schools (Kharem, 2006). It was after integration when Black males became more invisible in schools, were racially marked as a stigma to white students, and were less enthused about their education (hooks, 2004, p. 39).

Today, images and stereotypes of Black male identity formation in the past now enter the realm of popular culture. Based on current statistics, many of our future teachers from the dominant culture will be teaching in urban schools, densely populated by African American/Latino communities. In this context, critically reading the cultural contexts of identity making of popular culture in urban schools is of immense importance. The cultural site of popular culture now plays a key role in the distortion of image-making processes of Black male identity. Movies, television, film, radio, music, talk shows, political campaigns, and newspapers are filled with hyper-sensationalized images and stories that leave the common public more afraid than understanding, more judgmental than empathetic, and more miseducated than informed of the daily experiences urban youth face. The narratives we hear are often isolated from contexts and circumstances produced within inequitable relationships of power in the social structure of society. These contradictions and distortions in mainstream public discourse of image making of urban youth in popular culture set the conditions upon which African American students, Black males in particular, are often marked as "bad kids."

Regarding contemporary popular culture, Joe Kincheloe states that a culture of fear has been produced in society about Black male youth through the circulation of negative images in popular culture, which inevitably impacts relationships between students and teachers in the classroom (2007). Pedro Noguera states that teachers and administrators in urban public schools often possess a misguided fear about urban Black male youth because they don't know the lives, experiences, and communities of the students they teach (2005). Subsequently, perceptions school officials and teachers have about

these students have most often been informed by the production of stereotypes through cultural representations fueled by the media. For example, "Research by Dorfman and Schiraldi demonstrates that 76% of the public depend on the media to formulate their opinions about youth crime; and that African-American youth are more likely to be shown as perpetrators of criminal activity in the media" (Hayes, 2007, p. 193). Giroux argues that "within the last decade, youth have become public enemy number one—blamed in the press, in Hollywood film, and on an endless array of right-wing talk shows for nearly all of our major social ills extending from violence and drug use to the breakdown of family values" (2006b, p. 178). Talk shows such as the *O'Reilly Factor* have frequently targeted Black male artists such as Ludacris in hip-hop as "contributors to the debasement of civil society in America" to support his ongoing "culture wars" debate on the conservative Fox News channel. In 2007, political pundits associated the Michael Vick case and the underground world of dog fighting with hip-hop culture (Prier & Beachum, 2008, p. 531). There was an implicit racial implication between Michael Vick, dogs, and hip-hop culture that rearticulates racial discourses about the Black male as savage beast into new cultural representations between race, gender, and masculinity in hip-hop culture. The discursive and ideological production of films within the hip-hop genre such as *Menace to Society, Dangerous Minds, 187, The Substitute, Boyz in the Hood,* and *Juice* reproduce narratives, images, and scripts of dangerous, uncontrollable, psychotic, urban Black male youth who threaten the social order of the school. The titles in some of the films, such as "187," which is the police code for homicide, and obvious phrases such as "Menace" *to Society* and "Dangerous" *Minds,* signify to the audience the risks and chances one takes when interacting with "aggressive," "violent," and "dangerous," urban youth. It is not only the language, but the visual texts that communicate these messages to us. In the opening scene of *187,* one of the teachers, Garfield (played by Samuel L. Jackson), is stabbed twelve times by a Black male youth, Walker, for flunking him. Ironically, the character Walker is played by Method Man, a rap artist and icon in hip-hop culture in real life. In this context, teachers and administrators are in a war zone, risking their lives in enemy territory with these students on an everyday

basis. In the 1990s, *Menace to Society* was a popular film of the hip-hop genre and became the archetype representation of Black male nihilism. This film also opened in violence when O'Dog murders the store's Asian owner and his wife for talking about O'Dog's mother in public conversation. In *Boyz in the Hood* (a precursor to *Menace to Society*), starring former N.W.A. rap artist Ice Cube, one immediately hears gunshots, followed by the grim statistics about incarceration rates and internal Black on Black violence, committed at the hands of Black males. "Typically in hip-hop culture, most people have accepted a set of distortions and stock narratives of Black males as 'thugs,' 'gangsta's,' 'menaces to society,' and crime-prone deviants that have been commonly associated with hip-hop culture in mass media" (Prier & Beachum, 2008, p. 531). "While each of these films underscores how Black masculinity is constructed and emerges from the devastation of a ghetto existence, Giroux argues that the larger social structures of systemic rejection which constrain agency and possibility for Black male youth are noticeably absent from the film's context. He suggests that this absence of context within the larger social structure of institutionalized racism for many white audiences conflate[s] effects as causes, and predetermines Black urban youth as pathological and naturally violent" (Prier & Beachum, 2008, p. 525).

Giroux's point about the absence of context, with respect to encumbrances urban youth face in a society of institutional rejection, was evident when Debra Freedman had her pre-service teachers conduct a textual analysis of the television series version of *Dangerous Minds*. Given the dominant cultural background of the students, most tended to conform to reading the film through dominant codes that colonize the identity and culture of students of color. These readings reinforce a monolithic collectivity about their behaviors and actions in school. She states that the television version of *Dangerous Minds* erases the complexity and struggles of students' lives, while reinforcing dominant, ideological conceptions of Black and Latino/a youth as menacing (Freedman, 2003, p. 245). Essentially, the students bought into the dominant, media culture's commonsense notions about urban youth as deficits, violent, and in need of discipline.

The dominant culture of mainstream media has used the culture of hip-hop as a significant way in which urban Black male youth have

been demonized and labeled as the public enemy in society. Murtadha-Watts makes reference to the dominant culture's commodification and manipulation of urban Black popular cultural forms, such as hip-hop, in Nancy Lesko's edited volume *Masculinities at School* (2000). She states that the commodification and manipulation of hip-hop reinscribe distorted images and representations of long held, historical stereotypes related to urban street life, criminality, sexuality, sexual violence, physicality, strength, inhumanity, and dangerousness (Murtadha-Watts, 2000, p. 51). The images and stereotypes of Black males as volatile, aggressive, dangerous, and sexually predatory in popular culture have a specific history during enslavement when "whites developed many of their greatest fears and anxieties toward Blacks, particularly toward Black males" (Jackson, 2006, p. 16). We are still trying to unpack a history where the first African American president, Barack Obama, was seen in media by conservatives as a potential terrorist; liberals (e.g., Chris Matthews of MSNBC) suggested he needed to "humanize" himself to white working-class, female voters during the 2008 presidential campaign. Consequently, "we must have a discussion of Black popular culture and hip-hop cultures with an emphasis on rap music to draw attention to the tensions and conflict with Black masculinity constructions within urban educational structures" (Murtadha-Watts, 2000, p. 51; Prier & Beachum, 2008).

School officials are not isolated from the consumption of these images that have been circulated and produced by these various media outlets. The images we read in media and popular culture, and the ideological and political values that shape them, inevitably play out in the nation's urban school classrooms. As Douglas Kellner and Jeff Share suggest, the institution of the media is its own form of "public pedagogy" teaching us how we think about race, class, gender, and sexual orientation constructs and the power relations at work (2007). For example, the commodification and manipulation of discourses in hip-hop get represented in schools in ways that give false justification to institutional practices of discipline, control, and restraint of Black male youth. This was demonstrated in a case study by C. P. Gause, which explores how African American educators understand hip-hop culture and its impact on public schools. He noticed that images in the media, the stylization of one's clothes, and rap music all served as

constitutive elements within the culture of hip-hop that set in motion different social discourses for white teachers around the construction of Black masculinity (Gause, 2001). The messages they received from these discourses frequently defined their perceptions of Black male students as threatening or a menace to the dominant culture of schools (Gause, 2001). Gang attire frequently seen in hip-hop videos in relationship to the suspicion of violent activity; the cool pose as a cultural stance, attitude, and disposition of defiance to normal codes of conduct to mainstream society; and Black vernacular speech patterns, among other cultural and symbolic modes of machismo identity related to Blackness, all served to agitate disciplinary practices of white public school officials on Black male youth in disproportionate ways (Gause, 2001). This study demonstrated how Black males have been constructed as the public enemy through hip-hop culture that impacts disciplinary practices in society and urban public schools. At its worst, the distorted images of African American males in popular culture encourage an institutional culture of punishment, containment, and control of urban youth (Hayes, 2007). As public schools disproportionately enforce discipline and punishment practices toward these students, they often reflect a troubling set of actions informed by commonly held stereotypes of African American males, frequently seen in media and popular culture. As urban schools become increasingly diverse in the 21st century, K-12 educational leadership and teacher education programs will need to become critical readers of racialized, gendered images in popular culture. In this regard, there is a need to teach future urban school leaders the vast set of ideological and political values that shape the production of images in popular culture that reflect long-held racial anxieties and xenophobic fears of Black male youth in urban society. As urban educational leaders develop critical awareness of racialized and gendered politics that shape the production of these images, the transformation of a culture of criminalization to a culture of empowerment in urban schools might take shape.

In this chapter, I give discussion to urban high school youths' perceptions of how they felt society reads their bodies under the surveillance of what I term the hip-hop gaze in popular culture. Signs, images, language, and fashion in hip-hop employed by urban youth

were read by institutions of authority as symbolic texts of criminality with race and gender overtones.

In addition, when students discussed how society labeled them in the present, they rearticulated discourses related to tropes of incivility and dehumanization produced from the institution of slavery in relation to newly coded meanings within cultural, symbolic texts of contemporary popular culture. The ideological readings of these texts are often shaped by the manipulation and consumption of mass media in film, music, videos, and daily news, where the Black male image is produced and circulated as violent. Subsequently, the students said that urban public schools tend to adopt a set of attitudes and dispositions that view urban youth as troublemakers, based on these representations. According to the students, the cultural production of these readings creates the conditions upon which African American male youth are disciplined and punished in disproportionate ways than other student populations.

In the concluding section, I argue that educational leadership and teacher preparation programs need to incorporate critical media literacy in the curriculum. As urban public schools become increasingly diverse in the 21st century, teachers and administrators will need a new set of tools to help them critically read culture. The power and regulation of mass media in the dominant culture have wielded influence in the projection of taken-for-granted values and ideologies, assumed to be adopted by the common public without question. The media is the main source of communication and public pedagogy, producing images and representations that often omit or distort the lived realities of marginalized populations. Therefore, it will be important to critique how urban youth are represented in dominant-subordinate power relations in the social structure of society. It will also be necessary to understand how ideology, culture, and racial politics shape these representations in ways that mischaracterize youth in schools. In addition, it is crucial to understand how urban youth respond to these representations in relationship to their own self-identification processes, which can at some points reproduce a kind of hegemonic masculinity. This means critical educators must ask the right questions and rearticulate and decode a set of messages that provoke fear and discipline of urban youth in schools and the

larger society. Critical media literacy is a political project that has the possibility of reshaping and transforming a culture of classroom conflict, where urban youth can be retained in schools.

Urban Youth under the Surveillance of the Hip-Hop Gaze

Could it be my baggy jeans, or my gold teeth
That make me different from y'all

—Trick Daddy
"I'm a Thug" (*Thugs Are Us*, 2001)

In my discussions with students at the hip-hop community center, they often critiqued the ways in which administrators, teachers, and other authority figures, such as the police, viewed them in a pejorative fashion in urban schools and neighborhood communities. The cultural, symbol texts of their clothes, stylized in a hip-hop aesthetic, were read by the dominant culture in hegemonic, masculine ways that targeted their identities as criminals. These students entered the social imaginary of what could be specifically described as the "hip-hop gaze," a term I use that is inspired by the cultural work of Awad Ibrahim. He would suggest that youth in this study are not inherently "Black" as a fixed entity. They go through the cultural processes of becoming and being read as Black, through the hip-hop gaze, in everyday white, racist, communicative states of mind (Ibrahim, 2003). That is, the social context and social imaginary of being read and marked as Black under the hip-hop gaze happen through signs, symbols, language, and other texts in hip-hop culture that convey messages that Black male youth are dangerous, violent, and trouble in the dominant culture of white society. According to the students, the ways in which they wear their clothes, popularly associated with the fashion trends of hip-hop culture, are often read by public school officials and the police as symbolic texts of criminality. As Ann Ferguson argues, different cultural representations of the self for urban Black male youth are often enacted through language and style as subversive forms of communication in political resistance to dominant mainstream values and norms coded by the school (2003).

When students analyzed how they were labeled through their clothes, they possessed a critical and historical awareness of hidden societal scripts used to mark their identities in contemporary popular culture that reflected many of the discourses produced about Black males throughout the legacy of slavery. For example, in one of our group discussions I first wanted to gain students' perspectives on how they felt society views the meaning of being a Black man in American society. Interestingly enough, the students often used the ideology and legacy of slavery as a reference point to characterize how they feel they are viewed in contemporary urban society. For example, Marquis started the conversation stating, "We in modern day slavery" and that white society still expect them to "bow down" to them because historically, Blacks were slaves at one time (field-notes, focus group session, 10/15/08). However, he states that his generation rejects and has no fear in the racial hierarchy that attempts to circumscribe urban youths' subject position in society. According to this student, he asserts an attitude of resistance to the silent acquiescence or docility of conforming to white mainstream codes and values that is often expected of Black males in U.S. society. bell hooks states that this docility or "bowing down" as Marquis puts it, is marked by a culture in schools that traditionally do not encourage Black males to do the kind of questioning, critical reflection, and speaking out that is necessary for education as a practice of freedom and liberation (2004).

Corey and Marquis then spoke to animalistic discourses that reflect the logic of old racial politics of white supremacist ideology. The ideas of intellectual deficiency and savagery were common falsehoods and tropes during the institution of slavery that marked the race and representation of Black male life. For example, Corey states that his community doesn't have many resources because "everyone think that we animals" and that in his mind they are "portrayed as killers" (fieldnotes, focus group session, 10/15/08). Marquis chimes back into the conversation, making the link between being portrayed as animals in relationship to devaluing the knowledge they possess as critical citizens. He states, "just because we another color" it is assumed that "we can't think, and we all animals, knowing we got knowledge" (fieldnotes, focus group session, 10/15/08). In addition, Ronnie, an

older student asserts that in order to understand contemporary portrayals of Black male identity "we have to take it back to the minstrel period" (fieldnotes, focus group session, 11/12/08). The student's reference to the minstrel period is a specific era in history when whites put on "black face," a dark makeup substance to caricature Blacks in stereotypical ways. One of the images and characterizations of the Black male in the minstrel period, to which this student is referring, is that of the violent, dangerous Buck in popular cultural portrayals in white mainstream cinema and theatre. Quite perceptive, he stated that the production of these kind of images invoked an attitude of "the Black man is dangerous, don't touch him, be afraid of him...," and that these images have taken on a life of their own which suggest that "Whether we are acting like this or not, people viewing us like this...," despite the distortion and manipulation of these images in their production (fieldnotes, focus group session, 11/12/08).

Marquis was quite vocal throughout this entire discussion, and pushed the conversation a bit further in theorizing the social construction of Black male identity in contemporary, popular cultural, contexts. Students overall interpretations of how Black males have been socially imagined within particular historical contexts with racially coded meanings suggest the production of these discourses have been rearticulated through hip-hop culture. According to Marquis, urban youth are not only viewed as animals, likened to pit bulls or some "endangered species," but the style and aesthetic of their clothes, worn in hip-hop fashion, invites constant suspicion, surveillance, and racial profiling of their everyday actions in urban communities. In effect, the students feel they are wrongly targeted as criminals for the style of apparel they are wearing that is heavily associated with hip-hop culture. For example, Marquis points to Corey's clothes to make his point and says "It's like they are dog patrol." He says that when the police see them and see how Corey is dressing they will pick with him. Marquis feels Corey will be picked on and will invite suspicion of criminality on the street from the police for the way he is dressing. Corey is wearing a black doo-rag over his head, black baggy jeans, and new tennis shoes. This is a style and aesthetic commonly worn in hip-hop culture. Marquis says that he himself has been targeted for

this kind of surveillance when coming home from school and has been stopped by police at random on the street. According to Marquis, they ask him, "You got a gang thang on you? Why are you dressed like that?" (fieldnotes, focus group session, 11/12/08). He then stated that he knew they were profiling him to see if he was dealing drugs.

The aforementioned discussion implies that there is a kind of gaze, racial profiling, and surveillance that happens for urban male youth who wear and stylize their clothes in hip-hop fashion. In addition, the students suggest that hip-hop attire, in the minds of white society, signifies an association with gang activity and consequently, dope dealing, crime, and violence. According to the experiences and perspectives of these youth, the racial politics and representation of the African American male as violent and crime prone often circulate through signifying images and symbols of hip-hop apparel, frequently worn by these youth.

In addition, the students also talked specifically about saggin' in relationship to being criminalized and racially profiled. The act of saggin' is when youth frequently wear their jeans low, below the waist and is a common cultural practice in hip-hop culture. According to the students, the act of saggin' often signifies criminality to local authorities. Assumptions of criminality emerge when local police authorities look at the jeans and shoes that appear to be high end, brand name apparel, and assume students have sold drugs as opposed to working to purchase such apparel in a legal manner. For example, Marquis reenacts a typical conversation in the voice of the police, "Ok, he saggin', uh uh. He got a hundred dollar outfit on. Uh uh, uh uh, look at them shoes" (fieldnotes, focus group session, 11/12/08). While authorities assume urban youth who wear saggin' jeans signify persons who are engaged in criminal activity, the students counter that saggin' their jeans is just a habit and fashion style they frequently wear and nothing more. According to the students, the act of saggin' in hip-hop culture is not accepted, according to the cultural codes and values of mainstream, dominant culture. It is not just that saggin' isn't socially accepted, but, as reiterated here, the hidden, political implications are that urban youth are prejudged as dope dealers.

Along these lines, the students also discussed hip-hop fashion trends of saggin' in relationship to a post-structural re-articulation of the term, recoded as niggas. Note, both the style and aesthetic of "saggin'" in relationship to the use of the term "nigga" are cultural productions with ever-shifting meanings in hip-hop culture, particularly in gangsta rap music with race, class, and gender overtones. For example, students were unsure of the origination in articulation and re-articulation between saggin' and niggas. However, from their perspective, if one is visually seen by the dominant culture as saggin', which they point out spells niggas backwards, he is also pejoratively seen as a nigga, the signification of second-class citizenship. Corey makes the point that it is what the dominant culture of white society sees, the gaze, versus what they hear-verbal interpretations in terminology between saggin' and niggas, that is given currency or value in the public imagination of how urban African American male youth are criminalized in society. According to Corey, the common refrain in the social imaginary of the dominant culture is "Aw he saggin' so he got to be a dope boy!!" (fieldnotes, focus group session, 11/12/08).

Leroy also expressed his views on urban youth who sag their pants. He mentions an incident where he and his peers were offended when a well-intentioned white individual, speaking to a group of urban youth at a local youth conference, shared his views on negative perceptions of urban youth who sag their pants. Similar to Corey's earlier points, the speaker first told them that saggin spells niggas backwards. In this context, the term nigga was not used as a term of endearment, as is frequently the case in commodified forms of Black popular culture. Subsequently, he was suggesting to the students that those who sag embodied the image and identity of second-class citizenship, "the nigga." According to Leroy, he then told the students the act of saggin' is ignorant, an associative meaning with a lack of knowledge/intelligence. Leroy states, "And then he was like saggin' is ignorant so niggas is ignorant. That's basically what he was saying" (fieldnotes, focus group session, 10/8/08). This was a problematic interpretation for Leroy because he said the speaker made certain pejorative assumptions about the relationship between the style of one's pants and the integrity, character, values, standards, and intelligence one possesses as a human being. Leroy suggests that

one's character/intelligence should be made separate from how he wears his pants.

Undoubtedly, in the aforementioned incident the speaker was probably trying to make a point about the etiquette of "how one should dress in society," based on dominant, white mainstream culture. This view notwithstanding, there is something to be said about preparing youth, without condemning their identities, in a racist society that will morally judge and reject them based on their appearance. However, the point here is that many students translated the speaker's message as demeaning to their identity. The students felt they were unfairly judged, based on a style and aesthetic of clothes they wore, heavily attached to an identity they project. They were offended in being seen as "ignorant niggas" because they didn't affirm their identities in that way. In addition, the students suggest the term nigga has been re-appropriated from its original terminological use in contemporary contexts. For example, PJ gives the explanation that how the term "nigga" is used today, for urban youth, is different from its historical context. For example, he states, "back in the day was, in slavery terms, like they used to call us dumb niggas in stuff like that..." (fieldnotes, focus group session, 10/8/08). According to this student, there was little difference in being called a nigga and being literally seen as a dog. Subsequently, he was very aware of the dehumanizing context of its terminological use. However, he states, "But now, we take it as, all it's cool to call each other that" (fieldnotes, focus group session, 10/8/08). Another student indicated that he called his white friend nigga because they grew up under the same low socioeconomic conditions of poverty in the same neighborhood. He states, "That's my nigga" because they could relate to one another in a particular class context.

The back and forth re-articulation between saggin' and niggas in relationship to ideas about the "ignorance of youth" who wear their pants below the waist is a complicated conversation in the production and identity formation of urban youth. Depending on cultural context and use, there are different metaphorical interpretations at the symbolic and linguistic levels between the image of saggin' and the different messages and meanings it signifies between the dominant culture and the hip-hop generation. The image of African American

males saggin' became a larger metaphorical conversation about representation of the term nigga in relation to the questioning of race, class, identity, and citizenship of urban youth. While the dominant culture held traditional interpretations between style and language, urban youth used the term "niggas" as a linguistic re-articulation, often assumed to have newly coded meanings different from the racial epithet nigger, negatively used toward Blacks in slavery. Contemporary debates between the Civil Rights and hip-hop generations range from the word as a term of endearment versus an ugly reminder of second-class citizenship in urban, Black, working-class communities (Kelley, 1996). Some scholars, such as Michael Eric Dyson, suggest that the use of the term "nigga," by the Black community, represents a political, reversal of meanings to take something that was so ugly and reappropriate it, linguistically, into something more endearing. In this context, it means having the power, control, and right to remake something anew from the nastiness of white supremacy and determine how one will name and mark oneself, and the coded meanings one will give to that representation. However, Cornel West suggests that we must be careful in the terminology and use of the term, because we have no control over the term once it is circulated over the airwaves, globally, outside of the context of the Black community and onto compact disc in popular culture. Admittedly, I have my own concerns about use of the word "nigga." However, the conversation opened up a deeper analysis of how urban, Black male youth felt their bodies were read in hegemonic, masculine ways that continuously positioned them as the public enemy in popular culture. The students' re-articulation in terminology is demonstrative of their critical consciousness about socially pejorative scripts, constructed about them by the dominant culture. The custody of variations and different meanings associated with the term is reflective of competing ideological values that keep urban youth under the surveillance of the hip-hop gaze. The cultural shift in meanings redefined how hegemonic masculinity is being constructed in popular culture.

Urban schools are inevitably influenced by the bombardment of negative images of urban Black male youth produced in media, and popular culture more broadly. For example, Marquis was very frank

and expressive in his views of media portrayals of African American males in a white society. He states, "the media think, you feel me, we ain't nothin' for real, but...some bums..." (fieldnotes, focus group session, 11/19/08). This is how he feels that white society portrays and downgrades the images and identities of African American males. Marquis further states, "They don't want to see us make it because they feel like they the most dominant race" (fieldnotes, focus group session, 11/19/08). According to Marquis, these taken-for-granted narratives, the "common sense" ideology of white supremacy has been ingrained within the logic of the dominant culture. His remarks suggest there tends to be an oversimplification and generalization in this student's perception of "all" white people portraying Blacks in a negative manner. However, he is critical of and perceptive to the overwhelming evidence of dominant, media culture's influence and power in the regulation, manipulation, and distortion of images that have disproportionately marked Black males as "bums." Inevitably, the production of these images and the readings and consumption of them are heavily mediated by the institutional power, culture, and ideology of white society. These images in media circulate throughout popular culture, and have political ramifications in the social interaction and treatment of urban youth of the hip-hop generation.

The cultural production of symbolic texts in hip-hop culture, often read and associated with criminality, wrongly gives police departments and schools the green light to punish and discipline these students in a disproportionate manner than other student populations. For example, students critiqued the disciplinary practices of schools from teachers who labeled them as trouble when they see them walk in their classrooms with their pants sagging. According to Marquis, he understands that when teachers ask him to pull his pants up in school they are trying to prevent him from looking like, in his words, "an ignoramus." Jay-T says that as soon as they see him walk into the classroom with baggy jeans "they say that kid is going to be a handful" (fieldnotes, focus group session, 10/8/08). In this context, Dick Hebdige reminds us that style in youth subcultures is often read as intentional communication that signifies and commands to be read as a subversion to the normalized order of society (1997, p. 134). It is

this subversion in hip-hop style that, in part, communicates to the teacher that the student is a troublemaker. Jay-T says he has been written up twenty times this year, and insists that once you have been labeled by teachers and administrators as trouble it is hard to get out of the shadow of this label. He states that these labels are often predetermined the moment students enter the school and the classroom. In addition, he suggests that students are sent to the office and punished for these labels, based on the false perceptions that teachers and administrators have of them. Jay-T states, "These labels get hard because once they label you as trouble you gone be sent to the office because of that label....You are punished for it because of how you are perceived" (fieldnotes, focus group session, 10/8/08).

D-Jay states that African American males are more frequently targeted and disciplined in a disproportionate manner than their fellow white peers for minor infractions, such as wearing coats in the hallway. According to this student, the cultural dimension of race was at epicenter of power in white school systems that enforce policies in a discriminatory manner. He states, "You're always going to lose in the white system. They get on us too much" (fieldnotes, focus group session, 11/12/08). D-Jay insists that when white boys are in the hallway talking with their coats on, school administrators don't reprimand them. However, when a group of African American males are in the hallway with their coats, all of them are told to take off their jackets while not acknowledging or reprimanding white students for the same infractions committed. D-Jay was not so much in disagreement with the policy as he was noting the discrepancy in how that policy was enforced between the two populations. Ferguson suggests that both qualitative and quantitative examinations of the discipline gap and overrepresentation of behavioral sanctions for students of color are most acute among Black boys (2003), and are more likely to be punished with severity, even for the most minor offenses (Noguera, 2005, p. 56). Given that styles and trends in hip-hop culture are significant to these students' self-identification processes, it is inevitable that cultural antagonisms and tensions erupt between themselves and administrators who reprimand and discipline them.

Students expressed that disciplinary and social tensions they experienced with security, teachers, and administrators hindered

classroom instruction and learning. For example, Eddie remarked that in many instances they are missing out on more useful class time because most of the instructional/teaching time is spent on discipline for most of the academic year. He said that interruptions frequently occurred when security was often called upon to intervene in conflicts between teachers and students. PJ stated that disciplinary tensions are exacerbated when students attempt to speak up for themselves when they feel they are unfairly reprimanded and disciplined. This student suggests that teachers often posture an aggressive, authoritarian stance in their social interactions with urban youth when it comes to matters of discipline. PJ argues that whenever he attempts to question or challenge a teacher as to why he is being disciplined he suffers the consequence of being written up and getting a detention. He states, "when you say something, they want to write you up, and you know, give you detention" (fieldnotes, focus group session, 18/8/08). hooks and Kincheloe argue that the Black male students who are nonsubmissive, who speak their mind, tend to be labeled as the troublemakers in urban public schools (2004; 2007). In addition, Kincheloe states "Researchers have found that urban teachers devote an inordinate amount of time attempting to restrain and manage the energy and bodies of Black male students. In this context, we observe males students of color castigated for their speech patterns, gestures, eye contact or lack of eye contact, dress, and non-verbal interactions" (2007, p. 13). Subsequently, it was of the student's view that public school officials spend an inordinate amount of time disciplining them, rather than creating a culture where effective teaching and learning take place.

Reggie, a youth advocate and director of the center, states that schools often do not readily acknowledge circumstances where they have been negligent in the labeling and treatment of Black male youth. Based on his experiences with urban schools and African American youth, he says that students are too easily castigated, blamed, and written off in classrooms. He also states that African American male youth are too frequently seen as the problems, and in consequence, disciplinary measures are taken to remove them from the classroom to supposedly reestablish civility and order. "And so there approach becomes, get the hard ones out of the way so we can

deal with these others" (personal communication, 9/12/08). Noguera states, "Consistent with the way we approach crime in society, the assumption is that safety and order can be achieved by removing 'bad' individuals and keeping them away from others who are presumed to be 'good' and law abiding" (2008, p. 114). He asserts that schools look out for their own self-interests rather than the needs of the students, and use the "bad apple" example to justify removing urban youth from the classroom. The argument is that if we remove the "bad apple" we will be able to teach the others and have a controlled environment for classroom instruction and learning. Noguera further argues that research has shown that attempts to maintain order through the removal of a few difficult students is a misguided premise when instituting disciplinary policy (2008).

Framing urban youth in public conversation *as* deviant, inherently dangerous, social problems relieves *public* institutions, which are to be *in service to youth*, of their moral and civic responsibility in developing transformative structures of hope and possibility to meet the needs of these students. When urban youth are framed as the public enemy in popular culture, the infractions, "offenses," and social tensions with urban youth in schools and the larger society are seen as no one's fault or blame but the students themselves. Their confrontations with legal authority and tensions with teachers, principals, and other educational administrators are often seen as evidence of obstinate, crime-prone activity of these youth. The readings of inscriptions that we have given to urban youth in society are an unfair proposition in that we have not given them a chance to act and be, as all other children. As the students suggest, society has already marked them as trouble, making it difficult to rewrite the script. Their clothes, stylized in hip-hop fashion, came with a fixed set and custody of meanings that associated them with violence, drug dealing, killers, and other racial signifiers of criminality written through the discursive inscriptions of their apparel. Ronald Jackson uses the terminology of inscription to indicate the ways in which the Black male body has been "written on" as a canvas in historical and present-day contexts (2006). The idea of inscription is related to the multiplicity of socially constructed pejorative labels and signifying practices that have come to be associated with the subjectivity of Black male identity. He is clear

that because inscriptions on the Black body have been socially constructed, there is the possibility for rewriting these inscriptions. The implication here is that we can also think about scripting as an emancipatory act. However, before rewriting these inscriptions, Jackson states that one must go through the process of understanding and critically problematizing where pathological discourses related to Black male identity came from. This is what we have attempted to do in this section. However, I now turn toward the political act of critical media literacy as a pedagogical strategy to rewrite inscriptions that have narrowly characterized the identity of urban youth as the public enemy in society.

Critical Discussion: Toward a Critical Media Literacy of Urban Youth Identity Formation

The cultural tensions of how images and discourses of the Black male as public enemy have been produced and circulated in popular culture, and how youth respond to them, have contributed to students' struggles and educational experiences in urban public schools. Sometimes these issues play out when students are written up and sent to the office in a disproportionate manner than other populations. At other times, suspension and expulsion policies are enforced with the intention of removing "troubled students" and neglecting a set of issues that could be handled inside schools walls. Many of these conflicts and tensions occur through labeling practices of schools that cast these youth in a negative light. Subsequently, urban public schools tend to enforce zero tolerance policies on Black male youth for minor "offenses" that socially alienate them from their education and schooling process. These practices reflect the ways in which these students are treated as the public enemy in schools. The images of Black males that we read and consume in the world of popular culture (e.g., television, movies, magazines, film, newspapers, video, radio, music) subconsciously or consciously play a significant role in how society views this population in schools, classrooms, and urban neighborhood communities.

Reading the production and response of the Black male as the public enemy in popular culture necessitates a critical, intersectional

lens across and between the cultural dimensions of race, class, and gender in urban youth identity formation. Each of these constitutive elements of power in the social structure is understood in relation to the other dimensions. For example, we don't usually hear of anxieties and fears of white males and females who walk the streets of "America's urban inner cities," bringing the threat of crime and violence. Keep in mind, whites also represent a significant segment of the population in lower socioeconomic, urban communities. Yet, this is not the perception in popular culture in news media and film. The public hears of efforts to ramp up policing of these areas to rid urban neighborhoods of "thugs" and "gangbangers." In the commonsense discourse, these are primarily racialized, masculine stereotypes that target Black male youth. It becomes a class-oriented politics because the public normalizes criminal activity amongst these youth in poverty-stricken neighborhoods, rather than predominantly white suburban, affluent neighborhoods. While the vulnerabilities to criminal activity can happen across all races and gender groups in low socioeconomic status neighborhoods, the representation of this activity in popular culture is frequently assumed to be African American male youth. The cultural dimensions across and between race, class, and gender have important implications in understanding the social interactions, attitudes, and perceptions between Black male youth and public school officials.

It is of no surprise that urban African American male youth respond in ways that recognize how they are both viewed and treated as the public enemy in society. Most critical social theories of oppression/marginalization have said, in one way or another, that disadvantaged groups often internalize, to their detriment, what has been projected about them. This is one of the material effects of institutionalized domination toward subordinate groups who have been maltreated. Ronald Jackson references Mark McPhail's notion of complicity theory to state that members of oppressed groups, such as urban Black male youth, are inevitably complicit in re-representing the images in the media that have been told about them (2006, 1994, 1996). They are already posturing, in a variety of ways, against a system they don't trust. As history has shown, they have ample, empirical evidence to be distrustful of a nation that systematically sets

out to distort, disrupt, and dismantle their image and identity as human beings and citizens. In addition, media outlets, such as BET and VH1, and some hip-hop artists themselves, circulate and produce these images in ways that sensationalize and reinforce long-held, existing, anxieties and fears of Black male youth in the dominant culture of mainstream society. Urban youth who participate as fans and consume market-driven discourses in hip-hop frequently celebrate such forms of hegemonic masculinity. In the public consciousness of mainstream society, perception in popular culture becomes reality to an uninformed public that is void of the authentic experiences of urban youth culture of the hip-hop generation. The complicity of these re-presentations by urban Black male youth often serves as a defense mechanism to regain their own sense of control over their own identities. However, the rearticulation or reappropriation of these identities often reproduces a particular brand of hegemonic masculinity that is consequently detrimental and self-destructive to their own cultural processes of healthy identity formation (Collins, 2004). They have publicly consented to and learned a set of values associated with male dominance, measured and articulated by the political and economic white male power structure. bell hooks and Patricia Hill Collins both argue that discourses around hegemonic, Black masculinity, now produced, circulated, and represented in popular culture, are socially constructed in relationship to white supremacist capitalist patriarchy. In this regard, some Black males have been defining and constructing notions of Black manhood in response and relationship to patriarchal ideals that complicate alternative visions of a progressive sense of "maleness" for this particular community (hooks, 1992). That is, some youth have come to define what it means to be Black and male through the performance of strength through aggression, hostility, anger, and violence; the disparaging treatment of women and GLBT communities; an obsessive quest for economic capital; and the pursuit of respect in the streets to obtain status amongst their peers. These values are dependent on constructing notions of what it means to be a "real man" in relation to what it means to be a female or what is seen as an effeminate male in homosexual communities (Collins, 2004).

Mainstream, American popular culture set the tone for which hegemonic masculinity would be celebrated and embraced amongst the common public. It is an ideology where might makes right in defense of national security, where women are seen as subordinate to men in authority and leadership, and where money is the object of power. The characteristic traits of compassion and empathy are regarded as being soft and feminine, whereas machismo identity of manhood is constructed as being emotionless and hard (Collins, 2004). In aspiring to these supposed ideals in the hierarchy of manhood, many urban male youth take these values to their own subordinate social locations of marginalization, where their access to forms of power legitimatized by the larger, white male dominant culture has been denied (Collins, 2004). Some urban youths' celebration of these values, associated with hegemonic masculinity in popular culture, is but a reflection of socially accepted norms produced in the larger dominant culture. Patriarchal forms of masculinity have been integral to the very DNA and foundation of U.S. social, political, racial, and gendered contexts. The hegemonic contradiction in the consumption of these values by urban youth in dominant-subordinate power relations merely reinscribes societal projections of their identity as the public enemy in popular culture.

The students in my study are not passive victims, unaware of, or having no control of their actions and consequences in society. They are conscious subjects or actors who have agency in society. The majority of African American males are productive members of society, who resist and transcend the labels that attempt to name and mark their lives. Yet, this is not the view we see in the media. The students in my study possess a critical consciousness and work hard to reconfigure their lives in ways that challenge and resist stereotypes that have circulated in their communities. According to the director of the center, they mobilize hip-hop culture in a way that challenges dominant narratives that come to be associated with the aberration of "Blackness" and the ghetto in dominant mainstream media portrayals. In addition, they confront the language and discourse of gangsta rap that reproduces the cycle of hegemonic masculinity discussed earlier. They decode market-driven messages of the hip-hop industry, through critical analysis of films and lyrics of artists, that celebrate

violence, materialism, and other markers of machismo identity that have become a quasi rite of passage to manhood. The students are also instructed to create and perform their own lyrics in ways that make violence less of an option to solve one's problems. Doing this kind of cultural work is part of a larger political project in the transformation of their consciousness in a dominant, popular culture world that commodifies and exploits their identities in relationship to the vulnerabilities of urban life. It is this kind of critical pedagogy that confronts the power, culture, and hidden ideologies in mass media that attempt to work on the psyche and identity of urban youth.

Given the bombardment of messages urban youth are confronted with in the media, it becomes important for teachers and administrators in urban schools to work alongside this effort. Freire reminds us that we must be vigilant in understanding the power and effects of the media (1998). He states that we must possess a critical consciousness about what's being communicated, distorted, or excluded about particular groups in the media (Freire, 1998). We cannot merely accept the narratives, stories, and visual representations that are given to us within the dominant ideology of popular culture. There must be a critical questioning and awareness about whose interests are being served in the projection of certain images. Who is being harmed or hurt by these images? How do these images impact the role of power, culture, and ideology in the social structure of society, and schools in particular? As Freire argues,

> it is impossible to bring up the question of television without also bringing up the question of critical consciousness. Because to bring up this question or the question of the media in general is to bring up the question of communication and its intrinsic lack of neutrality. In truth, all communication is the communication of something either implicitly or explicitly for or against something or someone, even when there is no clear reference to them. In this sense, we see how the role of ideology plays its part, covering over or distorting facts and situations and masking the ideological nature of communication itself. (1998, p. 124)

The production of images of urban youth in media, and popular culture more broadly, has been anything but a neutral enterprise. The

consolidation of major television networks and radio has narrowed the pedagogical opportunities for diverse representations in the media. Images of African American male youth in daily television are still reduced to rappers, entertainers, and athletes. In recent years, the NAACP and civil rights leaders such as Jesse Jackson have critiqued and challenged major networks for their lack of minority representation in the media. For example, national networks such as CNN, MSNBC, and Fox News have yet to hire an African American as a lead anchor for any of their evening programming. In *Who Killed Black Radio News?*, Glen Ford suggests, with respect to radio, the neoliberal, market-driven consolidation and deregulation of media have shut off the voices and perspectives of local Black radio journalism in urban communities. He argues there is no single, full-time reporter of Black news in cities with major markets such as Detroit, Chicago, Atlanta, Baltimore-D.C., Houston, or Philadelphia, where Black audiences are estimated at more than one million; New York, in a similar predicament, has twice that number (Ford, 2003, para 1). This means that we not only have a distortion in the production and representation of diverse images in media, but voices about the identity and experiences of persons of color from persons of color are being silenced.

The invisibility of what's absent in media says something about the culture and ideology of dominant, mainstream popular culture. It celebrates whiteness as the norm and Blackness as strange, dangerous, uncivil, and abnormal. The distortion and misrepresentation of signs, symbols, images, and texts of the African American male, seen by millions of viewers in popular culture, create the conditions upon which he is already read as the public enemy in the social imaginary of American society. The ideological and cultural production of these images impacts urban youths' own self-identification processes in relationship to many authority figures, who, consciously or subconsciously, deal with them in a way that is reflective of society's narrow representation of them.

Teachers and administrators in urban public schools often possess a misguided fear about urban Black male youth because they don't know the lives, experiences, and communities of the students they teach (Noguera, 2008, p. 42). This does not mean that teachers and administrators don't care. Most public school officials enter the field

with the best of intentions because they do care about the lives of students they teach. However, the lack of knowledge in how to read culture, and the racial, gendered, social, and economic contexts that shape it, presents a challenge that can create a socially alienating environment in urban schools. In some ways, this is a reflection of urban school districts who struggle to find ways of recruiting and attracting African American teachers who could assist in these matters. For example, the U.S. Department of Education recently posted statistics that reveal only 2 percent of our nation's teachers are African American males. In states such as Ohio, where this study was conducted, approximately 93 percent of the teachers are white overall, and 74 percent of these teachers are white females (Ohio Department of Education, 2007–2008 data). I highlight these demographics not to suggest that white teachers can't teach African American males in urban schools. I reject such forms of absolutism. (However, closing the gap in the disparity of hiring practices between the two populations is essential to the overall project of building a more culturally sensitive environment for urban youth in schools. This is a topic that warrants further discussion, but I digress here for the purposes of this chapter.) Rather, this disparity speaks to the urgent need of alternative, pedagogical and curricular strategies in teacher preparation programs, and educational leadership programs more broadly, that will educate school officials in how to read culture, critically. This means taking seriously the cultural work of critical media literacy.

Critical media literacy must become a core component of educational leadership programs. The technical rationalization of standardized testing cannot solve attitudes and dispositions of school officials that are informed by misinformation and misrepresentation in the communication practices of popular culture. Critical media literacy involves examining, critiquing, and transforming power relations, cultural politics, and ideologies that circulate in the production of discourses in popular culture. As shown above, the media, in their regulation, production, and dominance of representations and meanings, teach us on an everyday basis, in some ways, more than parents and schools (King, 2007). Therefore, how we demystify the contradictions and distortions media teach, if you will, becomes an important pedagogical project of transformative action for critical media literacy.

In "Reading Race, Reading Power," C. Richard King outlines four cultural processes of antiracist pedagogy in critical media literacy that are instructive to educators, scholars, and researchers in the field of education (2007). This method involves a pedagogical understanding of the interrelatedness between signification, race, and power in media (King, 2007). The author suggests that we must understand the following: How to interpret and read the racialization of racial identity; connect methods of critical media literacy in relation to the political consequences of white supremacy in the social system; recognize how comparisons in norms of performativity, pleasure, desire, corporeality, and privilege are racialized differently and enacted between different groups in relation to a white media world; and question the conditions upon which knowledge, values, and identities are produced and appropriated within the hierarchy of a racialized world (King, 2007, p. 203). The cultural work of doing critical media literacy means having educators ask critical questions about the social, historical, economic, racialized, and gendered contexts that shape the production of a sign's or symbol's textual meaning. Who is authoring the production of a discourse, image, or text? How might the subjectivity or agency of urban youth be affected by the cultural production? In what ways do students and teachers reading and consuming these texts reproduce certain forms of social inequality between dominant and subordinate populations in society? How might we rewrite discourses that impact teachers, students, and administrators in more empowering ways? The politics of such pedagogy creates the conditions and possibilities for which a critical consciousness can be developed in ways that might lessen conflict between students, teachers, and urban school officials in the nation's classrooms. Maybe students will not be seen as the public enemy, but as valued citizens in a democratic society who possess an authority and voice in how they will be represented. In this way, the attempt to transform and change the racial optics of culture is a pedagogical project of social justice in urban education.

Chapter 4
"They Got Me Trapped"

In order to get students to critically think about issues of power and agency in relationship to Black urban struggle, I had the students look at the video of and lyrics to Tupac's song "Trapped" on the 1991 album *2Pacalypse Now*. I also had the students look at an image of Tupac in a straight jacket in *Vibe*'s 1998 book *Tupac Shakur* (Light, 1998). I selected these particular texts because they politically represented visual and linguistic ways in which Tupac articulated and embodied urban Black male youths' lived experiences with oppression and inequality. Shakur's visual and linguistic representations in film and music in socially and politically conscious hip-hop have a way of communicating and giving meaning to a set of circumstances that provoke emotion, unsettle our consciousness, and jolt our sensibilities in the way of those who have been oppressed. Referencing Leila Steinberg (Tupac's former manager), Dyson has claimed, "Tupac's poetry and life can be a means to the critical self-reflection that Tupac believed should be taught in the nation's classrooms" (Dyson, 2001, p. 93). Steinberg states that Tupac felt art could be included in school curricula "to help youth address some of the issues that they were experiencing in their lives. By combining art with education, Tupac felt we could begin to heal society's pain and confusion" (Shakur, 1999, p. 93). Steinberg hopes that Tupac's poetry will "encourage people to take the first steps necessary to see his literary importance, as well as have us acknowledge the life struggles of young Black men" (Shakur, 1999, p. xxi). I selected socially and politically conscious discourses of Tupac Shakur as part of cultural relevant curricula and pedagogies that are relational to the *voices of urban youth*. These discourses are reflective of their experiences and center their voices in ways that allow them to speak about their own circumstances that traditional school curricula have neglected to value in the discourse of democracy. Subsequently, the role of critical discourses is to first give critical awareness to the material contexts of

oppression and social critique of asymmetrical relations of power. In making visible these conditions of social and political inequality we have a better understanding of how to politically transform these conditions in society. It is then upon critical reflection of the inequality of these experiences that a resolution between the technical practices of institutions and urban youth affected by them, as well as future transformation of these realities, can take shape. This is crucial for those of us who center social justice at the axis of inquiry of our epistemologies in critical youth research. Subsequently, the image, lyrics, and video of Tupac grounded us in a discussion of what it means to be free versus what it means to be trapped within dominant-subordinate relations of power in urban society.

In the beginning, it was very difficult, at times, for me to engage students in deep discussion and critical reflection about how they view, see, and experience education and public schooling as Black males in urban contexts. This was evident when one of the students bluntly stated to me, "I hate school. I thought I told you I don't want to talk about school." I had to take a moment of critical reflection about their initial anger, silence, and agitation in speaking about the subject of education and school. It was at this moment that I reminded myself that in a neoliberal culture, students are used to being told what to do, blamed for the shortcomings of their circumstances, and generally, are not seen as having authority and knowledge to speak to and critique conditions that affect their everyday lived realities. This is part of a larger challenge in educational leadership where we seldom speak to young people themselves and ask them what they think about their education and schooling experiences in urban communities. Therefore, asking them about their experiences in urban public schools, and positioning them as subjects who have authority and power to speak and critique institutional problems and challenges they see in schools, was a new idea for them. However, as we progressed through these conversations, their silence or uneasiness in speaking about education and schooling eventually revealed and confirmed a very important theme in my research. That is, the neoliberal culture of urban education and public schooling have created a set of alienating conditions that consequently displace and push out urban youth in the process. Many students expressed that they don't

want to be there; they have to confront complex challenges outside schools that impact how they view their educational experiences inside schools; and the neoliberal politics of standardized testing all collude into what they term as a trap for Black male youth. As stated earlier, this term emerged out of a conversation we had on Tupac's song "Trapped" to designate how they feel confined and displaced in a public education and schooling system of unequal power relations that disenfranchises them. In addition, in an economic recession, finding stable employment tremendously impacted urban youths' negotiations of life futures between schools and the streets.

What is evident through our conversations is that students possess their own language of critique of education and schools. Listening to the voices of urban youth does not mean that we blindly accept what they say as gospel truth. However, the ideals and practices of shaping a democratic society suggest that we take seriously their voices, narratives, and experiences in urban education and the larger society. We take into account how their critical language of the street tells us something about how they are resisting the dominant culture of education, schooling, and the larger society. We listen to their experiences of disappointment, rejection, pain, anger, and uncertainty about their future in a society that has stacked the deck against them. I highlight their prophetic voices of truth telling, or what Cornel West calls frank speech, to cut through the contradictions and distortions of the nation-state, whose rhetoric gives lip service to claims of equality. Their voices, perspectives, narratives, and experiences are given value and legitimacy within the overall, unfinished, project of democracy. I center their voices as part of the agenda of social justice in urban education. It is within this context where we value how students understand the notion of being trapped within the larger urban struggles of the inner city. In critical dialogue, the cultural movement of standardized testing in urban school reform has political consequences in which, as one student suggested, they don't feel free. They feel it has trapped their options and choices for socioeconomic mobility for those who don't test well, which doesn't necessarily determine other forms of sociocognitive ability they do possess in knowledge acquisition. They do not blindly accept the idea that education is a free market, neutral enterprise of fairness and meritocracy as neolib-

eral discourses would have us believe. They critique the construction of knowledge itself, emergent from the idea of objectivity and rationality that limits more progressive ideas in the possibilities of what education could and should be. In addition, they also discussed their experiences and perspectives on education and schooling in relationship to larger social, political, and economic instability of finding stable employment. This tremendously impacted their negotiation of life futures between schools and the streets. These conditions also attracted what Dyson calls juvenocracy—the rule, regulation, and competition over urban territory amongst youth and young adults in the streets. When outside the grounds of school, some students suggest a great deal of street knowledge is required to understand the landscape and trap of outlaw, gang activity. Alternatively, students felt the street knowledge they possess and bring from the streets is not valued within the cultural context of schools. It was through the analysis of Tupac's hip-hop texts on being trapped that all of these factors emerged and characterized the students' overall sense of displacement, confinement, and alienation in their education and schooling experiences.

This chapter represents the impact of neoliberal reforms on urban youth in their communities. It demonstrates a set of pedagogical conditions in urban contexts that obstruct democratic individuality, community, and society. It represents a set of conditions that stifle imaginative creativity between teachers and students in urban schools. Finally, this chapter suggests that urban youth are very aware of what society attempts to conceal—that America's schools and the conditions upon which each school is situated are anything but equal. They speak prophetically, boldly, and courageously about why many children in urban schools are being "left behind." I now turn toward youths' critical readings of Tupac as a hip-hop text.

Urban Youth Claim a Street Language of Critique

As we read through and made sense of Tupac's different texts, I had the students select phrases that they thought signified what it meant to be trapped. While we looked at the video of "Trapped," the students and I looked at the words of Tupac's lyrics that were printed

from the Original Hip-Hop Lyrics Archive website. However, we must look at the nature of discourse production of the term "trapped" within the wider sociocultural practice within which this discourse occurs. That is, Tupac often critically spoke as a social activist whose lived experience emerges from the structural concrete realities of poverty, homelessness, social dislocation of the ghetto, and incarceration, among other wider social arrangements of systemic rejection. These circumstances produced a certain affect of disappointment in the Black community. The signification of the word "trapped" highlights and reconstructs issues of power and sociocultural relations between urban Black male youth and inequitable material practices of institutions. Tupac also used the term "trapped" to capture a sense of confinement of a community that is being cut off from the cultural and political terrain of urban space. These urban spaces are marked by extraordinary levels of hyper-policing, repression, and punishment of Black males. It is important to situate the meaning and production of the term "trapped" in relationship to institutional, systemic rejection. So often wider publics in the reading of urban life pathologize and disassociate Black children from the larger societal arrangements of institutional discrimination and social fragmentation they have inherited and encumber. This tremendously impacts their outlook on the world. For example, in the song "Trapped" Tupac employs the term as a metaphorical and symbolic expression that represents the confining circumstances of the ghetto in the Black community. Subsequently, the streets of the urban ghetto is not viewed as a space and place where urban youth want to be. Tupac's symbolic representation and geographical location of the ghetto is seen as a kind of prison, upon which the choices, decisions, options, and daily urban struggles of survival amongst the Black community are repressive to one's state of being. Subsequently, the signifier and geographical location of the ghetto is not celebrated, but is symbolically and metaphorically referenced as a trap in which urban youth are seeking to escape. In the midst of being "trapped" in the ghetto, Tupac speaks about frequent social tensions, regarding police brutality on African American males in urban Black ghettos. In addition, he states, "Too many brothers daily headin' for the big penn/[Brothas] comin' out worse off than when they went in..." (Shakur, 1991). This phrase alludes to

the disproportionate incarceration rate of African American males; however it also suggests the criminal justice system, supposedly an institution of "correction" and rehabilitation, has been more punitive than ameliorative of social ills confronting African American males in destitute circumstances. Subsequently, Tupac saw the predicament of urban youth being trapped in the ghetto as a contradiction to America's claims about equality, democracy, and social justice. This is why he states in the second verse, "Why did ya lie to me?/I couldn't find a trace of equality..." (Shakur, 1991) and repeats over and over in the chorus "Naw, they can't keep a Black man down" (Shakur, 1991) . As demonstrated in this text, a larger segment of Tupac's social and political work aimed to expose how Black communities are struggling and coping with tragic circumstances within wider institutional and socioeconomic constraints in an effort to wake up the compassionate sensibilities of American society to take social, political, and transformative action. In this regard, I wanted the students at the youth center to read Tupac's narrative about being trapped in relation to raising critical consciousness about their own experiences in urban society. In reading the critical discourses of Tupac, I wanted urban youth to open up their own dialogue in how they critiqued injustice in their own communities as we collectively thought about the larger project of social justice.

Some of the most common phrases selected by the group came out of the first verse. Phrases such as "trapped in this prison of seclusion," "living on the streets is a delusion," "too many brothers daily heading for the big penn," "there must be another route, way out," "trapped in this vicious cycle," "if one more cop harasses me," and the chorus, "they got me trapped," "they can't keep the black man down" were all common texts coded by the students. I then wanted the students to come up with their own definitions of what it meant to be trapped as they thought about the visual photo of Tupac in the straight jacket as a literal and metaphorical image of being trapped in relationship to the lyrics to the song that we had just read. They came up with words such as restricted, have boundaries, punished, stuck, locked up, contained, cornered, imprisoned, and can't go anywhere. They clearly grasped the idea that movement in the public sphere was being inhibited in some way, and that confinement or being trapped was an

oppressive state of being. While we looked at different phrases of Tupac's lyrics, how they constructed the broader political implications of trapped by their own definitions, and related them to their own experiences with schools in relationship to larger urban contexts, proved to be a powerful commentary. In what follows in this particular discussion, their experiences with education and schooling became the urban space that signified what it meant for them to be trapped. This session gave them an opportunity to give social critique to institutional structures of domination at work in their lives between schools and the streets, to have some awareness and context of how to transform these conditions in more liberatory ways. Tony understood quite well the ways in which being trapped is organized within dominant-subordinate relations of power. He states, "When somebody ain't trapped they got a lot of power, but when you trapped you ain't got no power at all" (fieldnotes, focus group session, 11/12/08). Tony further suggests that being trapped or not being trapped is understood in relation to the power and freedom on has or does not have to determine his/her destiny. He then states that being trapped does not grant one access to equality. Tony set the general framework for our discussion as we talked about power in relationship to the ways in which urban Black male youth felt confined, controlled, repressed, regulated, or "trapped" in their communities. For example, Marquis and Corey discuss their interpretation of what Tupac meant by being trapped. They suggest that Tupac used the word "trapped" as a metaphor or metonymy to describe concrete realities of the imprisonment and incarceration of Black male youth. For example, Marquis states that Tupac's reiteration of being trapped signified that "most of us incarcerated...Most of Black men are in jail...for petty crimes period...that's what he is sayin" (fieldnotes, focus group session, 11/12/08). Corey affirms Marquis's statement, and speaks about the pitfalls of incarceration, gun violence, and street hustling for African American males. These students are speaking to the disproportionate incarceration rate of Black males in the prison industrial complex that has been an alarming issue for some time now, especially for juveniles (Apple, 1996). Both articulated that Tupac was speaking to these larger issues. Corey then mentioned tragic circumstances related to violence, of which Black on Black

homicide is also a vulnerability; he also spoke to the illicit under-ground street market of drug activity. However, it's interesting that he makes the switch between explaining these circumstances and not forgetting that some Blacks also pursue an education, and are moti-vated to "getting money the legal way." It was almost as if Corey was saying that school is an option, but that few residents from poor urban areas perceive it as an economically viable option. To place the realities of incarceration of Black males in proper social, political, economic, and racialized contexts:

> Blacks are more than five times more likely than whites to be in the custody of correctional authorities, and black men are nearly eight times as likely as white men to be murdered or killed by law en-forcement officers. Based on these numbers, it is clear that the United States seems to have decided to deal with poverty by jailing or al-lowing to die a large percentage of people of color, many whose crimes and needs are directly related to the economic and housing conditions and the patterns of racial segregation they experience. This has had a dramatic impact on family structure and on the sense of a future among black youth. (Apple, 1996, p. 79)

Subsequently, the idea and experience of being trapped in relation to the disproportionate incarceration of African American males have to be situated in race, class, and gendered contexts. Students' narra-tives attempted to reflect the cultural dimensions of these contexts.

Marquis then suggested that Tupac did not speak about incarcera-tion as the final destination in life. He argued Tupac was speaking about the ugly conditions of violence, incarceration, and other urban struggles on the streets because he wanted young people to do more with their lives. Marquis asserts that Tupac used his tragedies, strug-gles, and sacrifices of his own life narrative in his music as life lessons to teach youth they don't have to go through these same obstacles. In addition, Marquis suggest that Tupac felt he was trapped by his own life circumstances that prevented him from accomplishing certain goals, such as going to school. Subsequently, Marquis argues the message and meaning of his life was to expose the vulnerabilities of the streets to encourage Black youth to get an education and pursue their chosen career. Marquis states, "he want the black youth as

young men and young women out here to do more....Get education" (fieldnotes, focus group session, 11/12/08). While life circumstances may prevent all youth from attending college, Marquis offered that Tupac would counter and say "at least finish high school. Do something with your life. Get a job. Don't be out here in these streets" (fieldnotes, focus group session, 11/12/08). This student's interpretation suggested that Tupac provided a critical consciousness for self-determination in urban youth about what our responsibilities as a Black community should be in transforming the material affects of social inequality in urban America. In the context of Marquis's comments, it should be noted that Tupac often mentioned in various conversations that the ugly, dirty, and graphic realities of the ghetto that he depicted in his music was to serve the purpose of promoting social change in his community so that someone might, in his words, "clean it up."

In the midst of our focus group discussions the students also told me, in different ways, why they don't like school. When PJ stated he didn't like school he followed the response with a rhetorical question, asking me for permission to see if he could be honest with me about the fact that he didn't like school. His questioning for permission was a subtle gesture that implied an initial reticence to share his disgruntlement with his experiences in public education, particularly with someone like me who was seen as an authority figure in education. Meanwhile, Aaron said he anxiously anticipated upon the day when his high school days will be over. He was more excited about being out of the environment of school then what he is currently learning while in school. Rasheed interjected into the conversation and stated, "Man, you know how boring school is?" (fieldnotes, focus group session, 11/12/08). Imani Perry states that for urban Black male youth, "Currently the school is a space where youth yearn for affiliation, but seldom find it a responsive environment" (2008, p. 173). Perry further argues that schools have not been spaces that have been emotionally responsive for many Black male youth who long for an emotional connection (2008, p. 173). In addition, many students who are marked and marginalized by the demographic intersections between race, class, gender, and other socially constructed markers of identity "often view schools as oppressive sites, and they respond by

dropping out of them both explicitly and implicitly in myriad ways" (Carlson & Dimitriadis, 2003, p. 30; Fine, 1991; Weis, 1985, 1990). For example, Demetrius states that when students drop out of school it often has nothing to do with their intellectual ability to perform well academically at school. He says there are a variety of reasons, such as dealing with pressures at home and with teachers and students at school, which creates a set of stressful conditions in which students drop out. Demetrius states, "Like, you just drop out because school is too much, for real, for some people" (personal communication, 12/12/08). In addition, PJ states that schools don't affirm the knowledge he has learned from the streets, which is knowledge he knows is not validated or valued within the standardized curriculum and pedagogy of urban public schools. He states, "I don't like school, and school ain't never been my thang. I'm not school smart but I'm street smart" (fieldnotes, focus group session, 11/12/08). Consequently, PJ said he'd rather be doing something else than be in school. It is not so much that he doesn't see himself as intelligent and having the cognitive abilities to process knowledge. After all, his "education and schooling" experience on the streets has taught him a lot. PJ's street smarts required him to have understanding of the underground street market economy, to know how to navigate competing tensions amongst rival crews for the control of urban territory, to hustle to make ends meet through devastating poverty, and to avoid the cycle of gang violence and incarceration that has confronted his own family. Elijah Anderson would characterize and describe PJ's street smarts as being street wise. This is a particular knowledge of the street that requires navigating complex, sophisticated, and potentially dangerous social interactions within public spaces of the street that has been acquired over the lifespan of one's time spent in the street. For example, PJ explains what is learned on the streets in response to Tupac's song "Trapped." He uses Tupac's phrase "trapped" to talk about how urban youth have to make decisions to navigate around certain "traps" of the streets that can have life and death consequences. For instance, when PJ talks about the trap of gang activity he says the lifestyle is a trap because "If you try to get out that gang, they gone kill you..." (fieldnotes, focus group session, 11/12/08). While you are in the gang he says there are rules you must abide by, but one

is still trapped. In this context, PJ says that one is not free because when you enter the gang you must follow a set of rules, and the consequences for not staying in a gang once you have committed to it could be fatal. The rules and regulations of gang life demand what Anderson calls a street orientation, which contrasts with "traditional mainstream values" of "decency and civility" that must be followed in organized gang activity. However, PJ also states that even those who don't participate in gangs have to follow the rules and regulations of the street in their own communities and neighborhoods. He maintains that if one is not in a gang he still is not free to move into certain neighborhoods and communities. Subsequently, in his neighborhood there are certain corners, blocks, or streets that are affiliated with certain gangs that have a reputation and street credibility that are not to be challenged. In addition, one's material possessions must be guarded as they are often seen as commodities within these territories. Subsequently, PJ asserts that you are trapped and not free to walk in certain territories of the street. Out of a neoliberal culture of urban disposability, usurped and drained of economic, social, and political resources, marked by racial injustice, Dyson states that a juvenocracy arises and operates in urban homes and communities. It emerges from devastating conditions of poverty, rampant unemployment, and economic injustice. Dyson states that these conditions have fueled survivalist tactics among the vulnerable that entice their involvement in the underground "political economy" of crack, violence, and acquisition of the gun, factors that are pervasively nurtured in American culture at large. Subsequently, juvenocracy is the unlawful and illicit regulation and control of urban territory by young males (under age 25). Subsequently, PJ reiterates the point there are rules and regulations in his neighborhood that must be followed, and there are persons in the street that run these rules and regulations in these communities. "You got somebody that runs you basically. The person that runs the hood and runs everybody else that's under it" (fieldnotes, focus group session, 11/12/08). PJ states that in his neighborhood, one must learn, understand, and adhere to the system and rules of the street. If one does not learn the "unofficial" curriculum and knowledge of the street, the consequences could be fatal. This requires being aware of certain geographical locations in

relation to gang territory and street crews, forms of communication that signal disrespect, the hierarchy of who runs and controls the street, and how to navigate and avoid circumstances that could be costly to one's life.

In response to PJ's commentary I wanted to gain further insight in how youth assess power between the streets and schools. Subsequently, I posed the question of how do youth determine who has more power between the streets and schools. PJ suggest there are different forms of power between knowledge on the street versus knowledge acquired in the traditional school system. He states that the D-boy (dope dealer) commands the most respect to his peers on the street. However, the act of going to school and getting an education is not placed on the same hierarchy of knowledge for urban youth who have to decipher the code of the street for self-preservation (Watts, 2004, p. 595). According to PJ, urban youth have some sense of power and agency over their lives between schools and the streets. However, he says it depends on how they use their power or sense of agency in their lives. He uses the example of a pastor who would say he uses his spiritual power of God who communicates through him to teach people certain values in moral ways of living. However, he also states power by individuals can be used in a negative manner as well. In this context, he gives the example of the D-boy who has a reputation on the street who is not be disrespected or in PJ words, "he gone kill you." Consequently, he says this too is power. PJ states, "you can be dumb as a box of rocks and have more power than the smartest African American that go to school and get straight A's, and did something with his life. I mean that's streetwise" (fieldnotes, focus group session, 11/12/08). In the context of the streets, PJ says the D-boy has more power and respect than the individual who possesses the traditional knowledge from school. He states that in order to gain a reputation and have street credibility the D-boy has spent time either selling large quantities of drugs, settling scores against one's foes through violence, and controlling, regulating, and protecting territory in one's neighborhood. While the D-boy has earned his power and respect on the streets, PJ says he also has to watch his back between the police and his rivals on the street. According to this student, urban youth from the urban community who obtain

knowledge from school do not have the same currency or cultural capital of respect and reputation as the dope boy on the street. Watts states that "since thoroughly street-oriented youth have little in the way of parental guidance and support in the home, they come of age in accordance with the outlaw code." And, "at the heart of the code is the issue of respect" (2004, p. 595; Anderson, 1994, p. 83). The run of urban territory through violent acts of aggression against fellow street vendors garners what many call street credibility in the city. Watts further suggests that when we factor in guns, crack cocaine, and gangs, urban youths' competition and adoption of the street code for respect and manhood become volatile (2004, p. 596). Subsequently, PJ states that it is the collusion of these cultural elements in the street that gives power to and shapes the dope boy's reputation. At the same time, how the dope boy gained respect also has him trapped in a sense because it heightens the stakes for his peers who seek to take his status through the same violent conflict that gave him that status.

The unofficial knowledge and curriculum PJ has learned and experienced through difficult life circumstances on the streets are considered irrelevant and unrelational to the standardized curriculum and pedagogy practiced in schools. Kincheloe states that urban public schools often dismiss the cognitive abilities of students' "street smarts," and therefore determine that otherwise brilliant students are incapable of doing academic work (2007, p. 10). He argues that street smarts require a high level of cognitive sophistication to deal with the daily struggles of students' tough urban environments that in many cases can compete with forms of "intelligence" on standardized tests that are heavily emphasized in educational policy. However, Kincheloe suggests that we have not translated and transferred this knowledge into meaningful ways in the classroom. Subsequently, PJ understands how his street knowledge is being devalued in urban public schools, and would rather be doing something else than the "school thang" because it is of no real consequence to social change or transformation that could politically intervene and improve his everyday lived reality. In addition, it has been his street smarts, rather than schools removed from these realities, that have been crucial to his survival.

PJ used Tupac's song "Trapped" to talk about the "traps" of urban life and gang activity in relationship to schools that didn't value this knowledge. However, he also related trapped in monetary terms to the idea that pursuing one's college education is not free. For example, he was somewhat disillusioned with the idea of working hard in high school to get in college when he says monetary debt will be awaiting you. PJ states while teachers are encouraging you to get good grades to obtain scholarships for college, you may or may not perform well enough to obtain these scholarships. Consequently, he argues colleges and universities are aware there is a great chance many students will be in great debt at these institutions when "You got to work with yo' job, and you got to budget yo money to try and pay them just so you can learn somethin'. That's a trap" (fieldnotes, focus group session, 11/12/08). PJ states that unless one is hustling in the streets, many youth feel they don't have the money to attend college. Subsequently, he feels there should be more open and free access to obtain a college education. In some ways, PJ is articulating the trap of neoliberal, corporate, commodification of higher education. In *Academic Entrepreneurs: The Corporate Takeover of Higher Education* (2006a), Giroux states, "The message to students is clear: customer satisfaction is offered as a surrogate for learning and "to be a citizen is to be a consumer, and nothing more. Freedom means freedom to purchase" (p. 90). PJ interrogates the corporate structure between high schools and higher education, between the hierarchy and quantification of academic status in relationship to the lack of monetary access to obtain a higher education. Giroux asserts that higher education institutions have reduced public funding for grants that assist with higher education for low-income minority students. He also argues that democratic ideals for critical citizenship and civic participation in education have succumbed to corporate, consumption practices of private, bureaucratic control of higher education (Giroux, 2006a). The politics of corporate consumption practices in higher education institutions have created conditions that facilitate institutional structures of repression for students like PJ who live in urban communities of low socioeconomic status. For students who come from disenfranchised, urban dislocation, the value, worth, and economic viability of education are often seen as a contested subject

against the value, worth, and economic viability of the street. The legitimacy and power of competing forms of knowledge between schools and the streets are always in negotiation for students who see themselves as having limited options and choices toward socioeconomic mobility. These students see higher education as an added barrier when it gives priority to market interests that privilege what Noam Chomsky calls profit over people.

Reggie, the director of the hip-hop community center, offers an explanation as to why schools seem to be alienating spaces and places for many of the students at the center. He states that rote memorization of meaningless facts as a learning technique is too rigid and linear in pedagogical structure and style for many youth. Subsequently, he states that many students are unmotivated by these methods and frankly are bored and tune out with this kind of content and structure in traditional public education. The lack of emotional responsiveness that students exhibit is due in no small part to market-driven practices of rote learning that have become so pervasive within the neoliberal culture of standardized testing in urban schools. Such an approach uses memorization of prescribed data and facts that have no meaning to the lives and social worlds of the students. Reggie specifically references Paulo Freire's banking concept, and makes the point that kids become emotionally turned off from school because schools do not respect or value the knowledge they bring with them to school. They become detached when they are just expected to regurgitate what has been given to them by the teachers. He states the knowledge and experiences students bring with them to school are often not valued, respected, or legitimized by teachers. However, Reggie argues these same students are expected to value the knowledge and experiences the teachers possess. In this context, he states there is a one-way, top-down approach in communication and knowledge acquisition between teachers and students. Reggie argues this one-way model suggest that teachers are seen as having the only legitimate knowledge and power in the pedagogical relationship. He asserts that many urban youth, who often come from oppressed circumstances, are simply expected to receive the bits of information that has been deposited to them. In *Pedagogy of the Oppressed*, Freire (1998) talks about teachers as depositors of information who fill the

minds of students with what they want them to know. Students are the receptors of this knowledge. According to this vertical approach between teachers at the top and students at the bottom, students should not question the presumed authority of this knowledge. It is assumed that the students know nothing and that the teachers know everything. There is no critical inquiry into this process that would be liberating and transformative to the students' educational experience. In this respect, Freire would argue that banking models in education are dehumanizing to the students. Reggie then makes the case about what a more liberating education would be for students. He speaks to Freire's horizontal approach to education, where there is no longer a top-down relationship between the authority of the teacher and the students. He states that in a two-way system of learning, the student brings a culture to the classroom, which can in a sense be taught and shared with the teacher. Conversely, he states the teacher brings a culture to the classroom, which can be taught and shared with the student. In these particular pedagogical contexts, Reggie states "they have a symbiotic relationship that draws from each other, and is connected and intertwined" (personal communication, 9/12/08). Subsequently, he argues the construction and teaching of knowledge should happen between the teacher and the student, and the student and the teacher, which he says is a much more empowering and liberating approach to the students. In the horizontal formation for pedagogical relations between the teacher and the student, the teacher is no longer the sole authority over knowledge, one who is deemed as the prescriber of knowledge. According to Freire, there should be a teacher-student and student-teacher relationship where together they are mutually co-constructing knowledge as authors and teachers of their own social worlds and lived experiences that make up who they are as human beings. Unfortunately, he argues, this form of pedagogical relationship is not occurring in schools.

Banking models in education, such as standardized testing, are seen by youth as more of an obstacle than opportunity to academic success and achievement. For example, Evan related trapped to the "trap of education" in relationship to the standardized testing movement that has become prominent in neoliberal, urban school reform of public schools. When I asked the students what else makes them feel

trapped, Evan responded, "the OGT. You can't graduate out of high school without passing the OGT" (fieldnotes, focus group session, 11/12/08). This student was critically aware about the political consequences (not graduating from high school) of not passing the OGT, which in Ohio is the acronym for the state's standardized test that stands for the Ohio Graduation Test. He then discussed how knowledge and learning in schools is quantified in a way that students politically feel trapped. For example, Evan suggests that students are painfully aware they must score a four hundred on the OGT in order to pass and graduate. Subsequently, Evan notes that if a student scores three hundred and ninety-nine he has failed the test. "And to some people, they feel trapped doing that" (fieldnotes, focus group session, 11/12/08). Evan feels that standardized testing, such as the OGT, is a trap for many students because he says these tests don't account for realities that some students, such as himself, don't test well under such high stakes consequences. He says he gets nervous in taking such tests in these conditions, and often forgets a lot of what he supposed to remember when he takes such tests. Evan is critically conscious and aware of the state's mandatory standardized tests, and the devastating consequences of not graduating for those students who do not pass the test. The test effectively reproduces the cycle of urban underclass communities and hinders upward socioeconomic mobility. In addition, he understands that the neoliberal corporate culture of education and public schooling has confined and "trapped" the learning experiences of students through a technical process of quantifying learning and academic achievement. Given the enormous social and political weight of the test, it has also created and imposed a certain psychic pressure and fear. This psychic pressure and fear that Black students often experience when taking standardized tests are what Claude Steele calls stereotype threat (Perry, Steele, & Hilliard, 2003). Stereotype threat characterizes students who undergo an enormous amount of pressure and nervousness to succeed on tests when the commonsense language in the public suggests that students of color frequently fail these tests. Students conform to society's negative expectations and stereotypes about Black students not succeeding on these tests, and succumb to performing dismally on such tests. As students continually think

about the consequences if they "fail," it becomes a self-fulfilling prophecy.

Demetrius and Lamar spoke about the pressures that urban schools push for in competing against white communities to achieve higher scores on standardized tests. Demetrius states that his teachers have a common perception that predominantly, white public schools receive better resources and instruction than predominant, Black urban schools. Subsequently, this student says that his teachers engage in an aggressive push for their students to perform extremely high on standardized tests. According to Demetrius, performing well on the OGT becomes the method and means by which Black urban schools can attempt to be on par with predominant, white urban schools. He states, "Like our schools, like OGT, they want our scores to be high, like above, off the charts and stuff like that" (personal communication, 12/12/08). Haroon Kharem argues, "In non-white neighborhood schools, the push for state standards takes away from teachers real classroom instruction and curriculum development [and] has dire consequences as they focus on test prep" (2006, p. 10; Davis, 2003; Johnson, Boydon, & Pittz, 2001; McNeil & Valenzuela, 2001). Similarly, Lamar also comments on the redundancy and routine of standardized tests. This student gives a stinging moral and political critique on schools that overemphasize standardized testing, while neglecting to link education to the "real world" concerns of poverty that greatly affect urban youth and their communities. He states, "Every year they feeding us these tests, while the poverty rates keep rising. Man don't nobody care about school when you tryin' to eat" (personal communication, 12/12/08). In addition, he feels that teachers are not as focused on teaching as they are to just pick up a paycheck. Lamar then argues that many of the socioeconomic struggles students face, particularly in matters of poverty, shorten the time in which students have to dedicate themselves to school. According to Lamar, there is an implicit relationship here between tests that are irrelevant to the real-world concerns and experiences of the students, and how the test adds another burden to the series of socioeconomic obstacles he faces on an everyday basis. Implicitly, he is asking, What is testing going to do to solve the pains and struggles I have with the destitute conditions that I live in? How can I concentrate on pursuing

an education when the threat of hunger is faced daily, and finding a meal at night is not guaranteed? How are teachers using education to speak to my experiences as a way of helping me transform the realities and conditions of my circumstance? The weight of poverty that confronts many urban youth adds additional responsibilities for them and their families, which often places the cultural irrelevancy of standardized tests to a second priority in meeting the goals of their academic career. While I don't completely agree with Lamar's generalization about teachers, his statements reflect and speak to a restructuring of teaching arrangements that has minimized critical learning experiences in the classroom as teachers are pressured to succumb to state pressures of teaching to the test. In this regard, it could be said that more authentic and critical learning experiences between students and teachers are sacrificed. It is assumed that standardized testing and the technical routinization of schools are far removed from, and are of no immediate pressing consequence to, Lamar's struggles to literally survive on a day-to-day basis. It is this outside curriculum of oppression that informs Lamar's critical orientation into the contradictions and meaning of education and schooling in addressing crucial issues of poverty. Kharem argues that as performance on standardized testing has become the only method by which states measure academic achievement, schools in urban communities that don't make the cut face reductions in funding, leaving many Black communities to suffer in utter poverty (2006, p. 10). The poverty that Lamar speaks of was made real and concrete for me when I had an opportunity to speak with him when visiting his neighborhood. Visible markers of dilapidated housing, boarded up houses and businesses, vacant gas stations no longer in service, and broken-down jalopies on the side of the street signified the material ruin of the community in which he lives. These observations also revealed the empirical evidence of socioeconomic disenfranchisement and urban displacement he confronts on an everyday basis.

In addition, many students from low socioeconomic backgrounds are juggling multiple responsibilities in their everyday lives that teenage youth in circumstances of privilege don't have to be concerned about. For example, the allocation of time and monetary ways to pay the rent or other bills are just two of the pressures and respon-

sibilities that youth of economic hardship have to face on a day-to-day basis. As the students continued to discuss the difficulties and challenges with education being a trap in their lives, the relationship between work, school, and economic survival emerged as a daily struggle for them. For example, Evan and PJ suggest that access to material resources is hard to come by in a society in which you are not free. Evan states, "You're not free here...livin' in this world right now..." (fieldnotes, focus group session, 11/12/08). In this context, the idea of being free or trapped was frequently seen in relation to the weight and responsibilities of finding work to maintain socioeconomic stability for their families. This is perhaps why Evan stated one is not free in this world because he says in order to make it in U.S. society one must hustle on the street or find menial work in getting a job. PJ affirmed these sentiments, stating that you have to struggle for everything to make it in this society. He also defined this struggle between hustling in the street or being educated enough to find work. PJ argues, "You got to be educated, or if you don't have that, you can be a street hustler" (fieldnotes, focus group session, 11/12/08). He gives the example that in order to have a mansion one must be educated, and if one is not educated then one's option is to hustle to get "that mansion." In either case, PJ insist that it's not going to be easy in gaining access to capital to get "that mansion." There is an implicit assumption made here between the struggles one must go through to get an education in relationship to enormous improbability of most average Americans ever obtaining a mansion, which appears to be a figurative, symbol for PJ that one has "made it." If one does not possess an education, then the students suggest that alternative options are to hustle through the illicit underground economy of the street. In this way, PJ speaks to the idea that "it's not going to be a walk in the park" between hustling on the street versus obtaining an education. The idea of finding work for these youth was a struggle; when they did find work it was just enough to make a small financial contribution toward economic responsibilities in their families. They feel trapped within a set of narrow choices that still seem to be confining to and limiting for the possibilities of what they are able to obtain, or who they can become in the future. The widened gulf between upper elite and the urban underclass has created no gray

area of economic sustainability in an era of globalization. In today's global economy, the availability of jobs in urban communities has increasingly become vacant, or the jobs that are available pay lower wages than some decades ago. Given that the information age has replaced service sector employment, and the standardization movement in neoliberal urban school reform has increasingly stratified hierarchies between high-status and low-status jobs, economically viable and stable employment is hard to come by for many urban Black working-class communities. Subsequently, many urban Black male youth perceive their narrowing options between hustling through the informal economy of the street versus the protracted struggle of pursuing education that is increasingly contracting their life futures for socioeconomic mobility (Anderson, 2008). In this way, students feel trapped, or not free between these two options.

William Wilson, James Quane, and Bruce Rankin argue that urban ghetto communities with high poverty and joblessness have critical implications to social organization and life chances of residents who occupy these neighborhoods (1998). For example, as it relates to the economic choices and options between school versus the street, Marquis is very open about his own internal struggles between poverty and illicit street activity. He said that he and his peers often contemplate between staying on the right path by obtaining their education or engaging in unlawful activities in the street to make money to survive. According to Marquis, the negotiation and contemplation of their perceived options and choices is a reflection of economically, hard times they are going through in their lives. Subsequently, when he hears his peers say "I got to eat man. I got to rob somebody" he has felt the same way; but he finds the spiritual resolve to resist such temptations, stating "You got to pray to the Lord, you know what I mean" (fieldnotes, focus group session, 11/12/08). He states that he has learned to develop a mindset to make it through the tough times in his life. In Lewis Gordon's *Existentia Africana* (2000), he suggests that hopelessness and despair surface amongst those who no longer have faith in the social structure to assist in ameliorating social problems. He says these conditions and circumstances give rise to educational problems, social problems, and economic problems (Gordon, 2000). Gordon also states that because Blacks face limited

options in society, are in everyday negotiation of social life, it increases the probability of Blacks breaking the law on an everyday basis; and such limited options force every Black to face choices about the self that place selfhood in conflict with humanhood (2000, p. 87). In this regard, Marquis critically reflected on momentary experiences of what Gordon calls a political nihilism (1997, p. 92). This is when there is a lack of faith in the political as a means of social change, and also in the human ability to effect social change. Wilson, Quane, and Rankin state,

> The behavior, expectations, and aspirations of youth from inner-city ghettos are directly affected by the joblessness and other social dislocations that pervade these communities. The overrepresentation of jobless adults and the lack of opportunities for gainful employment lead to reduced youth expectations about their future and a weaker commitment to education as a path to social mobility. The development trajectories of ghetto youth are also threatened by the prevalence of criminal elements and deviant peer groups in ghetto neighborhoods, which provide attractive opportunities for involvement in illegal and other non-normative and risky behavior. (1998, p. 63)

However, it must be noted that Marquis was critically conscious of his state of being and did not submit to various forms of internalized oppression. This was noted when he states, "You got to pray to the Lord," and "We'll get through it though." In this regard, he has some sense of what Michael Dantley would call critical spirituality that sustains and gives him hope in transcending the present predicament of his circumstances and America's contradictions between claims of equality and his actual everyday lived experience of inequality.

The students were also preoccupied with and concerned about the nature of work and employment in relationship to the economic responsibilities they had to support their families. In very complex ways, the challenges with work and socioeconomic stability had a tremendous impact on the students' perceptions and experiences at school. For example, Michael Apple notes that it is naïve to merely focus on the school to find long-term answers to the dropout dilemma (1996, p. 70). Apple and Christopher Zenk delineate the relationship

between structures of poverty in the United States, emerging trends in job loss and job creation, and how matters of race, class, and gender have impacted structuring opportunities for the educational achievement of youth and for youth employment (Apple, 1996, p. 72). Some students, such as Tony, have begun seeking alternative options that enable them to balance responsibilities between work and school. He attends Yonkersville, which is an alternative high school that seems to give students more autonomy and independence in how they utilize their school time. Tony is attracted to Yonkersville because of the flexibility the school's schedule allows for his daily work schedule. His former school, Central, did not allow for this kind of flexibility. Apparently, students at Yonkersville are allowed to maintain a job and fit their school schedule around the times they have to work during the week. The idea that the institution of the school can give Tony more flexible time around his work schedule is very important to him. He says that he is able to have tremendous autonomy in setting his own hours throughout the day, and can leave at times that are convenient for him. Tony says that he typically attends school in the morning and leaves early in the afternoon. It appears that Yonkersville also takes into consideration after-school programs as credit hours during the tenure of a student's high school career.

While Tony appreciates the flexibility in Yonkersville's class schedule around his work schedule, all of the other students who attend the traditional public high school contend that Tony is in a better socioeconomic situation because he gets to keep the money he makes. They, on the other hand, have to give their money to their family to provide for the economic sustainability of the household. The very contentiousness and sensitive nature of this conversation between these youth speaks to the preoccupation, necessity, and fragility of urban youth finding stable work for youth employment for the economic survival of their families. For example, Evan states "Like, us, like, I know I do, when I get money, it ain't my money. I gotta give my money to my mom or my dad" (fieldnotes, focus group session, 11/12/08). Subsequently, the money he makes is to help maintain the financial obligations of his household. According to Evan, he does not have the pleasure, leisure, and flexibility to use the money he makes for his own purposes. However, he argues that Tony

is not required to use the money he earns to help with financial obligations of his family. Evan tells Tony, "You ain't gotta do that bruh. Yo momma lets you keep yo' stuff" (fieldnotes, focus group session, 11/12/08). As the conversation continues, Evan reiterates the point to Tony that working for him and his family is not an option. His economic circumstances dictate he does not have the privilege to decide if he wants to work or not. In his family, finding work is mandatory. All of the other students at the center, such as PJ, reaffirm Evan sentiments, stating "You gotta help yo family out" (fieldnotes, focus group session, 11/12/08). However, Tony appears to have some kind of arrangement where he works with his uncle who gives him money to help work with him at his place of employment. According to the students, this arrangement appears to be optional and not out of economic necessity or obligation to help ends meet for the economic survivability of Tony's family. According to Tony, his uncle provided employment for Tony to show him responsibility of what work life is about in preparation for adulthood when he gets his own apartment. Unlike Tony, Evan says that his paycheck can't go toward buying the latest gear and fashions that appeal to urban youth. Evan states that Tony is in a more privileged situation in that monetary resources seem to come his way in an easy fashion, and he doesn't have to deal with the everyday struggles that he faces with his family. According to Evan, he has to work for money that he doesn't own because it goes directly back to the obligations and responsibilities of his family. Other students, such as Rasheed, also affirmed Evan's point stating, "We gotta WORK bruh!!" and that Tony's situation is not the same as many of the other students at the center (fieldnotes, focus group session, 11/12/08). The students also make the case that the kind of work Tony has found is consistent and stable, which apparently has been a different experience for the other students. At a very young age, it appears that Evan seems to have already taken on adult responsibilities, due to the financial circumstances his family encumbers. In hearing the tension and frustration in his voice, the lost of his youth to the adult grind of work seems to inform why Evan said earlier that he feels he is not free in this world.

While work and money are important to all of the students, Evan makes the distinction between the economic necessity of work as an

imperative to compensate and assist with the collective needs of his family versus work as an individual choice to fulfill one's own luxuries and self-interests. While Tony makes the point that he too has to give his family members money, PJ retorts that he has a stable job that he can count on. Implicitly, this suggests that for most of the students at the center, stable employment is not an assumed privilege in their lives. It is something they struggle to claim access to. Evan makes the point that with the exception of Tony, all of them have been born into socioeconomic constraints that have produced the additional financial responsibilities in sustaining economic survival of their families. Rasheed adds that work for them is not a choice but an obligation that must be carried out in their families for their own economic survival. In addition, the other students are calling Tony out on the monetary privileges he has because his uncle played a role in getting him his job. It seems that while Tony's family is not wealthy, they seem to have what Pierre Bourdieu calls cultural capital, or high-status knowledge, that lends them currency and access to stable employment in his community. According to the students, this makes a difference in terms of the monetary privileges he enjoys. There are some implied absences within this text that Rasheed and Evan are alluding to. Given their statements, the issue of unstable jobs and employment as it relates to the socioeconomic circumstances of their families seems to be a core issue that confronts the vulnerability of their everyday struggles. Tony suggests that he too has responsibilities of helping out with the family. However, it is almost as if Tony has been granted "responsibility" as a gift to teach him life's lessons. For Rasheed and Evan, life's lessons are being taught now, and there is no room to grow up because they are already handling a set of responsibilities "as men" in the present moment. In this way, "the school of life" for Rasheed and Evan has been and is already in session.

The differential, racializing effects in relationship to the changing nature of the labor market for Black males suggests that "Over the last three decades, low skilled African-American males have encountered increasing difficulty gaining access to jobs—even menial jobs that pay no more than minimum wage" (Wilson, 2008, p. 56). William Wilson insists that for Black males, education is perhaps more crucial than it

is for other populations to secure employment (2008, p. 56). In addition, Wilson argues that the loss of blue-collar work, particularly in manufacturing jobs, to globalization has been devastating for Black males because that has been a "significant source of better-paid employment for Black Americans since World War II" (2008, p. 60). Concomitantly, Wilson further suggests that the academic experiences of underachievement and high school dropout rates of Black male youth are closely related to their negative experiences in the labor market. "Black males are far less likely than black females to see a strong relationship between their schooling and post-schooling employment" (Wilson, 2008, p. 65).

Cornel West once stated, "Poverty educates, and it shapes the way they look at the world." The socioeconomic conditions of poverty in relationship to urban youths' employment prospects cannot be overstated in their impact on the educational experiences of students in urban communities. Giroux states, in "Class Casualties: Disappearing Youth in the Age of George W. Bush,"

> In 2000, the poverty rate for African-Americans was 22 percent, basically double the rate for the entire nation....In Chicago the poverty rate for blacks is 29.4 percent and only 8.2 for whites. The poverty rate for black children is 40 percent, compared to 8 percent for white kids. (February 2004)

Most educational scholars and researchers have long noted the relationship between nonaffluent students and the obstacles and challenges such material realities present in making it to high school graduation. In *Cultural Politics and Education* (1996), Apple states that for those students who live in poverty it is 300 percent more difficult to graduate from high school (p. 74). This is not to suggest that students cannot overcome obstacles of poverty among other external factors that go along with low socioeconomic status. These students are not merely passive victims of circumstance without any sense of agency over their lives. However, it is to suggest that life confrontations with these realities present added barriers to overcoming economic marginalization, which impacts the difficulties and struggles they experience in education and schooling.

Conclusion

Many of the pressures and vulnerable circumstances many urban Black male youth have to face happen outside of schools. These pressures and challenges, for example, have to do with navigating the cultural and political terrain of gang activity, not succumbing to the perils of the prison industrial complex, facing the lure of the underground street market economy, living day-to-day with the existential issues of life and death, and enduring devastating poverty that makes whether one is going to eat a choice and not a given. These circumstances outside schools inevitably impact what goes on inside schools. These sociocultural dynamics should alert scholars, practitioners, and critical educators to make a concerted effort to make schools spaces and places where students want to be. We should not only create and make schools places where they want to be, but to serve moral, political, and ethical ends of connecting pedagogy and curriculum to enable learning that will transform their lives and future possibilities. In this study it is clear that urban public schools have physically shut them out of their academic learning process; however, in collusion with this challenge, this study suggests that that which they were learning proved to be insufficient and far removed from dire life circumstances that they face on an everyday basis. What this means is not only that these students are publicly excluded from the physical space of urban public schools, but that the content and curriculum, within the standardization of learning outcomes, have excluded and confined knowledge that emerges from students' sense of identity, lived experiences, and cultural locations that they bring with them to school. In many ways, it is this knowledge that has been crucial to their survival. This means that we need to think creatively about the educational possibilities and benefits if students are to account for and take into consideration knowledge they obtained from the street, the sociocognitive abilities that have been crucial to their very survival, and curricular and pedagogical strategies that might be more meaningful and motivational to their pursuit of learning.

These conversations revealed how the neoliberal politics of standardization, and more specifically, standardized testing, have suffocated and emptied out what Freire calls their passion to know. I agree

with Kincheloe in that standardized testing has sucked the lifeblood out of learning, sapped the joy, spontaneity, and creativity of what should make for academic learning that is intellectually rigorous and fun at the same time (2007). He states, "Teachers have to learn to negotiate such a terrain, to figure out how to deal with students who react to their socio-cultural situations, their relation to the culture of power in diverse ways...simply demanding that students memorize a particular amount of designated data for standardized tests will never work" (Kincheloe, 2007, p. 19). He further argues that promoting cognitive knowledge and academic skills that are not connected to the larger issue in the struggle for social justice and change is a disservice to students (2007, p. 19). As it relates to urban Black male youth, a critical curriculum and pedagogy relevant and relational to their lives and experiences in urban contexts need to take into account how their identity and sense of agency in relationship to learning experiences in schools are responding to asymmetrical relations of power. That is, we must find ways to mobilize the anger, hurt, and pain that emerge from the larger social, political, economic, and racialized contexts outside of schools and reshape these sociocultural, cognitive, and emotional experiences into spaces and places that will allow for critical knowledge, positive self-affirmation of their identities, and self-actualization toward personal and social change. I would argue that their very lives could depend on the necessity of this knowledge.

The implicit challenge with the nature of work and stable employment preoccupied the students' minds. I couldn't help but think that these were adult stresses that many of our youth should not have to encounter at such early stages in their lives. I was not clear on the nature of work and labor that these young people had to produce. However, it was clear that work was not an option or choice. It was crucial to the economic survival of their family. In an era of globalization, as decent stable employment for youth continues to dissipate, particularly for urban Black males, the expectations of schools as conduits of socioeconomic mobility have become less real for them (Wilson, 2008). Some of the students implicitly suggested that alternative means and methods of the illicit informal economy of the street have become contemplated options, in their young minds, as a means of survival (Anderson, 2008). As one student stated, "You gotta find a

way to make that money." While I did not explore the specific relationship between unstable employment during and after school in relationship to urban youths' participation in informal economies of the street, this will be crucial work in the future for those looking at complex negotiations between agency and structure between work and schools. What is clear from these conversations are the complexities of finding decent and stable work for urban Black male youth that go along with the sheer weight of poverty in this low income community that pressured these students to think about life as adults rather than teenage youth who could be carefree, and be curious about new stages in their development as young people. Subsequently, given their responsibilities of work to help maintain economic stability in the household along with stresses confronted within the institutional practices of schools, their perceptions of schools were that they were alienated from schools, which they saw as one more obstacle or trap in their lives. That is, the institution of the school was not seen as a public sphere that could help them confront the material conditions of their realities. In this way, schools were stifling to the construction of knowledge for transformation and empowerment in their lives and futures.

The students' overall sentiments of being trapped in education and urban society remind me of a lecture given by Ralph Ellison in 1963 entitled, "What These Children Are Like." He states that the education urban youth receive in the outside world of the streets teaches them they should not reach for certain things, or be imaginative or creative in exploiting their potentialities, and that the education they receive in schools is no way reflective of or relevant to the constitutive elements that shape cultural contexts in their environments. He stated that the discourse in public education tends to ask the question of what is wrong with these students instead of appreciating the talents, skills, and intelligence that emerge from these young people. What is often not appreciated in the public discourse on youth in urban settings is the resilience they have in surviving a set of obstacles that other citizens faced with these challenges would have given up hope were they in the same predicament.

It is safe to say that emotional bonds of caring, necessary for successful pedagogical relations between teachers and students, have

been disrupted for these youth by neoliberal reforms in urban educa-tion. This is exemplified in students' narratives in how they feel they are viewed as the public enemy in public schools, the discipline and punishment practices they encumber, their disgruntlement with the current movement in education to standardize teaching and learning, and racialized and economic barriers that impact all sectors of public life in urban communities. We have to take into account these condi-tions when we see youth turn toward alternate subcultures, such as hip-hop. New cultural modes of identity making take shape through market-driven forms of brand identification, influenced by the mass media of the hip-hop industry. In many cases, urban youth purchase to consume the representation of a lifestyle associated with high-end fashion, the possession of money, fame, power, and success. Market-driven forms of hip-hop celebrate what West calls market relations and market identities. These market relations and market identities that took shape under the commercial order of neoliberism at school characterized a protracted struggle in the space of the school for many urban youth to be what they term *that dude*. What it signifies to be popular, respected, recognized, and noticed at school as *that dude* is measured by the economic means by which one can purchase the lifestyle that is celebrated in music videos of the hip-hop industry. Those who cannot afford to do so are seen as lame. I now turn to chapter 5 to explain urban youths' cultural investments to be *that dude*.

Chapter 5
"It's All about Being That Dude"

To make the people happy and give them what they want sometimes is not a good feeling, ya dig. It's harder to tell a kid to stay focused, go to school, do the right thing, stay away from all the negativity, stay away from gang life, stay away from [teenage sex with] girls, stay away from trying to make some money, cause we in a materialistic world. You tellin' the same kid that got to go home and watch T.V., and all it is is sex, violence, drugs on T.V. All they show you is about ballin' on T.V.

—Jim Jones, Hip-Hop Artist, 2008

While the neoliberal culture of urban public schools seems to engage in cultural and social processes of displacement and exclusion of Black male youth, many students of urban working-class communities have turned their attention toward the alternate popular public sphere of hip-hop culture. It is in the cultural realm of the popular where we can begin to understand the investments, desires, and everyday consumption practices that shape the ways in which many urban youth have bought into a certain Black masculine identity formation. That is, the corporate, commercialized discourse within hip-hop has become the commodity of capital that many urban Black male youth consume to explore and shape patriarchal definitions of manhood.

However, the students at the hip-hop youth empowerment center were not passive consumers of cultural consumption. They spoke as critical subjects who defined the terms of urban teenage struggle that shaped many of their peers' desires and consumption practices within the neoliberal, corporate, commercial discourse of the hip-hop industry. Importantly, the students astutely observed that many of their fellow peers' desires and consumption practices had to be understood in relationship to their social, economic, and political marginalization in urban contexts. The commercial discourse in the hip-hop industry has sold many urban youth the myth of achieving overnight success and monetary gain to obtain the American dream, while appropriat-

ing patriarchal notions of power and respect in the process. In consequence of this sociocultural dynamic, many urban Black male youth have been greatly influenced by a set of values associated with getting fast money, gaining power through the respect of one's peers via aggression if necessary, obtaining the attention and adoration of girls, and having a certain style, attitude, and aesthetic about oneself that convey a hustler's ethic and guarded confidence. This ethos, drawn from the cultural and symbolic resources expressed within the commercial discourses in hip-hop, shapes what the students collectively defined as *being that dude*.

Market-driven commercial discourses of the hip-hop industry played a significant role in how students at the hip-hop community center contextualized their generation's struggle to construct an identity to be "that dude." As evidenced by the term, that dude is a masculine, constructed phrase urban African American male youth came up with to describe contemporary, capitalist, patriarchal notions of manhood that many urban youth adopt, measured by the influence of commercial discourses in the hip-hop industry. This idea is based on a set of masculine and market-oriented values, heavily celebrated in the culture industry of hip-hop. *Being that dude* is predicated on a toughness, along with a style and aesthetic, with the "self-made" ethic to make money. According to the students, possession of these characteristics allows one to be noticed, popular, and recognized to obtain power and respect at school.

The masculine ideas that many urban youth have around toughness, or what they term as being hard, to "be that dude" are heavily influenced by iconic rap artists who the students feel sell images of themselves in the media as "hard" to get paid. They suggest that the artists feel they have to take on this image for the hip-hop industry, and this image has become popularized in local urban neighborhoods. In their words, "If you a rapper you got to put some hardness to you" if your music is to be heard in the hood. They also stated that rappers can have an audience if they are also talking about getting paid, along with projecting an image of being hard. The students also suggest the notion of being hard brings the artist sex appeal with the ladies. It is within these cultural contexts that shape masculine identity constructions in relation to consumption practices of market

ideals that informed how many urban youth constructed notions of what it means to "be that dude" in the social world of hip-hop.

The cultural production of lyrics and images of rappers being hard that influence students' ideas of what it means to be that dude foregrounds some context into urban youths' 'desires of the style and aesthetic of rappers' fashion trends that are commonly viewed in videos and other popular cultural events of the music industry. Students suggested that high school is a fashion show, where everyone is trying to be that dude by wearing the latest fashions seen in the hip-hop industry in order to make themselves look good and become the most popular person in school. In other words, their popularity status and respect are elevated at school when they have the ability to buy high-end, hip-hop apparel such as the French fashion and accessory brand Cartier or Coogi, frequently seen in hip-hop videos and music award events on networks such as BET, MTV, and VH1. The students stated that many urban youth desire to dress like the rap artists they see in the media do because they want to emulate the idea of living a certain lifestyle associated with opulence. For example, a gold rope chain, shoes, diamond jewelry, etc., are seen as cultural artifacts of hip-hop that can be worn to obtain the image, idea, and sense of belonging to a lifestyle that is supposed to give one a sense of self-worth. It is not only the adoption of the style and aesthetic in hip-hop, but the ability to afford purchasing these high-end, expensive items that affords one the respect of being that dude in school. Alternatively, the students suggested that if one cannot afford to adopt the high-end fashion, sensibilities of the hip-hop industry, he is seen as dirty, a square, or lame at school. In their words, he is considered to not have a name to himself. Nobody wants to get looked at as lame, but everybody wants to be that dude, to be the freshest dude in school. The students suggested that *being that dude* is an image that must constantly be maintained to preserve one's popularity status at school. So much was it a struggle to be that dude that many of them spoke of incidents locally and nationally where certain accessories, clothes, or jackets were taken from students, in order to obtain the power and status of being that dude.

In *Becoming Somebody* (1992), Philip Wexler discusses the relationship between how and why working-class students form youth

subcultures and self-identification practices in market niches of popular culture in relationship to their sense of alienation in schools. The sense of alienation and displacement of urban youth in schools is what Wexler would call interactional, relational lack. It is the interactional, relational lack in the apparatus of the school that contributes to students forming collective identities in youth subcultures (Wexler, 1992). Students turn toward youth subcultures in response to a set of rational, institutional methods that have become mechanical and more detached from having authentic committed relationships and social interactions with these youth (Wexler, 1992, p. 34). For example, how urban youth construct their associated meanings of "being that dude" through market-driven niches within commercial discourse of hip-hop is possibly reflective of their sense of alienation in schools. When we discussed, in chapter 4, the issue of students feeling trapped, they did not want to speak much about their experiences with school, as it seemed to be a source of great tension in their lives. In this sense, their silence spoke volumes about a hidden curriculum in schools that has effectively shut off the value and potential of their voice as coproducers of their educational experience. One student broke the silence and captured many of the students' sentiments when he stated that he hated school, and that teachers spoke to him and his peers in what he felt was a disrespectful manner. In addition, this could have had something to do with the fact that many of these students stated, in one way or another, that they were labeled in negative ways by school officials who deemed them as trouble. We can recall that students surmised that teachers already had in mind who they would be enforcing discipline on and sending to the office, based on these preconceived labels. As stated by the director of the center, the cultural contexts of schools toward many African American male youth seemed to be to remove, dismiss, and dispose of the "hard ones" in the class so that teachers can "deal with" and teach the other students. Other students chimed in and said that school was a boring experience, couldn't wait until it was over with, and that they would always lose in the white system. The students also mentioned they possessed a certain kind of street knowledge that was useful and valuable to the street but not in the classroom. In this context, students felt their intelligence and knowledge were legitimized, valued,

and could be applied in the street versus the traditional culture of the school. In addition, their struggles with standardized testing could also be factored into their overall sense of displacement and alienation in schools. These narratives are not meant to capture the totality of what all urban youth feel about public schools. It is also not to suggest that all teachers, administrators, and other public school officials are incompetent, mean spirited, or treat all urban youth in a less than positive light. This would be disingenuous, as many school officials desire to make a positive difference in the lives of all students. However, centering the voices of urban youth gives us a snapshot of some long held, hidden tensions and social antagonisms felt by urban African American males that seldom get heard or validated in the larger context of urban school reform. More specifically, we rarely hear from students, such as the students I worked with at the hip-hop youth empowerment center, who are on the very fringes of dropping out of school, about the kinds of pedagogical conditions that may contribute to their overall sense of alienation and displacement in urban schools. It seems to me that as schools become less of a socializing agent of identity, it opens the door for market-driven niches in popular culture to fill in the void for these youth. That is, based on Wexler's notion of interactional, relational lack, these narratives also give us a glimpse of material conditions of detachment and emotional disinvestment between students and teachers in schools and larger societal contexts that may play a role in shifting cultural contexts of urban youths' market-driven consumption processes of identity making in popular culture, and hip-hop in particular.

The student narratives of feeling trapped in urban schools and the larger society give us some contexts into how school environments can be considered alienating to these youth, and the pedagogical conditions that may attract urban youth toward market niches in hip-hop when they feel schools have been alienating to their sense of personhood and identity. As institutional practices and policies of schools have created conditions that lend themselves to less caring and nurturing relationships between teachers and students, new alternate processes of identity making may emerge in popular culture that are in response to an institutional system where nobody cares (Wexler, 1992). The idea that *nobody cares* represents a culture in

schools when there has been a displacement of emotional bonds and social interaction between the teacher and student, the pedagogical relations necessary for successful teaching and learning (Wexler, 1992, p. 35). Wexler argues, "The reasons that teachers 'don't care' have to do in part with state-mandated rationalization of curriculum" and the disciplinary apparatus is a part of the institutional methods and practices of that apparatus (1992, p. 35). It is here where youth subcultures go through a cultural process of what Wexler calls becoming somebody, replacing and filling in the emotional void in the lack of caring relationships in schools, that perpetuates a rigid rationalization of its administrative practices. Zero tolerance measures of discipline, the widely recognized labeling and stereotyping of Black male youth, and the rationalization, instrumentation, and standardization of the curriculum all feed into a culture of detachment between students and teachers within the overall disciplinary, institutional apparatus of the school. As teachers become increasingly confined to neoliberal, market-driven measures in schools and students reject and resist these measures, market-driven niches in popular culture take on increasing significance for urban youth who feel entirely alienated from the schooling process. It is these institutional practices and ways of going about regulating urban Black male youth in schools that have simultaneously precluded less regimented and rigid ways that have not succumbed to a narrow instrumentation of knowledge, teaching, and learning. These practices also prevent more caring and nurturing relationships with students in schools. It is these particular contexts that play a role into urban youths' cultural investments in market-driven niches of the hip-hop industry, where they want to *become somebody*, where they want to *be that dude* in school.

In the next section, we come to see alternative modes of compensatory identity making (Wexler, 1992) of urban youth through consumption of market-driven niches that circulate and are produced within the subculture of hip-hop. The students came up with the phrase "being that dude" to describe their peers' consumption practices in the hip-hop industry when I asked them to make sense of the urban struggles that Tupac mentioned in his 1992 Malcolm X Grassroots Movement speech, which he gave in Atlanta, in relationship to their own tensions and struggles in the present moment. The

students first mentioned "the economy, jobs, high gas prices, and how everything was going up" as major struggles for their communities. However, the socioeconomic contexts of these matters in their conversation dialectically precipitated what seemed to be a more preoccupying conversation for them about their peers' desire to get money so they could be the "freshest" dude in school. The cultural politics of what it meant to "be that dude" demonstrated a major cultural shift in contemporary politics of urban struggle in the Black community that is reflective of what Stephen Haymes and Cornel West call market desires and market mentalities in popular cultural consumption practices.

Corporate Identity Consumption in Market-Driven Commercial Discourse of Hip-Hop

Haymes argues that consumer capitalism within the dominant culture controls the production and inscription of meanings in its commodities (1995, p. 29). He suggests that the economization, commodification, and consumption of Black male identity and representation in popular culture now pose as threats to Black self-image and self-determination (1995, p. 30). In a neoliberal culture, where the economic interests of the market take a priori, market-inspired ways of life seem to predominate over nonmarket ways of life (Haymes, 1995). For example, Marquis and Corey talk about rap artists who adopt images and representations of what Guy Debord calls spectacular consumption (1983; Watts, 2004). Spectacular consumption is when there is a separation between the sign — authentic meaning of the social world of the artist — versus the commodified image of the artist — emptied and separated of all meaning in the social world — and the image that is projected in mass culture of the media for popular cultural consumption practices (Watts, 2004, p. 594). Marquis states the images and identities rappers often project are often shaped by the dictates and expectations of mainstream America. He says in many cases rappers produce narratives and lyrics that is assumed to be what the people want to hear. Consequently, when an artist is producing what people want to hear he is producing what he feels will sell in the music industry. In addition, Marquis states that some artists will rap

about guns and dope dealing because this is what is expected of the people from their neighborhood environment, even if this is a lifestyle the artist has never lived before. Corey argues that while some artists have lived the lifestyle they speak about in their lyrics, there are many artists who are "selling they selves to get paid" (focus group session, 10/8/08). He states the most popular thing for an artist to do is to sell the image of what he says as being "hard." The idea of being hard is a masculine constructed image of aggression and toughness by the standards of a capitalist, patriarchal culture in dominant, mainstream, American society. Subsequently, this student states there is a desire for most rap artists to portray the image of being hard "so they can get paid just to collect they check" (focus group session, 10/8/08).

Many rap artists have adopted market-driven, commercial discourses in the hip-hop industry. They have become complicit in meeting the demands of multinational corporations in dominant mainstream popular culture that run the music industry. In some respects, many mainstream, commercial artists in the hip-hop industry have taken up market-inspired ways of living, where it's no longer about the authentic experiences and representations of urban life, but circulating commodified representations of it that have taken on new meaning in mass culture. For example, Marquis suggest these commodified representations of being hard are based on marketed identities that seem to be most appealing to the music industry. He states that as a rap artist "you got to market yourself a certain way when you in the industry" (focus group session, 10/8/08). Marquis maintains the image of the rap artist being hard will "have the most sex appeal than the soft singin' guy rappin' bout the girls all the time" (focus group session, 10/8/08). Similarly, Corey states that in being a rapper "you got to put some hardness to you because you a rapper" because of expectations between themselves, audiences from local urban communities that listen to rap music, and the industry itself that expect the artist to be hard.

Haymes argues that dominant, mainstream cultural consumption practices and manipulation of Black popular urban culture remove the narratives, experiences, and histories of Black folk (1995). Subsequently, he states that this has contributed to the shattering of Black civil society that takes root, and urban youth culture's collapse of

communal values shift toward consumption of pleasure—that is, sex, money, violence, entertainment, or instant gratification (1995). This precludes meanings toward love, self-confidence, and other forms of healthy self-regard. Haymes argues that there is a need to reclaim a pedagogy of place for Black urban struggle and resistance in the city (1995). For example, students suggest the cultural consumption practices of market-driven ideologies in hip-hop is reflected through many rap artists simplified narratives of making large amounts of money. Marquis states, "if you a rapper all you got to do is talk about getting some money and people gone listen to it" (focus group session, 10/8/08). He states many artists who come from destitute circumstances use this narrative in a vigorous attempt at the most efficient means of making money in the music industry to survive in their daily lives. Darrel adds that rap is somewhat seen as the new hustle, replacing the dope game as an alternate route to make legitimate money. He states that for many urban youth, getting into the hip-hop industry is seen as an easier avenue to make money then selling drugs. This is why he feels that so many youth are attracted to pursuing rap as a new street hustle. In this context, the music is seen more as a commodity to be sold for economic gain than any authentic commitment toward non-market values of love, respect, and collective unity in the Black community. This fetish with the consumption of commodities in popular culture makes vulnerable the negation of historical and political reclamation of Black identity for self-definition and self-determination. The commodification of the hip-hop industry has attracted many vulnerable urban youth to take a shot at the American Dream, to sell urban life as a commodity, absent of historical and social context or meaningful narratives of one's experiences in the city.

As rap artists have become icons in the minds of many urban youth, they have become trendsetters of fashion and style in the hip-hop industry. The cultural production of lyrics and images of rappers being hard is part of a larger masculine context that in many ways influences students' ideas of what it means to be that dude. Subsequently, the style and aesthetic of rappers' fashion trends in hip-hop, frequently consumed in videos and other popular cultural events of the music industry, impact the style and fashion trends of urban

youth who want to be *that dude*. Hip-hop moguls, such as Russell Simmons and Sean Combs, have been key figures in the industry who have commodified the fashion styles and trends of hip-hop artists into mainstream popular culture. It is within these contexts that students at the center talked about the everyday negotiations they and their peers had to make about *becoming somebody*, or being "THAT DUDE" through the culture industry of hip-hop. For example, after viewing Tupac's 1992 grassroots movement speech, Ray spoke about many urban Black male youths' preoccupation with being that dude, and tryin' to be fresh in the material sense, as what defined their struggle today. He stated that high school has become a big fashion show where urban youth project the attitude of being that dude by acquiring the latest fashion styles and trends in popular culture. Ray suggests these popular cultural consumption practices have become very important to many urban youths identity making processes. According to Ray, high schools are spaces where many urban Black male youth want to be seen as "fresh," which in hip-hop vernacular means having a certain aesthetic and style related to how one wears one's clothes to impress their peers. He states, "It's like everybody tryin' to be fresh. Everybody tryin' to be that dude" (fieldnotes, focus group session, 10/8/08). "Within black street culture, fresh is a word used to express aesthetic evaluation of the unnamed forces behind a style, a concept, that add something new to our way of seeing—enhancing the visual experience of the look, the gaze" (hooks, 1990, p. 51). For Ray, "being that dude" is a kind of performative identity for Black males to heighten one's status as a popular person in school. The student continues, "They get that money so they can buy stuff to make them look good" (fieldnotes, focus group session, 10/8/08). Ray states that this is the central struggle and preoccupation for a Black teenager today. He states that many students use what money they are able to acquire to purchase brand name clothing because "It's tryin' to be that dude, tryin' to be the most popular person" (fieldnotes, focus group session, 10/8/08). In this instance, Ray speaks of cultural consumption related to accessing money as a means by which one can purchase a certain style and aesthetic to become that dude, which is also equated with being a popular person in school. How Black male youth struggle with their own sense of identity in relation-

ship their desire to be popular, for Ray, is seen as the main struggle for them in high school. Ray then followed up by suggesting that many urban youth appropriate their sense of style, to be the most popular person, and to be that dude, through cultural consumption practices of what they see on TV.

Ray also suggest when urban youth see the latest fashion or popular brand names, such as Cartier, a high-end French fashion and accessory brand frequently worn by many hip-hop artists as seen in mass culture of the media, it often shapes their own fashion sensibilities. He states, "Didn't nobody know about Cartier glasses, or nothin' like that till people [on TV] started wearin' 'em. Now everybody got Cartier glasses" (focus group session, 10/8/08). However, Shawn extends Ray's conversation of constructing and shaping one's identity of being that dude when I ask why they think urban youth invest their identities in such commodified ways. He states that urban youth consume a certain style and aesthetic by what they see on television to fulfill their desires to live a certain lifestyle that represents opulence. He argues that when urban youth see rap artists on awards shows, such as VH1, wearing accessories, such as expensive rope chains, the image represents a lifestyle of wealth they want to emulate. Shawn is speaking of the ways in which some urban youth desire and construct spaces of play and pleasure associated with a lifestyle of affluence in the social world of hip-hop. In the world of the hip-hop industry, artists often wear and showcase very large, thick, gold rope chains in videos as cultural and symbolic expressions of being visibly rich. This accessorized fashion trend was first popularized by Def Jam artist Slick Rick, who would drape several thick gold rope chains in his videos. According to Shawn, when urban youth can also acquire cultural and symbolic expressions of opulence, it gives them a sense of belonging. To meet the consumption of this need, many shopping malls and mom and pop shops in local urban communities sell imitation versions of these chains for youth to purchase in their stores. This is symptomatic of what Haymes suggests to be the dominant culture's manipulation of market desires by capitalist, consumerism of exploitable youth. Subsequently, Shawn states that many urban youth are inclined purchase similar fashion accessories as the artists they see on TV. In addition, Shawn also says the collective images of

artists wearing the latest hip-hop styles and fashions on these award shows represents a group urban youth yearn to affiliate with or belong to. In a sense, Shawn says urban youth live through the fantasies of rap artists by adopting similar fashion styles as these artists that are highly visible in mass media. He states,

> Shawn: Like you would see on VH1, and all the award shows, and everybody dressed a certain way, and you wish you were there so you go out and buy everything, you know. Little things you see, and yeah I like that style. I might wear that. And you know, you feel like you in that group. (Focus group session, 10/8/08)

Similar to Ray's statements about youths' cultural consumption practices based on what they see on TV, Shawn states that TV networks, such as the video music channel VH1, can powerfully influence the commodification of cultural consumption practices that entice and motivate youth to adopt and purchase fashion trends worn by popular hip-hop artists. For Shawn, all this gives many urban youth a sense of belonging. They are in a sense, "that dude" because they are a part of the popular group, as measured by visual representations of what they see in the market-driven, commercial world of the hip-hop industry.

PJ states that students are consumed with imitating clothing styles they see in the media because they don't want to be seen as lame or unpopular to their peers in school.

> PJ: Basically, I mean, for real, people don't want to get looked at as lame. For example, if you wear Polo all the way down to the socks, or Coogi straight down, everybody look at you in school, like, aw you the freshest dude in school right now...it's a image basically. Everybody want that image. (Fieldnotes, focus group session, 10/8/08)

In contrast to being a square or lame at school, PJ insists that if one can wear apparel such as Polo or Coogi, one will be considered the most popular dude in school. Heretofore, Polo was marketed as a very expensive designer clothing brand associated with elite "high" culture of suburban America. As the hip-hop industry has become a

part of the cultural consumption of mainstream corporate America, artists have re-appropriated and expanded the commercial influence of high-end lines, such as Polo, into urban America. Coogi is also a very expensive clothing line; however, their commercial market is more explicit toward the urban community. Rap artist Biggie Smalls popularized and associated Coogi as "hip-hop urban apparel" when he rhymed on the classic *One More Chance* remix album, "I stay Coogi down to the socks," rhetorically underscoring his own high-end style and aesthetic, fashion sensibilities, which he implicitly related to the value and worth of his own personhood. In this respect, PJ's statements about wearing "Polo all the way down to the socks" or "Coogi straight down" explain the ways in which students appropriate high-end clothing apparel as a barometer of their own value, image, and self-worth, while at the same time, garnering the attention and popularity as being the freshest dude in school.

As we continued the conversation about how the students defined their struggle in relationship to being that dude, the students discussed their perceptions on what they felt their peers would receive from being that dude. While the first thing the group briefly mentioned without further context was girls, they soon conversed about struggles with respect and the self-destructive, internalized oppression that can culminate in violence when others can't afford the same material possessions to obtain the status of being that dude. They also talked about the pressures of maintaining the image and status of being that dude in relationship to acquiring, keeping, and maintaining their own source of money to preserve this status. For example, PJ states that when you have obtained the image and status of being that dude you have to maintain that image and status. He states, "When you become that dude or that man, I mean you gotta, basically you gotta keep that image" (fieldnotes, focus group session, 10/8/08). The group suggest that for those students who cannot maintain the status and image of being that dude are seen as a square, lame, "dirty," or unpopular and unknown person in the school. Given the "fashion show" that takes place at school, the students suggest it is seen as unacceptable to buy clothes that one can afford because such apparel doesn't meet the style and status of being that dude. Subsequently, PJ states that in order the maintain the image and status of being that

dude a student must have a steady flow of cash to continually pur-chase high-end fashion apparel in popular culture. PJ clearly under-stands that in patriarchal society predicated on culturally consumed images related to market mentalities, being that dude is a culturally and socially constructed identity that must be maintained to keep one's self-worth intact. The alternative of not maintaining this image, as defined by their word "dirty," is to be invisible, unnoticed, and shamed from public space. PJ's comments on how one maintains the status of being that dude are reflective of Ray's comments that you have to have some money to purchase high-end designer clothing circulated in the market-driven culture of the hip-hop industry.

The students also suggested that aspirations to be that dude, par-ticularly amongst an oppressed population, can provoke competition and individualism that can have self-destructive and life-denying consequences amongst a vulnerable community. For example, Leroy states, "'Cause I know a lot of people, not only from this city, though, but from other cities too, like that done died, though, just for having, you feel me, somethin' fresh on…" (focus group session, 10/8/08). In some circumstances, the preoccupation with being that dude on the street can garner unwanted attention from individuals who don't have the economic means to purchase and acquire the material possessions and status of their peers. In this regard, life itself is unfortunately reduced to a market commodity. Ray reaffirms his earlier point about the competition and struggle for urban youth to obtain status to be that dude in relation to Leroy's commentary of getting robbed for having something "fresh on." He argues the idea of someone getting robbed signifies a larger protracted struggle about status and power to be that dude through the taking of another's possession of material commodities. Ray states the person who is getting robbed has material items that someone else on the street wants. "So that person that's robbin' that person is tryin' to get what they got to make them go up in [status]" (focus group session, 10/8/08). Ray states that this is what characterizes urban struggles related to being that dude amongst an oppressed community. He describes that the dialectic of *taking from* is related to *not having* material possessions, which fosters a market mentality of possessive individualism that one pursues material goods to heighten one's

status of being that dude. In turn, Kadeem states that the heightened status of being that dude will gain one some respect as well as some enemies for the aforementioned reasons Ray describes. Haymes would argue that this form of internalized oppression, resulting in death over competition for material goods to gain the respect of being that dude, is a response to the breaking down and shattering of civil society from market-driven, cultural consumption practices from the dominant culture.

Shawn clearly understands the way in which the dominant culture has circulated a set a discourses related to market mentalities of cultural consumption when he responds to Ray's metaphorical analysis of high school being a fashion show where urban Black male youth purchase the latest apparel to be that dude. Shawn states "America ain't nothin' but a high school, a fashion show...and that's the struggle" (fieldnotes, focus group session, 10/8/08). Implicitly, Shawn clearly makes the connection between many urban youths' patriarchal values tied to market relations in relationship to the larger American culture of consumption. In consequence, Haymes would argue that the dominant culture's commodification and cultural consumption of Black popular culture in urban space have played a significant role in stripping alternative survival practices for communal survival, collective consciousness, and self-determination amongst the Black community in urban public space.

Introspectively, Tony wrestles with having to keep pace with a patriarchal, market-driven society, where being that dude is equated with how many expensive clothes one can buy. For Tony, it is important for youth to keep in mind that life should not to be reduced to a market relation, and that students should be accountable to themselves in how they organize their life. According to this student, the idea of being that dude is regressive to one's growth and development in pursuing other more meaningful goals in life. He states, "You can't be that dude for the rest of your life; and, I mean you got to have better things to spend your money on instead of expensive clothes, you feel me, like, just having your life together, period" (focus group session, 10/8/08). Similar to the other students, Tony recognizes there is a danger to self-induced forms of cultural consumption

practices related to being that dude that can erode cultural practices of self-determination that Haymes speaks about.

PJ recognizes that being that dude is a performance or posture often presented by his peers. However, he maintains that he will stay true to himself, irrespective of what others may think. PJ states that in high school everybody wants to "be that man." He says life is not about "frontin" (being something one is not) to be that dude. PJ sees himself in a different manner than many of his peers. He states, "Me personally, I ain't tryin' to be that dude. I just be myself..." (fieldnotes, focus group session, 10/8/08). Although PJ understands the socially constructed performance of being that dude, he has bought into the idea of Ameritocracy, that if only you follow the rules governed by the system, you can easily navigate through it and achieve the American dream. According to this student, if one attends high school regularly, graduate, go to college then one can actually "be that man" and get a house. For him, this is the patriarchal definition of being a man, and gaining access to socioeconomic mobility. PJ states, "you can actually be that man when you get out of high school and you go to college and you get yo diploma and everything and you get yo house" (fieldnotes, focus group session, 10/8/08). PJ's goals are admirable, and for his immediate practical purposes, he has a great attitude about what he wants to accomplish in the future. Being a man, for him, is related to moving up the socioeconomic ladder, and based on advancing through the system. However, in this particular conversation, PJ doesn't take into account his and his peers' earlier statements about the difficulties of an educational school system that attempts to predetermine their access to upward social mobility through standardized testing, that is void of a curriculum related to their everyday lived experiences, and that pushes them out through excessive disciplinary practices. These experiences indicate that urban public schools have not been spaces in which urban Black male youth can be who they are as young men. Subsequently, many of them act out, find alternative spaces through popular culture, and in many cases, go through the cultural process of being that dude in response to structures that have cut off educational, and thereby economic, possibilities of what society says is being a man. Consequently, for

many urban youth, those who have made it through the school system have succeeded in spite of it and not because of it.

Conclusion

In summary, critical conversations with the students revealed that many urban Black male youth have mobilized cultural expressions of being that dude through a set of images of rap artists that circulate in heavy rotation on various music video channels or other programming related to the neoliberal commercial culture and industry of hip-hop. The media production and hyper-visibility of Black male artists throwing money in the air, wearing the freshest gear with accessorized jewelry, poppin' champagne with tons of girls on the yacht, and obtaining aggressive forms of power and respect of their peers all grab the attention of many vulnerable urban youth who are searching for visibility and recognition, all of which is reflective of low socioeconomic circumstances and institutional practices that have attempted to reproduce their status as underclass citizens. As Paul Willis states, "Without some cultural marking, youth feel in danger of being culturally invisible, which increasingly means socially invisible." (Willis, 2003, p. 405) Some students then validate and legitimate their identities through the material acquisition and consumption of clothes, shoes, and other accessories that are frequently worn by famous hip-hop artists as seen and marketed through the companies they endorse, or the videos displayed in heavy rotation. They mentioned to me that students who don't have the ability to purchase these goods are seen as a square, lame, and ultimately, less than a man. In a neoliberal culture of commercial consumption, schools inadvertently become contested sites where there is tremendous pressure for Black male youth to get their "hustle on" by any means necessary to obtain capital for the acquisition of material possessions that they feel will gain the respect of their peers, and impress the ladies alike. In turn, the students called schools "fashion shows" that reflected a neoliberal culture of corporate consumption, where struggles for identity and agency are being waged on a constant basis. They were critically aware and self-reflective of the asymmetrical relations of power between the cultural politics of neoliberalism that advances the myth of overnight monetary success in

relationship to youths' cultural consumption of values in the corporate hip-hop industry that has affected many vulnerable Black male youths' decisions within the larger social, political, and economic contexts of urban society.

The market-driven culture of the hip-hop industry has been a significant influence on compensatory modes of identity making by these youth, derived from the lack of social and emotional investment, or a more caring and nurturing environment in schools. Contrary to our commonsense notions that students bring with them to school the "cultural baggage" of popular culture, and then schools react is a misnomer. Rather, as Wexler suggests, the complex ways in which identities are taking shape through market niches in popular culture are a result of social and emotional neglect within the apparatus of schools, and I would add for these youth, the larger society. It is in this sense that the market-driven culture of the hip-hop industry has become a significant location from which students look to construct and make sense of their identities and social worlds. Urban youths' consumerist practices of the latest material commodities in hip-hop emerge out of this collective sense of belonging, to bring symbolic value to oneself in spaces and places such as schools in which one has been devalued. The emotional investments and desires to be like the commodified images and cultural representations of the artists they see on TV are reflective of their quest to become somebody in spaces and places where they feel like they are nobody. Whether it is at schools or in the streets, it can be reasonably argued that many of these students have been denied massive forms of social and emotional investment, or sufficient bonds of more nurturing and caring relationships with institutional structures in society. I would argue that it is for these reasons that many urban youth want to become somebody and "Be That Dude" through the market-driven culture of the hip-hop industry.

Market-driven discourses that circulate within the corporate industry of hip-hop in media, film, and music have to be seen as forms of knowledge and power that are counterintuitive to progressive, visions of the culture. As hooks suggests, the pedagogy and propaganda of the media in a white patriarchal, capitalist society works best when African American male minds are young and are not "yet

schooled in the art of critical thinking" (2004, p. 27). She states "Few studies examine the link between black male fascination with gangsta culture and early childhood consumption of unchecked television and movies that glamorize brute patriarchal maleness" (hooks, 2004, p. 27). In this context, the artists themselves or record executives commodify and circulate a gangsta ethic of being that dude for global consumption practices in the media. The mutual production of these commercial discourses knowingly or unknowingly serve to reproduce hegemonic ideologies and relations of power. Both groups have been complicit in proliferating one dimensional, images and messages that privilege profit motives rather than non-market values of love, respect, and community. However, we must keep in mind that urban youth from ghettos of the American metropolis do not wield the same kind of power in the regulation and control in the production and circulation of commodified images as multinational corporations of the music industry. Subsequently, we must consider the differential impact on how urban youth see themselves through the seduction of dominant consumption practices in mass media culture of the music industry. In addition, the cultural dimensions of race and gender in relationship to consumption practices and market identities that urban youth take up is reflective of the power and regulation of white, majority owned multinational corporations (to reference Chuck D from chapter 2) to sell Black masculinity and urban life in a bottle. That is, as market-driven discourses in the corporate industry of hip-hop circulate narrow characterizations of a predominate African American male image, impressionable African American male youth are sold ideas about what it means to being that dude. The machinery of these ideas circulate within institutional networks of power in the media such as magazines, movies, music, film, and fashion industries in hip-hop. The political impact on urban youth themselves lies in the fact that students recognized these images and ideas as limiting to their life futures. The students recognized that measuring one's identity according to one's ability to consume the latest fashion trends and styles in hip-hop is ultimately regressive to their growth, development, and maturity as critical citizens.

The impact and consequences of distorted, market identity representations of African American male youth in the hip-hop industry

have to be understood within wider networks and relations of power, culture, and ideology that are part and parcel of institutional structures of domination, oppression, and marginalization. Consequently, the struggles and conflicts over market identities to be that dude in the dominant cultural manipulation and exploitation of Black popular culture must be seen as a political project. This is particularly true when we think of powerful and seductive role institutional networks and commercial discourses within media have in targeting consumption practices and desires of the nation's most vulnerable in society. On the one hand, the dominant culture of the corporate industry has manipulated and created the conditions for the seduction of commodified, Black popular cultural consumption practices. On the other hand, this distortion in the consumption of narrow images and representations of African American males threatens to erase more authentic images, meanings, and representations of Black life.

In chapter 6, one will see a very intentional political project at play, where the staff and the students themselves at the hip-hop community center are re-imagining new identities that are not predicated on market-driven discourses in hip-hop. For example, there was intentional effort to produce hip-hop texts that center narratives of urban youth around social and political consciousness. We discussed the reading of critical hip-hop texts to make connections with students own experiences; students also wrote their own lyrics in a critically conscious manner to interpret their own social realities in empowering ways. The youth center was very explicit about using the culture to help students understand that one's identity is not wrapped up in how many women you have, the type of cars you can drive, the clothes you wear, or the amount of money one has in his pocket that defines one's manhood. There was effort to counter the dominant, hegemonic images of market ideologies that are sold to these youth on an everyday basis. The center helped young people understand that their identities are not confined to market-driven ideologies, and new alternative visions can take shape where students can critically think about their purpose and place in the world in radically different ways. This center opened up new critical pedagogical opportunities to rename oneself and construct identities that resist the stereotypes that are circulated, produced, projected, and distributed in mass media.

The stories students told in their rhymes had to be substantive, forcing them to think critically about the choices and decisions they make in their lives in ways that give redefinition to notions of "Blackness" that are not monolithic, essentialized, or stereotypical in narrow characterization.

The students are developing what Stephen Haymes calls a pedagogy of place for Black urban struggle and resistance. It is a space and place for Blacks to develop pedagogical strategies of resistance in their struggles for humanization, self-actualization, liberation, and what bell hooks calls radical Black subjectivity. The youth center served as a counter-public sphere where Blacks create new spaces in educative ways to reclaim their histories, identities, narratives, and experiences that have been lost within the commodification of Black popular culture; new discursive strategies that challenge stereotypes that have assaulted the humanity of Black life; and opens up new critical dimensions in Black popular culture that enable progressive visions of political and social transformation of urban life in the city. Blacks are enabled to redefine and organize cultural and social movements in Black popular culture on their own terms, and in ways that are not controlled and regulated by material and discursive ideologies of the white dominant culture.

Given the power and influence of hip-hop, educators need to think about critical pedagogical strategies in culturally relevant ways to mobilize, counter-hegemonic strategies within the culture toward social change, transformation, and social justice. The discussion must move beyond good vs. bad binaries that normally stunt the growth of our conversations of understanding hip-hop culture and our engagement with young people. There is a need to raise new questions that lead toward new pedagogical strategies toward hope and possibility in the continued, unfinished project of creating what Cornel West calls democratic individuality, democratic community, and democratic society. Subsequently, this text is not just about understanding the importance of rap music and hip-hop for urban youth. This work is about understanding how urban youth and youth advocates at a hip-hop community center resist the technical practices of traditional education that has been socially alienating to many African American youth. Subsequently, they

create their own democratic practices in hip-hop outside the tradi-
tional walls of urban public schools.

Given the complexity of challenges facing urban youth, there is no
blueprint in "what to do" to solve the vast array of racial, social, political,
and economic challenges many African American students are confront-
ed with in schools and urban communities. Subsequently, doing cultural
work of hip-hop at the youth center did not begin with a set of standard-
ized measurements and assessments in the pedagogy and curriculum to
see if students are meeting AYP. This was not the mission, goals, or
objectives of the youth center, which is what attracted me to this study. It
is not to be understated that preparing students to meet state bench-
marks and standards is a necessary practical reality for their survival.
While these linear methods have been great at linking academic
achievement to test scores, they have not been great at linking public
education to social justice and democracy. These methods are absent of
historical, social, and cultural contexts that have shaped urban youths
identities and experiences in North American society. Subsequently, the
knowledge that emerges in diverse urban contexts is too often discount-
ed in the traditional curriculum and pedagogy of public schools. This
puts many urban youth at a great disadvantage in classrooms when they
have to consistently reorient themselves to the cultural production of
knowledge that is based on hegemonic, norms of the white dominant
culture. In turn, institutional practices of schools tend to ignore peda-
gogical questions around what makes knowledge, culture, and identity
critical and relevant for the students they teach in urban public schools.

As shown throughout this text, it is undeniable that hip-hop is an
integral part of the lives and identities of many urban youth in U.S.
society. They draw upon various discourses in hip-hop to help them
process how they think about the society in which they live. Subse-
quently, learning how to read the language, culture, and identities of
urban youth in hip-hop becomes an important pedagogical project for
school officials and teachers alike in urban schools. However, much of
these insights cannot be gained from the traditional walls of a class-
room or even in most schools of education across the United States.
These critical insights need to draw from hip-hop artists who are
organic intellectuals or teachers of the streets. This means that schol-
ars, researchers, and practitioners need to recognize that young

people have something to say about their lives and experiences through hip-hop that can be valuable to the broader discussion of democracy and social justice in urban education.

In what follows in the next chapter is an examination of community based literacy practices in hip-hop outside the walls of the traditional school culture. This discussion gives educational leaders some insights into how local communities are developing democratic practices in hip-hop that can potentially have a positive impact on the lives of urban youth. The space of center can be seen as a counter-public sphere where urban youth and youth advocates develop alternative pedagogies in hip-hop in ways that resonate with the struggles and experiences of young people in empowering ways. The center is also seen as a homeplace away from the vulnerabilities and temptations of the streets. What is taught and learned at the center between the students and the staff serves to empower urban youth toward social change and transformation of their lives. The youth center wanted students to begin to think about their lives, circumstances, and surroundings in different ways; that they have more options than what they see in the streets; that despite its challenges, education can be an avenue in assisting in the transformation of one's life future. As students and artists of hip-hop, it was the youth center's desire for these young people to use the cultural practices of hip-hop to be critical citizens of their lives in ways that contributed to student success.

Chapter 6
Counter Public Spaces of Resistance

As public spaces for critical-cultural citizenship have shrunk for Black male youth within the neoliberal culture of urban public schools, there has been a need to organize counter public spaces of resistance for social change and transformation. Situated within urban spaces of marginalization, critical discourses and movements within the art form can recover hip-hop as a relevant, viable, counter public curricular and pedagogical space that resists the current neoliberal, hegemonic, commercial order. This counter public space allows educators, activists, and students to construct and organize political pedagogies that redefine and reshape circumstances in the public sphere of education. These educational initiatives heighten critical awareness and enable transformative action inside and outside urban public schools. I am speaking of critical dialogic and material spaces where youth and educators alike can begin to critically analyze social constructions about what it means to be Black and male in this society as a way to open up new discursive terrains of struggle and transformation. Such counter spaces also represent moments of resistance to "deficit" theories in public schooling that place the blame for underachievement on marginalized urban youth and a supposedly dysfunctional culture of poverty. In effect, public schools have participated in labeling and targeting urban youth as "public enemies" who resist educators' efforts to "uplift" them.

Hip-hop as a counter public space also mobilizes a resistance to forms of cultural consumption of commodified discourses in the hip-hop industry that distort the lived experiences of urban Black male youths. The dialectical tensions between Black male youths' "authentic" subjectivity within urban contexts in relationship to the power of neoliberal, corporate interests that fuel hip-hop's mass-marketed commodified discourses present a crucial site of critique of commercial discourses within capitalist patriarchy. These discourses have privileged North America's values of dominance, control, violence,

misogyny, materialism, etc. Counter public spaces of resistance in hip-hop can allow Black male youth to reclaim the power to subvert, challenge, and speak and give voice to their circumstances through creative self-expression and cultural practices of the art. Hip-hop as a counter public space can open up critical, dialogic praxis that allows us to read hip-hop texts within and against the traditional texts of the critical Black History tradition, Black Power movements of the '60s, and Civil Rights' texts. This requires that we think about how artists or texts within hip-hop culture can contextualize present moments in relationship to historical links with ideas of the past (Ladson-Billings & Donner, 2005, p. 294). In this way, we can make meaningful, relational, and intersectional connections between and across genres to better understand the continuum of the past, present, and future.

Finally, centering hip-hop as a counter public space of resistance for Black male youths means finding creative ways to open up more democratic spaces through nontraditional curricula and pedagogies that are in direct contrast to traditional "banking models" of education (Freire, 2004). For example, "hip-hop community centers as public spaces can be seen as sites of learning, critical reflection, and transformative knowledge production" (Prier & Beachum, 2008, p. 531). These centers serve as spaces where "students may engage in developing affirming identities in dialogue and interaction with others," and for youth empowerment and self-actualization (Prier & Beachum, 2008, p. 531). To paraphrase Freire, hip-hop may enable marginalized youths to "read the world" by naming the forces that oppress and silence them, and to thereby engage in the struggle to change their world. It opens up new opportunities for critical discursive dialogue and transformative action between urban communities and public schools.

One such hip-hop community center that represents a counter public space of resistance doing such critical reflective work is an after-school program, housed in what I will call the Open Mic Empowerment Center (OMEC). OMEC began in 2006 in an urban area of a northern rust belt city. The center is a federally funded after-school program in collaboration with the Office of Minority Health, the local university, local urban public schools, the department of parks and recreation, national hip-hop nonprofit organizations, and the city's

combined health district. OMEC uses the cultural practices of hip-hop as a form of violence prevention, and to enhance and promote positive affirmation and empowerment of African American male identity. African American male youth (9th and 10th graders) were designated as the targeted population to address specific areas of need, with respect to concentrated pockets of crime and violence in low socioeconomic areas of the community. The pedagogical purpose of OMEC is also designed to improve academic performance, curb the high school dropout rate through retention, and lessen the opportunity and chances of drug use. According to the health grant, OMEC is designed to reduce what they term "at-risk" factors amongst African American males from low socioeconomic status neighborhoods in urban, inner-city communities. It is the goal of the center to promote positive, healthier lifestyle choices amongst African American male youth; the center also utilizes the cultural practices of hip-hop culture to develop skills and talents that open up pathways to youth empowerment, self-actualization, and redefinitions of self and identity toward creating new hope and possibility in their future life aspirations.

OMEC runs a series of workshops developed around academic achievement (which focus on after-school tutoring); all of the cultural elements of hip-hop culture (e.g., deejay, emcee, b-boy/b-girl, graffiti, and entrepreneurship); physical fitness and recreation; effective life choices and decisions; transitioning from a youth to a young adult; the incorporation of language arts; career development; and various skill sets for leadership. These facets of the program all play an integral role in the curriculum and pedagogy at OMEC.

Also, OMEC works closely with high school counselors, parents, and community advocates of the youth in the program to identify existing challenges with the students; the center also provides mentorship and guidance on a weekly basis; and OMEC locates family, school, and community support networks that can assist in the improvement and success of the students in school and in life.

Finally, OMEC draws upon the culture of hip-hop to confront difficult life issues that students are facing in their everyday lives. The center selectively uses various lyrics of hip-hop artists to confront some of the painful realities and choices students are confronted with

on an everyday basis. The students are encouraged to use their own skills as local hip-hop artists for critical self-reflection and transformative social change. That is, students creatively use rap music to express themselves in ways that stimulate critical consciousness and promote more life-affirming possibilities that resist certain temptations of the streets. I would argue that given the nature and scope of the program, OMEC is taking a proactive, creative, aggressive stance of self-reliance and accountability; however, the progam's foci emerge in response and resistance to traditional methods, approaches, and institutional practices of schools that have failed to meet critical, life-pressing, issues and needs of these youth. It is the center's goals to work on empowering and developing youth for critical-cultural citizenship through hip-hop culture.

It's Like My Second Home

> This is the vacuum, the gaping hole, for the record, that created hip-hop culture, a predominantly poor Black and Latino male-initiated art form, in America's ghettoes right on the heels of the Civil Rights era in the late 1960's, early 1970's. And this is why hip-hop, to this day, with its contradictions notwithstanding, remains the primary beacon of hope for poor African American males. I cannot begin to count how many underprivileged Black males across the nation have said to me "Hip-hop saved my life." That speaks volumes about what we as a society and as citizens are not doing to assist the less fortunate among us. (Powell, 2006, quoted in Prier & Beachum, 2008, p. 519)

> Basically, I feel that you know what I mean, hip-hop culture is like it's our life, you know what I mean. It's our feelings, you know what I mean, it's um it's the struggle period. I mean you know we done been through a lot as far as history wise and it's a different thing. I feel like it's a way out. I feel like it's a way out for many colors, and a lot of other cultures too. (Lamar, local high school student and hip-hop artist from OMEC)

The pressures, experiences, and struggles with matters related to socioeconomic conditions of joblessness, unstable employment,

poverty, incarceration, and inadequate education are symptomatic of systemic rejection, institutionalized racism, and overall urban displacement of Black male youth in society. In such an oppressive state, they confront the vulnerabilities to violence and homicide that threaten to snuff out their very existence. These are the hidden effects upon a vulnerable population that our society has been indifferent to. These are the conditions, to restate the words of Lewis Gordon, "that place self-hood in conflict with humanhood" (2000, p. 87). The daily material effects of oppression and institutionalized racism are concrete realities for Black male youth. The public spaces in the streets, schools, and their neighborhoods have proven not to be free, safe spaces for the creative production of identity making. Increasingly, in an era of neoliberal urban school reforms, the public sphere, or spaces for civic engagement and critical-cultural citizenship, and alternative modes of political resistance for empowerment have contracted for these youth. That is, under constant surveillance and police repression, the threat of incarceration, the privatization and disinvestment in urban public schools, limited access to jobs and stable employment, and changing shifts and transformations of decent work due to globalization have confined and narrowed the public sphere in which urban Black male youth can survive. It is important to understand these realities not to submit to a finitude of inevitability, or that we have given up hope toward social change and transformation of these realities, no matter how difficult the task. However, it is to understand the discursive and material conditions that shape hardened attitudes toward life because life has been hard to them. In this regard, the question for us as radical, critical pedagogues is, how can we open up new democratic spaces and places where cultural citizenship can manifest in urban youth for their own private practices of transcending and transforming narrow spaces that have contracted the public sphere of their schools, neighborhoods, and the streets? Given the current state of affairs between urban youth, schools, and the larger society, how can we construct alternative sites of resistance that are more empowering and emancipatory to the humanity of these students' lives?

Haymes's work in critical pedagogy involves the development of conditions necessary for the construction of a pedagogy of place for

Black urban resistance. The need to develop a pedagogy of place for Black urban struggle and resistance is reflective of loss of space and place, due to oppressive institutional practices and discursive formations inscribed between race and the "urban" city by dominant, white mainstream culture. According to Haymes, the idea of place in the urban city is a culturally specific institution, and is assigned a set of meanings and values according to those who produce and circulate particular discourses in relation to these meanings and values (1995). Heretofore, Haymes argues that the legacy of white supremacy has attempted to define the terms and use of public space, predicated upon a racialization of Blackness in biological terms. The racial politics of what it means to be Black (e.g., dangerous, exotic, strange, intellectually inferior, uncivil) has impacted the racialization, and thereby political organization of urban space and place. This means that Blacks have been displaced economically, socially, politically, and racially within cultural specifications and definitions by white, capitalist, consumer culture. Haymes argues that state practices that have to do with the organization and redevelopment of urban space (e.g., gentrification); the access or lack of access to public spaces such as education, housing, employment, health, and welfare in the city; policing and repression of "dangerous" urban bodies; and the commodification of Black popular urban culture contribute to forms of displacement of Blacks in the city. The racialization and complexity of these spatial politics have left Blacks in search of space and place in the city. Subsequently, Haymes's work indicates that there has been an ongoing struggle, where the notion of place or urban territory is linked with the identity politics of Black folk, however not in essentialist, biological terms. In this way, in resistance to institutional practices of a white power structure, he asserts that there has been a need for Blacks to reclaim space and place within the cultural and political terrain of the urban city. Haymes argues that one way of doing this is by drawing from critical pedagogy in conceptualizing the development of a counter public sphere that takes into account the everyday lived experiences and marginalized circumstances of the Black community (1995). Subsequently, counter public spheres or counter public spaces enable Blacks to create an oppositional identity, and come to redefine on their own terms of how they make space,

place, and culture in the city. A counter public sphere incorporates the enactment of social identity, discursive opinion, and the social geography of urban space that take into account unequal power relations of dominant and subordinate groups who live in different spatial environments of the city (Haymes, 1995, p. 113).

> The concept of power is key to interpreting this positionality, to understanding how public spaces relate to one another in the context of the city. In particular, if power is linked to the production of urban meaning, then those public spaces located at the center of the city life dominate its meaning, and in so doing define the cultural and political terrain in which marginalized public spaces, in this case black public spaces, resist, form alternative identities, and make culture in the city. In this way, the physical space of the black ghetto is a public sphere, a culturally specific institution. Because inner-city blacks live on the margins of white supremacist domination and privilege, they have no other alternative than to struggle for the transformation of their places on the margin into spaces of cultural resistance. (Haymes, 1995, p. 113)

"Critical pedagogy in the context of the black city life has a crucial role to play in the production of counter-publics, in constructing political and cultural practices that organize human experiences in liberating ways" (Haymes, 1995, p. 114).

One of the ways in which Haymes talks about developing a pedagogy of place or counter public sphere for Black urban struggle is through bell hooks's notion of homeplace as a site of resistance. In *Yearning: Race, Gender, and Cultural Politics* (1990), hooks theorizes the idea of homeplace as a site of resistance that is helpful in how I think about the political utility of how students, staffers, and the director mobilized the hip-hop community center as a cultural site of resistance. For example, when I asked Eddie, who is a deejay, what brought him to the hip-hop youth empowerment center, he identified it as a second home, a space and place away from the streets. He offers, "this is my second home. I'm in these places more than I am at home" (personal communication, 12/12/08). Eddie says he barely walks the city streets, and is motivated by activities that will keep him off the streets. He jokingly says that his extensive commitment and

involvement at the youth center has caused friends and neighbors to question if he actually lives in his house. He became involved at OMEC through the recommendation of his friends who knew he had a passion for music. Eddie said he always had a big interest in music, and his friends were aware of that and strongly encouraged him to attend the center because music was a core focus of the center's program. Eddie also felt the center would occupy his time in a more positive manner than spending his time in the streets. "They say, they do everything you like to do, and it a keep you off the streets, and stuff like that, cause I do anything to keep me off the streets. I barely go outside" (personal communication, 12/12/08). Eddie liked the fact that the youth center was a good environment for he and his peers away from the streets; it was a place where profanity was not tolerated; it was also a place where he could work on his production skills of making beats in the recording studio of the center. His friends told him, "Man, you make beats and you like get to record and all types of stuff like that" (personal communication, 12/12/08). Eddie was also excited that it was an afterschool program. The importance of hooks's notion of homeplace, metaphorically and in the material sense, signifies the very urgent need for safe, nurturing, and caring spaces and places to go in a society that has rejected, narrowed, and limited human activity in the public sphere. To this point, the place of the center means a lot to Eddie. He constructs the hip-hop youth empowerment center as a second home, a place and space that resist the streets and the surrounding areas of his home. It is the music and homelike space of the center that have attracted Eddie to be a part of the program.

Jabari was facing domestic violence circumstances in his home. Subsequently, his mother sent him away to live with his grandmother, where the center is located. It was his grandmother who encouraged him to seek out the youth center to do something positive with his life. It was at the youth center where Jabari felt he could express himself through the art of graffiti. Jabari made emotional connections with the center, as it allowed him to self-actualize and express his creative talents and abilities through graffiti art. The art form not only allowed Jabari to express himself, but the center provided a creative space for experimentation of new designs he was developing. He

states, "I'm just like, aw I see spray paint, let me try this, and I just start doing different designs, just different lines" (personal communication, 12/12/08). Jabari says he is extremely passionate about his art, and is constantly working on his drawing, spray painting and sketching out new ideas. The center has enabled Jabari to express himself in nonscripted, nonstandardized ways that, consequently, opened up new imaginative possibilities for the creation of new knowledge construction through the cultural practice of graffiti art. He states the passion he puts into the artwork of graffiti enables him to take his mind off the stresses he has to deal with outside the youth center. Subsequently, the center and cultural practice of graffiti provide him with a kind of homeplace away from the realities and struggles in his home life.

Lamar also speaks of the culture of hip-hop more broadly as a homeplace as well. He states, "The way we look at it is hip-hop is a home for all God's children period...everybody he created. Anybody can do it" (personal communication, 12/12/08). Lamar sees the culture of hip-hop as a space and place that has no boundaries, rules, regulations, or limitations as to who can participate and have access to the culture. He also states that urban youth are attracted to hip-hop because it's "one way where we can express our self without having a degree in this and all that, and it's basically like an American sport now." Lamar can find a "home" and place through the culture of hip-hop because one's participation is not dependent in relation to the over-obsessive credentialization and hierarchy of obtaining degrees in schools, which implicitly, he underscores, have excluded, limited, or confined education removed from being a democratic practice for young people. Organizing a pedagogy of place of resistance for Black urban struggle is very much about mobilizing cultural practices of hip-hop outside the traditional political economy of the state (Haymes, 1995). Implicitly, Lamar's remarks about the current system of schooling suggest that through its classification, hierarchy, and standardization is reproducing systems of inequality that segregate students between college prep and industrial, between working class and managerial, between manual labor and service sector occupations (MacLeod, 1987). It is this political system that was designed to stratify and segregate the upper and lower classes of society. Subse-

quently, Lamar suggests that finding a home and place in hip-hop is about creating new cultural models of self-actualization (Haymes, 1995) for the expansion of democratic practice in urban education (Dolby, 2003).

It is also through the construction of a homeplace where communal bonds of emotional investment for nurturing, care, self-recovery, and political resistance to structures of domination contribute to how the students constructed the center as a pedagogy of place for Black urban resistance (hooks, 1990). For example, many of the students felt that the center was a homelike atmosphere where they could talk about difficult life issues with staffers and the director of the center, whom they referred to as father figures. The students felt comfortable in approaching staffers who were seen as mentors at the center for encouragement and advice in how to make decisions about their daily struggles. PJ states that he and many of his peers grew up without fathers. Subsequently, over the course of time spent at the center, he and other students have established a level of trust in the staff in such a way that they bring their problems to them as they would their own fathers. He states, "So you know you get somebody that you close to and you talk to…and you a look at 'em as a dad so they can help you get out from what you was doin', and keep you from being dead or locked up" (fieldnotes, focus group session, 12/3/08). Some of these students have been caught up in life or death situations, and have been misguided in being alone in the streets. In this sense, it is the construction of a homelike atmosphere, a place where one can go to, not only to find a safe space from outside practices of oppression, but to do the inward political work of self-recovery that defines it as a homeplace (hooks, 1990). While hooks talks about Black females as the traditional forebears of domestic politics in the household as caregivers, nurturers, and teachers, she does not limit this type of care and guidance to females. She actually supports and advocates new models of manhood and a progressive politics where men take up these roles as well. Whereas, students may not feel as comfortable discussing their challenges at school, Demetrius says you can talk about anything at the youth center without being ridiculed. He states, "Then we can talk about stuff, like, stuff like, we going through without nobody laughing or anything" (personal communication,

12/12/08). In this way, the hip-hop youth empowerment center provided a pedagogy of place to discuss difficult life circumstances without embarrassment, shame, or blame. Reggie, the director of the center, speaks about the center as an alternative homelike atmosphere in this way:

> Reggie: But there going and they're being asked to perform [in school], but they're waited with stress, and with burden, and with emotion, and they got all kinds of stuff happenin' in their homes, and they don't have outlets. Many of our kids don't feel heard. So to find a place [hip-hop youth empowerment center] that allows them to speak, and not just be spoken to is powerful. Their voice is liberating. (Personal communication, 9/12/08)

It is a space and place in which students feel comfortable to speak what's normally unspoken, to break the silence of pain (hooks, 1990). In addition, students saw the youth center as a home because they had developed close bonds with each other in a similar manner as a family. The idea of a family at the youth center gives them a sense of a home, some place to go to that aids in their resistance to structures of domination that may be at work in their lives. It is evident of students sense of family and home when students such as a PJ make statements such as, "We have topics we talk about. We all go out to eat like a family" (fieldnotes, focus group session, 12/3/08). Demetrius also spoke about the close bond he and his peers had developed at the center as he too sees the youth center as more of a family.

A homeplace provides a community network of resistance and support for guidance, encouragement, and love that politically affirms the students' struggles for humanization (hooks, 1990). For example, Eddie and Roy see the youth center as a place that teaches you how to make the right decisions in certain situations, and motivates them in how to succeed in life as young men. Roy added that the youth center taught him to "keep my head up" and be resilient, despite whatever obstacles he faced. Eddie states that the program is built around mentors who want the students to make the right decisions, and choose a positive direction in their lives. The students received political gestures of love and compassion from their mentors, who were simultaneously seen as father figures and as an extension of

their family. According to the students, the male staffers and the director of the center have taken up the progressive role as caregivers, nurturers, and teachers who provide guidance to the students when having conversations about difficult choices and decisions they have to make in their everyday lives. The development and construction of a pedagogy of place in urban territory are tied to cultural processes of identity making in the city. It is the space and place of the center that enabled students to do the difficult work of inward self-recovery, renewal, and healing of the self. Similar to PJ, Rasheed feels that he and many of his peers might have succumb to the vulnerabilities of jail or prison if it would not have been for the presence of the youth center in their lives. He states that being at the center prevents his involvement with negativity that he frequently sees in the streets. Rasheed says that time spent at the center has been positive in his life, and has changed his old ways for the better. He admits that prior to coming to the center he was accustomed into doing things that could get him into jail. However, he states "then you come here, and then you stop doin' what you doin; it changes us a little bit" (fieldnotes, focus group session, 12/3/08). For hooks, the idea of a homeplace allows one to heal inwardly from racists' oppressive structures of domination, and in the development and nurturing of one's spirit (1990).

In addition, reading the students' critical self-reflection journals, some of the students indicated that the hip-hop youth empowerment center was a way out of the hood. In group discussion, some of them expanded more on what they meant, regarding how they construct the center as a pedagogy of place out of the hood. For example, Rasheed states that the youth center is a place where one leaves all their pains, disappointments, and other struggles behind them. Tyrone says the center "take your mind off a lot of stuff" (fieldnotes, focus group session, 12/3/08). Referring to Nancy Fraser (1991, p. 69), Haymes calls this a process of withdrawal and re-groupment (1995). One is enabled to withdraw from the harsh external realities of urban displacement, regroup, and create a new pedagogy of place where one can remake oneself anew at the center. Some of the students referred back to the phrase "trapped" as the signifier and meaning of confinement and repression within urban spaces and places of the

city. As Aaron suggests, you get away from the trap "Mentally not physically. You can't get away from it" (fieldnotes, focus group session, 12/3/08). He states that the center keeps one's mind off of the harsh realities of confronting the traps of urban society. In this regard, much of the group saw the space of the center not necessarily as a space that ended all of the inequitable material realities they had to confront in their communities. However, the center provided what critical race studies scholars would call social and psychic spaces of self-preservation against structures of domination. According to Haymes, part of the political work in developing a pedagogy of place for Black urban struggle and resistance is about constructing a place where one can heal inwardly for those who daily face institutional structures of repression in urban inner-city life (1995). In this regard, Aaron is hinting at the momentary internal relief in resistance to external practices of marginalization. In most critical discourses, such as critical pedagogy, there is always a linkage between critical con-sciousness, critical self-reflection, and social transformation with respect to the mind and material reality. Critical awareness about oppressive realties and critical self-reflection about what those reali-ties mean in one's life enable one to think differently about actions, choices, and decisions that impact whether one chooses to live or die, or comply, for example, with a nation-state predicated on the dispro-portionate imprisonment and incarceration of Black people in the United States. This is crucial to the work of transformation in the material world because there is an explicit political attempt at altering and transforming oppressive circumstances impacted by inequitable material realities. For example, resisting acts of what Freire calls horizontal violence amongst one's own oppressed group becomes a political intervention toward social change and transformation of material reality. In this regard, what education means more broadly to one's own life that is politically more empowering to one's every-day circumstances is a part of the work of constructing a pedagogy of place for resistance and Black urban struggle. For example, PJ talked about the difference the center has made in his life since he first started the program. It was during the beginning of the youth empowerment program when the staff first asked him what he would be doing with his life if he chose not to participate in the program. He said his honest

response was, "I told 'em, either locked up or dead...because the simple fact that, what I was doin'" (fieldnotes, focus group session, 12/3/08). "It is important to remember that black public spaces in the city have historically been centered around daily survival; it is these "spaces of survival" that serve as public spaces where Black people develop self-definitions or identities that are linked to a consciousness of solidarity and to a politics of resistance" (Haymes, 1995, p. 117). Subsequently, PJ is here for additional purposes other than just his motivations for rap music. While he is passionate about rap music, he states there are life affirming reasons of hope and possibility toward a new future that also gives him motivation to participate at the youth center. PJ said the youth center has literally saved his life. Similar to Rasheed's comments, PJ states that time spent at the youth center has shifted his focus away from activities on the streets. Developing a pedagogy of place for Black urban struggle allows urban youth to overcome and resist nihilistic mentalities about life, death, and imprisonment, and is considered a political act of resistance. This is a part of the inward work of self-recovery, renewal, and transformation that can take place in the kind of homeplace of the hip-hop youth empowerment center.

Eric Watts states that given that our youth come from urban centers blighted with poverty and an educational system overwhelmed and underfunded, it sometimes follows that kids see themselves as damaged or deficient (2004, p. 595). Drawing from William Julius Wilson and Elijah Anderson, sociologist L. Janelle Dance suggests that the labeling and pathologizing of Black males by the police, the schools, employment, and welfare agencies weaken the resolve of these students (2002). Subsequently, these students' counter position takes the forms of hard core attitudes (or gangsta posturing), survivalistic tactics, and anti-mainstream sentiments in the streets where they reside. More specifically, Dance argues that the wear and tear of mainstream rejection deflates and levels aspirations; creates fertile ground for survivalistic, anti-mainstream sentiments; and renders Black male youth from low income urban communities vulnerable to involvement in illicit street culture activities (2002, p. 5). Therefore, it is no surprise that some of the students see prison and death as a normal way of life that happens in their communities, when we think

about the racialized normalization and massive overrepresentation of incarceration rates and Black on Black homicides for Black males all over the country. For example, Marquis expresses his gratitude in having the hip-hop youth empowerment center in relationship to his thoughts about death amongst Black males in urban life of the city. He states, "This a legendary program cause in this city we'd never thought we was gone have this man, cause this the city of what, this the city of where skinny dudes die, you feel me" (personal communication, 12/12/08). His statement of "the city of where skinny dudes die" is a reference to the rap lyrics of Tupac Shakur. From memory, he appropriates the lyrics to a song entitled "Str8 Ballin'" from Tupac's 1998 album, *Thug Life*. On this track, Tupac raises a rhetorical question, asking how can he survive in a city where "the skinny niggas die"; he later states "Even when they kill me/they can't take the game away from a young G..." (1998). Tupac often spoke frankly about the existential realities of Black on Black homicide in urban communities amongst Black males. "Black men ages fifteen to twenty-four are victims of homicide at a rate of 85 per 100,000, while the rate in the general population is only 6 per 100,000. In 2005, 49 percent of murder victims were black, and the majority of that black victim population was male" (Perry, 2008, p. 171). It is within this context that Marquis draws upon Tupac's text to make connections between the perception of life prospects for Black males in his own city in relationship to Tupac's sense of the tragic (West, 1994) about Black on Black homicide. Given the vulnerable circumstances of these students' everyday lived realities, many of them stated that the center has preserved the state of their very being and existence. Cornel West has stated that we are in a moment in which these youth feel a sense of nihilism, or a state of meaninglessness and hopelessness about life's opportunities, given the current state of affairs (1994). He states that it is the eclipse of hope, and the absence of struggle to survive life's crushing circumstances, that induces the nihilistic threat to very sustainable forms of existence upon which Black communities depended, historically (1994). For example, PJ hints at the vulnerabilities to West's notion of the nihilistic threat, but has not resigned or submitted himself to it. Therefore, the meaning of the space and place of the center for PJ is constructed as a space of resistance against death and imprisonment.

PJ often struggled with issues of life, death, and imprisonment throughout group discussion, as his father was a firsthand point of reference who was shot and went to jail through his involvement with the underground market economy of the streets. Marquis remarks about this being "the city where the skinny dudes die" and some of the other students' comments about jail and imprisonment all reflect some sense of despondency and despair, and why the center is so important to their lives. It is in this sense that the space and place of the Open Mic Empowerment Center allowed many of the students to talk through difficult circumstances such as these, as part of the inward work of self-recovery (hooks, 1990).

Reggie, the director of the center, has worked with these youth for several years, and understands the complexities of these sociocultural dynamics that urban Black male youth are confronted with in their daily lives. Subsequently, he talks about some of the immediate goals that remain central to the curriculum and pedagogy of the Open Mic Empowerment Center. He states, "The immediate situation is to have them engaged in very positive activity that will enhance their chances of living cause these brothas are struggling with issues of death and imprisonment..." (personal communication, 9/12/08). Reggie was very cognizant of urban youths' preoccupation and expectation of life futures that seemed to point toward incarceration or death. It was not so much that students wanted to end up incarcerated or dead; however, tragedy had become so much a part of their daily lives in what they had seen in their families that many had come to expect they would assume the fate of their fathers, grandfathers, cousins, brothers, uncles, etc. who had gone through such experiences. This was the unfortunate reality of the social world in which they observed in their immediate surroundings. Subsequently, Reggie stated that his immediate goals with the students at the youth center was to engage them in positive activities that would attempt to buffer against the tragedies that many students had come to expect in their lives. He wanted them to understand that they could become subjects and change agents over their own lives, and they didn't have to submit to being an object, where life acts upon you and determines your reality in a preconditioned manner. Despite all of what they had seen, heard, or experienced in their lives, Reggie wanted them to know they had the

power and agency to be different from the tragedies they had observed. In addition, he wanted to students to value the talents, skills, and abilities they possess, and with these attributes to know and understand they have something powerful, meaningful, and important to contribute to society. Reggie also wanted the students to realize they could set high goals and aspirations for themselves, and that they could realistically achieve the goals they had set for themselves if they stay focused. He states, "And I want these brothas freed up to truly believe that they can make a difference in the world" (personal communication, 9/12/08). In *Pedagogy of Freedom: Ethics, Democracy, and Civic Courage* (1998), Freire talks about an openness to dialogue (p. 120) that I think is instructive here in understanding the relationship between Reggie and his students at the center. Reggie gives recognition to the social world out of which students experiences emerge as a pedagogical context for understanding the subjectivities of where students are located. It is this context that informs Reggie's openness to their world, and how he can politically intervene on behalf of these students that defines his openness to dialogue with them. Freire states,

> There is no doubt in my mind that the material conditions under which the students live give them the wherewithal to comprehend their own environment as well as the capacity to learn and to confront challenges. But, as a teacher, I must open myself to the world of these students with whom I share my pedagogical adventure. I must become acquainted with their way of being in the world, if not become intimately acquainted then at least become less of a stranger to it....My openness to a world that is life denying as far as my students are concerned becomes a challenge for me to place myself on their side in support of their right to be. (1998, p. 120)

The making of a pedagogy of place for Black urban resistance is about making space and place where one can confront tragedy and hardship, pain and anguish, and resist the impact of institutional structures of repression. The formation of a pedagogy of place through the Black public sphere allows one to interpret reality in more emancipatory ways (Haymes, 1995). The metaphorical idea of hip-hop as a homeplace for these students is about "making homes

where all black people could strive to be subjects, not objects, where one could be affirmed in our minds and hearts despite poverty, hardship, and deprivation, where we could restore to ourselves dignity denied us on the outside in the public world" (hooks, 1990, p. 42). Reggie sees the space of the center as a way in which to transform and reposition the object-subject location of students. Remember, in the top-down vertical relationship in schools, students are typically told what to do, assumed not to possess any knowledge, and are seen as receptors of what teachers tell them. Freire calls this the banking system in education. In this sense, students are traditionally seen as objects, who are normally spoken to, spoken about, and deemed as having no authority from which to speak. However, in resistance to these ideas Reggie sees his role as opening up dialogue with them so they may see themselves as subjects who can be producers of their own knowledge, and who have a sense of agency to politically intervene on the world in order to transform the predicament of their circumstances. This too is a part of the inward work of self-recovery, a place in which one can heal (hooks, 1990). "Teachers and students (leadership and people), co-intent on reality, are both Subjects, not only in the task of unveiling that reality, and thereby coming to know it critically, but in the task of re-creating that knowledge" (Freire, 2004, p. 69).

Critical Pedagogies of Resistance in Rap Music

The production of counter public spheres in development of a peda-gogy of place for Black urban struggle and resistance crucially allows one to speak in one's own voice (Haymes, 1995). Haymes argues that a central way in which the formation of a pedagogy of place can come about is through Black popular culture. He states that Black popular culture is reflective of the production of urban meaning in the city, and the production of urban meanings in the city is reflective of Black popular culture. For example, Marquis says that one of his goals as an emcee is to represent his city. It is through his rhymes where he wants to show love to his city, and give his listening audience an authentic representation of the city. Marquis wants to tell the people what life is like in his city, and to dispel the myths and showcase the social

realities of the city. Letting people know about his city, what it represents, and what life is like for those who live in his city is important to Marquis because he feels that most people across the country don't know much about life in his small local hometown as they do in cities such as New York, L.A., and Atlanta. As a rap artist, remaining "true" in representing the authentic life experiences in one's city has always been important in hip-hop music. In many cases it is almost impossible to separate the artist from their hometown as key symbolic meaning to their brand and identity. For example, it's difficult to separate Jay-Z from New York, T.I. and Ludacris in Atlanta, Lil' Wayne in New Orleans, or Kanye West's hometown roots in Chicago. These artists frequently speak about their cities in much of their lyrics. As a result, their listening audiences know more about their hometowns, the struggles they have had to endure in their upbringing, and how these struggles and experiences in their cities have helped to shape the identities of these artists and their outlook on the world. Subsequently, Marquis says he wants to represent his city in a similar manner as more iconic rappers have done for their cities. He and Evan then suggest that representing one's own city through rap will gain one some name recognition in his local community. Marquis also suggest that telling about the experiences of what happens in their city is also a form of love, respect, and appreciation for one's city and how it has shaped them. As a form of Black popular urban culture, rap music, and hip-hop culture more broadly, is reflective of urban youths' meanings they produce about their everyday lives and realities in the urban city. Marquis's construction of meaning about the city through the cultural practices of rap represents Haymes's discussion on making space and place in the city, which links identity politics of Blacks in relationship to urban territory. This is part of constructing a counter public sphere through the social geography of urban space within unequal power relations of the city. In this regard, the significance of name recognition of the city, and the experiences lived in the city, is intertwined with, and simultaneously a part of, Marquis's and Evans's identity altogether. This is a part of the conditions by which Blacks in urban territory can develop a pedagogy of place in the city through Black popular urban culture. Therefore, the formation of hip-hop as an urban youth

subculture, and the cultural practices that derive from it, can be central to the larger question of how students utilize Black popular urban culture in the construction of Haymes's pedagogy of place for Black urban struggle and resistance.

Black popular culture, if recontextualized from its more commodified forms, is the voice of the Black urban movement (Haymes, 1995, p. 138). For example, as it relates to the cultural practices of hip-hop, the director of the center, Reggie, is a proponent using the art in a more liberating, empowering, and critical fashion for these students. He states that he often meets young local artists who say they will be next big thing in the commercial industry of hip-hop. Reggie says they rap about fictitious money, cars, and women they don't have as a cover up in avoiding more life pressing issues. Subsequently, he and his staff at the youth center encourage urban youth as rap artists to take a more introspective look at themselves to share with the world a set of experiences society can learn from.

> Reggie: That's where you take a chance when you tell the world something about you. When you start to look at you critically. And, you know, without just an entertainment value. Without sayin' I'm this alter ego, I have money that I don't have. I got women that I don't have. I got bling. I got this, I got that. (Personal communication, 9/12/08)

In chapter 2, I outlined three different discursive genres within the culture of hip-hop (i.e., social/political, gangsta, commercial discourses). When Reggie works with his students he is advocating a kind of resistance to market-driven values of corporate, commercial discourses in hip-hop related to sexism, misogyny, and the "bling-bling" era of narcissistic opulence. There are "competing identity tensions for Black male youth within commodified forms of hip-hop culture, which can indeterminately affect the values of these youth within a market driven culture of consumption" (Prier & Beachum, 2008; West, 2004). Haymes argues that the manipulation of Black popular urban culture in the city, through privatization and corporate consumption, has silenced the narratives, experiences, histories, and popular memories of Black folk in how they make space, place, and

culture in the city (1995). Subsequently, dominant, mainstream, corporate, commodification and consumption of Black popular urban culture attempt to take away spaces and places where Blacks can construct a pedagogy of place that draws from historical and social references as context for cultural models of identity making. There has been an attempt to silence the histories, experiences, and struggles for resistance of Black folk that enable more emancipatory practices of making culture in the city. According to Reggie, it is about using the music to let one's voice be heard in a more critical manner, frequently located in social and political discourses of the art form. These discourses politically resist market-driven discourses in the hip-hop industry. As it relates to hip-hop culture, "It is important that we distinguish our acknowledgement from the negatives that corporate interests promulgate violence, racism, misogyny, and crass consumerism" (Ladson-Billings & Donner, 2005, p. 293).

Subsequently, urban Black male youth at the hip-hop youth empowerment center are developing a counter public sphere or counter public space in their production of meaning about the city through hip-hop culture and rap music. However, they recontextualize the culture and practice of the art from its more commodified commercial discourses that have been destructive or unhealthy to Black life, as seen, in chapter 5, on *being that dude*. They discuss the meaning of hip-hop as being quite different from its commercial representations. Students, such as Monte, suggested that rap music was about "people putting their life in lines and bars" (fieldnotes, 12/3/08). Anthony offered that hip-hop was a cultural means of expressing oneself, while Evan stated, "It means a story of someone's life who been through a struggle or a problem and life" (fieldnotes, 12/3/08). Similarly, Ray says that rap music tells us something about a person's everyday surroundings, and how they grew up in their local communities. Tyrone added that if lyrics in the music are represented as an authentic narrative, it can inform the audience on what might be happening in an artist's life. In students' reflection journals, the critical discursive space of rap music enables artists to articulate their way of life that emerges from a particular kind of urban struggle in the city. There is an emphasis upon cultural expression that is reflective of one's narratives and lived experiences in the city. Marquis and Dewayne

also suggest that rap music becomes the location and discursive space by which students feel free to express themselves in more meaningful ways that contrast with commercial discourses frequently celebrated in the mass culture of the hip-hop industry. While Dewayne suggested that hip-hop was a means to express oneself, Marquis said the hip-hop youth center taught him that he can express himself in a more substantive manner "instead of just rappin' and not sayin' nothin' like" (fieldnotes, focus group session, 11/19/08). PJ applauds the efforts of one of his peers at the center who he says is an example of someone using the art of rap music to introspectively discuss real issues going in his life. He says this person is quite different from some iconic rap artists who may use the experiences of their family members' lives as their very own narratives when they may not have gone through any of those experiences. Unlike these artists, he says his fellow peer at the center is a respected artist because he is not talking about living a rich lifestyle he doesn't have, living in a neighborhood where he has no residence, or being involved in criminal activity or the criminal justice system that has not been a part of his lived experiences. PJ says this artist is very intentional about remaining true to himself and "He ain't just makin' up somethin'..." (fieldnotes, focus group discussion, 11/19/08). Marquis emphasizes the point that it's not just about rappin' and not "sayin' nothin'." According to this student, one must have something important to say that goes beyond impotent rhetoric (frequently seen within market-driven, commercial rap) when communicating through the cultural practice of rap music. PJ and Demetrius affirm Marquis's point in stating that artists at the center value the importance of giving authentic representations of themselves and their craft as rap artists. Remember that Tricia Rose states that the ghetto, or what Haymes would call urban territory in the city, has been the main signifier of authenticity in rap music (1994, 1995).

PJ also sees Robin Kelley's point that we must also take into account the performative, aesthetic element of rap artists that includes the way something is said versus the presumed "authentic" meaning of Black life of what is actually said (Kelley, 1996, p. 190). He uses the example of Scarface, a well known hip-hop artist for his street storytelling abilities. PJ suggests the listening audience is aware that

Scarface is telling a story from beginning to the end of the track. He says the listener is able to distinctly recognize a story is being told, what key events unfold throughout his stories, and when that story ends in that particular song. Given that we know Scarface is telling a story, PJ says it doesn't matter if the story is Scarface's own personal narrative. He states the main point of Scarface's music is the meaning of the message through the storytelling of his lyrics. Subsequently, he says the focus is on the story itself and what we take from it as opposed to a rap artist's misleading accounts of how he has "kept it real" in the hood. In this context, PJ does not deny genuine efforts made by many artists who value and utilize rap as an expressive cultural art form. However, Kelley states that what the artists are communicating is not always reflective of their own authentic lived experiences or the monolithic, essentialized representation, character, and behavior of Black life (1996). He states that it is the style and aesthetics of how the artists communicate their stories in rap music that is crucially important as well. To give PJ's comments some context, Scarface is considered a veteran in the world of hip-hop and rap music. He often speaks in third-person voice, which communicates to the audience that he is a kind of street ethnographer who gives various representations of life in the urban city through participant observation. That is, all who have listened to the narrative structure of Scarface's songs clearly understand that there is no blurred line between life imitating art and art imitating life. In other words, he "kept it real" through popular memories and authentic representations of stories about urban life that he was narrating in his music. Subsequently, the students at the youth center mobilized and understood the cultural practices of rap music in ways that contrasted with the market-driven discourses within the commercial industry of hip-hop.

In constructing a pedagogy of place for Black urban struggle, Haymes argues that critical pedagogy enables Blacks to come to terms with their own voice, to develop a critical consciousness that allows them to articulate their own experiences with place making in the city (1995). Aaron suggest there is a level of relief from one's own everyday struggles when you are able to hear an artist put similar experiences in their rhymes and talk about how they have dealt with those

Culturally Relevant Teaching

experiences. He says that when you have gone through what the artist is speaking about, one is affirmed in the recognition of not being alone in experiencing everyday urban struggles in one's neighborhood community. Aaron argues that being affirmed in listening to what he calls "true hood events" that are relevant to urban youth is no guarantee of being free from the trap of urban struggle. However, he states a sense of relief happens because urban youth learn and gain perspective from how rap artists have tried to emerge positively out of a rough set of circumstances. In this context, people of color can listen to the counter narratives of others that are relevant and relational to one's own lived experiences, which provides new methods or modes of coping with or subverting and transforming circumstances of oppressive realities at the margins of dominant culture (Delgado & Stephancic, 2001; Ladson-Billings, 1999). For example, many students identified with the lived experiences and narratives of hip-hop artists such as Tupac. For instance, Jabari states that he resonated with Tupac because he feels the way Tupac felt when he spoke about his life circumstances. He appreciated the film I had shown entitled, *Tupac's Resurrection*, which he states, "remember when you was tellin' us about the whole Tupac thing. You gave us the whole video and everything like that. That was education. That was a very good education" (personal communication, 12/12/08). He also mentions that other videos were shown at the center, which featured artists such as Ice Cube, who he says also incorporates hip-hop and education into their music. Similarly, Marquis said he felt the pain Tupac felt because he has witnessed some of the same tragedies and obstacles in his own home life that Tupac experienced. When I asked Marquis if he agreed with Tupac's often graphic approach when explaining tragedies and struggles in ghetto communities to effect social change he said he agreed. Marquis felt that Tupac often shared graphic narratives to get people to pay attention of what's happening in these communities to provoke change in the larger society so that these events could stop. He said this was Tupac's way of sharing "a little piece of his ghetto lifestyle" to inform the masses so that these conditions could change. Rasheed and Demetrius added that Tupac was speaking about real life issues that were happening in urban communities. In addition, Eddie redefines the potential and possibili-

ties between knowledge, education, and learning through his critical reflection of Tupac Shakur in relationship to Black male life in urban society. He saw Tupac as organic intellectual who used the streets to communicate life lessons about everyday lived experiences of African American males in the streets. According to Eddie, the concrete realities of the streets served as a form of critical pedagogy for Tupac, as a means to reach urban youth of the hip-hop generation. These students provide a more critical and emancipatory interpretation of social reality because there is a period of critical self-reflection between Tupac's life in relationship to their own. The reclaiming of the biography, history, narrative, and lived experiences of Tupac was empowering for the students because they could relate and identify with what he went through as pedagogical context for their own lives. Haymes asserts that Black popular urban culture is reflective of urban lived realities in the city, and life in the city is reflective of values and experiences circulated and produced in Black popular urban culture (1995).

The director of the center argues that the study of hip-hop texts can be a bridge into the social world of the student, and can serve as a kind of education for critical consciousness and transformative thinking for Black male youth.

> Reggie: It offers them all kinds of opportunities for self-expression...using hip-hop as a backdrop to talk about, you know, gangs and violence and drugs and tying that in with, the lives of folks who have been right there on the front line with that stuff, with the Pac's and with the Biggies and with the Ice Cube's.... (Personal communication, 9/12/08)

Although schools may not recognize or value the culture of hip-hop, as it is not a part of the standardized curriculum, Reggie maintains that artists such as Tupac, Biggie, and Ice Cube are reflective of the social world that many urban Black male youth come from. Reggie's remarks reflected the sentiments of the students. That is, you cannot dismiss the entire culture of hip-hop without simultaneously dismissing the complex lives and experiences of urban Black male youth who reflect the realities that many of the artists are speaking

about. "Black males must see themselves in the work they read, write, or speak about....These particular texts engage most critically the everyday lived realities of black males coming of age in inner city black ghettoes" (Prier, 2006, p. 26). The director of the youth center understands that using hip-hop as a teaching tool for urban youth to critically learn from relevant experiences relational to their own lives is not a part of the mainstream curriculum in urban schools. However, he states that urban schools may need to rethink traditional teaching practices in education that are removed from contemporary, Black popular urban youth culture. This is a part of the social world that urban youth emerge from. How urban youth critically reflect on their experiences in the urban city through Black popular urban culture is a means to redefining the terms of place making. The act of making culture in the city through Black popular culture demonstrates the creation of counter public spheres that resist white mainstream notions and values as to how one can make space and place in the city.

In an effort to resist commercial discourses in hip-hop (absent of historical and social contexts to identity making), the center also reclaims the historical and social references in what shapes the political, social, and racialized context of hip-hop. This proved to be very important to the students' construction of a pedagogy of place for Black urban struggle and resistance to hip-hop as a market-driven form of voyeuristic entertainment. For example, Demetrius and Marquis suggest it is important to understand the historical context of hip-hop, and why the cultural art-form has emerged in ways that extend beyond just the lyrics in rap music. They suggest that one cannot fully understand rap music and the culture of hip-hop just by reading the words of an artist's lyrics. Subsequently, they suggest it is important to understand the historical context of the messages and meanings behind the lyrics that an artist is rhyming about, and why artists have chosen to express themselves, using the particular phrases and words they articulate in their music. In addition, Marquis reiterates the fact that one cannot understand the music and culture if one doesn't understand the history that has shaped the culture of hip-hop. The students advocated for the production of meaning about urban life in rap music that provided historical and social contexts to the

words that are spoken by the artists in the culture. In contrast to the consumption of commercial discourses of the hip-hop industry, Lamar also sees hip-hop as a way of life and urban struggle, beyond a market-driven form of entertainment for corporate consumption practices.

> Lamar: Basically, I feel that you know what I mean, hip-hop culture is like it's our life, you know what I mean. It's our feelings, you know what I mean, it's um it's the struggle period. I mean you know we done been through a lot as far as history wise and it's a different thing. I feel like it's a way out. (Personal communication, 12/12/08)

According to Lamar, there is a historical context to the meaning and cultural production of hip-hop as a way of life. In understanding hip-hop culture as a way of life for young people, it "centers *their* struggles and experiences in an oppressive society" (Prier & Beachum, 2008, p. 530). When Lamar speaks about hip-hop being the struggle, he is talking about how urban youth have come from destitute circumstances of nothing, and using the culture of hip-hop as a method and means to making their lives into something. He suggests urban youth have found creative and innovative ways to employ the cultural practices of hip-hop into entrepreneurial endeavors that have helped them survive urban struggles in their communities. He states that hip-hop is "A way out of the dungeon, the basement, bottom of the spectrum...Hip-hop is...a way out of the hood" (personal communication, 12/12/08). Lamar understands hip-hop culture as a way of life that emerges from urban working-class conditions. At the same time Lamar sees the culture of hip-hop emerging from low socioeconomic conditions of urban struggle. It is these same conditions and spaces of marginalization that fuel his resilience to transform the predicament of his circumstances through the culture. He draws from the creative and innovative aesthetic of hip-hop that draws from limited resources to transcend the boundaries that would otherwise limit structures of opportunity for urban youth. It is the attitude of struggle and resistance in hip-hop that can be traced back to the Civil Rights Generation. There are some interesting pedagogical possibilities in what both generations can learn from

each other as we move forward in matters of social justice in urban education for the 21st century. I discuss these matters in the next section.

Microphone Politics and Urban Resistance between the Civil Rights and Hip-Hop Generations

In the development of a pedagogy of place for Black urban struggle and resistance, all critical pedagogues understand that present-day challenges and circumstances for oppressed communities have historical and political contexts that have played a significant role in shaping these present realities. Subsequently, understanding urban struggles of resistance mobilized by freedom fighters and urban social movements from the past as contexts for mobilizing present-day struggles of resistance is considered a politically subversive act of resistance. The act of developing a pedagogy of place to reclaim popular narratives, histories, and memories of activist, social, and political movements of the past to provide insight into contemporary movements, such as non-market-driven forms of hip-hop, is integral in the development of a pedagogy of place for Black urban struggle and resistance. Rearticulating the past as context for the present is significant to the development of a pedagogy of place for narratives, histories, experiences, and popular memories of Blacks that have not been given a place in dominant, mainstream popular culture. Subsequently, the center circulated visual and linguistic texts within the historical context of the Civil Rights Movement and Black Power traditions of the 1960s, early '70s. The center also circulated works written and produced by contemporary hip-hop intellectuals/filmmakers/artists, which were visibly placed alongside one another on the shelves.

One of the ways in which OMEC reclaimed popular memories of the past in relationship to contemporary struggles of the present was through the explicit production of what I term to be critical, sociopolitical, hip-hop texts. These are texts within the genre of hip-hop/contemporary popular culture that produce critical narratives, experiences, and histories regarding the social, political, and racial inequality of marginalized communities. Such texts foreground the

pedagogical conditions upon which urban youth are provided with a language of critique that analyzes the role of power, culture, and ideology in urban society through relevant, popular cultural texts of hip-hop in semiotic and linguistic forms. It is through their reading of critical hip-hop texts where students draw from and reclaim popular memories of the critical, Black history tradition in relationship to contemporary history of the hip-hop generation. Forging an intertextual bridge between both histories and generations provides students with a critical consciousness about past and present-day realities and struggles of social inequality that might guide transformative efforts of urban youth toward social justice (Prier & Beachum, 2008). The politics of this pedagogy created the conditions by which students could then use this critical knowledge through the cultural practice of the art form (e.g., emcee, deejay, graffiti, b-boy) as transformative and empowering actions in their own lives. For example, I noticed the chalkboard was inscribed with the different ideological philosophies between Malcolm X and Martin Luther King Jr. Malcolm's column read, "to own land, justice, accept other groups, equal treatment, freedom to speak, self-defense, self-definition, self-determination, Black unity, By Any Means necessary." Martin Luther King Jr.'s column read, "non-violence, integration, national unity." Across from the chalkboard on an adjacent wall there was a large poster of Tupac Shakur next to another large poster, inscribed with the words "courage" and "empowerment." The presence of both texts across the Civil Rights and hip-hop generations suggests the center's historical connections between the past and present cultural and social movements of the Black community.

The students saw Shakur as more of a social activist connected to larger urban social movements of the past within the critical Black history traditions. For example, Eddie valued the historical context, narratives, and social reference of Tupac's family. Tupac's mother in particular, as part of the Panther 21 during the Black Power era, had a profound impact on the biography and political orientation of Tupac's life. Eddie felt the influence of his mother and the Black Panther Party had a profound influence on Tupac's intellectual and political acumen. He states, "And some of the things he was around just, like his mother was a Black Panther and part of the movement and Black Power and stuff like that" (personal communication, 12/12/08).

According to Eddie, Tupac was a very deep thinker and an extremely intelligent person. That students, such as Eddie, were able to read Tupac as a social and political text between the Civil Rights and hip-hop generations was due in no small way to how I developed the curriculum and pedagogy around Tupac Shakur. For example, I was very intentional about making connections between the legacies of Tupac's family as Black Panthers in relationship to the political content of his social and politically conscious lyrics in hip-hop culture. Along these lines, we discussed why activist groups, such as the Black Panthers, were silenced because they used their voices to speak truth to power. The larger point here was that what you speak has power to affect social change in society. As hip-hop artists, we wanted them to think about the power of their voice in music, and the ways in which their voice can have an impact on society and their communities. We taught them that those who used their voices for this purpose, such Martin, Malcolm, and the Black Panthers, were prophetic voices that sought out social justice for oppressed communities.

Lamar was another student who spoke passionately about the cultural formation of hip-hop in relationship to larger historical contexts of struggle within the critical Black history tradition. "Forged on the heels of the Civil Rights movement, hip-hop's rhetorical vernacular and cultural aesthetic of artistic expression emerged from the margins of economic and social decay" (Prier & Beachum, 2008, p. 522). The centering of historical struggles between the Civil Rights Movement, Black Power era, and the hip-hop generation was very important for Lamar. He understands these three traditions in relationship to asymmetrical relations of power between a white-dominated society that has sought to silence the voice of Black male leadership. Lamar seemed to draw upon each of these urban social movements as context for today's contemporary struggle in how urban Black male youth come to assert their voice in present-day contexts of hip-hop culture.

> Lamar: As far um, you know our history, as far as when they had slaves and what not. They set up this place called America. You know what I mean. As far as they enslaved us by our minds, period. The way we live. You know what I mean. Malt Liquor, Tobacco products, and stuff like that. Know what I mean. And they know we

didn't have some type of power, know what I mean. It's like back in the day they set up the Black Panthers — they wiped that out. Martin Luther — they wiped that out. Know what I mean. Malcolm X — they wiped that out. You know. They start, they tryin' to keep us from gaining our power because we — our eyes is just now opening. You know what I mean. We lost. (Personal communication, 12/12/08)

Lamar articulates the institution of slavery as the beginning foundation for the colonization or psychic control of Black minds; the silencing of language, culture, history (ways of life); the commodification of alcohol and cigarettes through targeted marketing of such commodities for the manipulation and exploitation of vulnerable consumption practices of urban communities; and the assassination of Black male leadership during the sixties. He critically and powerfully speaks of these events in terms of their relationship with power in white mainstream society. In his view, there has been a historical context to various forms of subjugation, subordination, and oppression suffered by Black people in the aftermath and effects of white supremacy and consumer capitalism that have displaced urban life in the city. In respect to issues of power relations, it is in all these ways that Lamar suggests that Blacks *lost* during this era. Given his critique in the loss of Malcolm X and Martin Luther King Jr., loss is also seen in terms of losing one's voice in speaking against white supremacist subjugation. Quite clearly, Lamar is undergoing a subversive act of political resistance through historical memory of the past as context for thinking about current struggles of urban youth in the contemporary moment. Kevin Powell speaks to the subversive act of remembering the freedom struggles and tradition of Black leadership as a crucial political gesture of resistance (2003). He states that both the silencing of these voices, or counter narratives, and not remembering these voices are losses to the system, as Lamar stated. As Kevin Powell observes,

And history tells us that the system will tolerate Black men who work for and within its walls, who do not question or buck the system, who instead are cheerleaders for the status quo, and who do not say, like Martin Luther King Jr. or Malcolm X, that the system needs to be turned on its stingy head and the filth shaken from its pockets.

When the tradition of struggle and remembrance breaks, the past is forgotten and the system triumphs. (2003, p. 113)

Lamar then makes a connection between this loss in relationship to new cultural movements of the hip-hop generation and the loss through the silencing of Tupac Shakur. For Lamar, Tupac was seen as a kind of new generation activist in the struggle for Black people.

Lamar: And this hip-hop thing, know what I mean, as far as when Tupac was in it, he was looking out for a lot of people you know what I mean. And he was speaking about the struggles, and a lot of people was coming to join with him. And they couldn't have that. You know what I mean. Like we need to come back in power with this, you know, this hip-hop thing. It's opened doors to movies, sports, and um, know what I mean, businesses, and all that. You know. We getting' a little bit more than what they thought we could do, and I don't think they appreciate that a lot, but they got to role with it. (Personal communication, 12/12/08)

Lamar makes connections between the loss of critical voices of the critical Black history tradition in relationship to the loss of Tupac as a potential critical voice for the future of urban youth. While I would argue that Tupac is not Martin Luther King Jr. or Malcolm X, it is the significance and meaning of why Tupac's life was so important to urban youth such as Lamar that has to be considered here. This is especially crucial for those of us who are seeking to develop pedagogies that are critical and relevant to the urban youth we teach in the classroom, or teachers in urban school districts who are interested in learning more about forms of popular culture that are significant to the construction of urban youths' identities. According to Lamar, the commonality between King, Malcolm X, and Tupac are clear. All were considered to be politically outspoken Black males against injustice in Black America. History has shown, in the context of Black male life, those who have been outspoken against and in resistance to the white power structure of society tend to get silenced in one way or another. We know King's and Malcolm's lives were cut short by a collusion of complexities enacted by individuals and institutions within the nation-state who sought to preserve the status quo order of social life

between Black and white America. We know that the death of Tupac was instigated by his own preoccupation and confrontation with a nihilistic, fatalist mentality; and market-driven, fabricated, coastal tensions in the media between rival gangs across the East and West coasts. The outcome of these realities is due in no small part to the restriction of oppositional voices by the nation-state on the one hand, and the aftermath and consequence of internal oppression amongst a marginalized population on the other hand (e.g., Shakur and Malcolm X). Remember that Malcolm was also gunned down by his own people, albeit it has been suggested they were part of a larger government-run operation. Freire would argue that both outcomes in the silencing of oppositional Black voices are necessary to the maintenance and preservation of the dominant culture in society. This is the loss of power, of losing critical Black voices, to structures of domination that Lamar is articulating here. The production of counter public spheres in the development of a pedagogy of place for Black urban struggle and resistance crucially allows one to speak in one's own voice (Haymes, 1995).

I also observed films within the genre of hip-hop sitting on the bookshelf. These texts included *Wildstyle, The Art of 16 Bars, Freestyle,* the *Art of Rhyme, Inside Hip-Hop, Scratch,* and *The Industry: The Real Behind the Game.* Some of these films educate and teach students of hip-hop on the aesthetic, cultural practices of hip-hop, and honing the creative craft of the art form. Other films, such as *Wildstyle,* is the first film ever produced about hip-hop, and which incorporates performances of all of its elements. The center also had classic hip-hop texts such as Dyson's *Holler If You Hear Me* (2001), Chang's *Can't Stop, Won't Stop* (2005), Russell Simmons's *Life and Def: Sex, Drugs, Money, and God* (2001), and *Makin' It: The Hip-Hop Guide to True Survival* (DeJesus, 2003). Books such as Dyson's work captures the life, music, and symbolic text of Tupac Shakur, while Chang's opus gives a complete historiography about hip-hop culture as a whole. Simmons's text draws from his own life narrative, along with his struggles and triumphs as a businessman in the hip-hop industry. These texts are produced from contemporary hip-hop intellectuals who have theorized hip-hop as a cultural production, foregrounding the historical, material, and discursive conditions that shaped it. They also highlight

key artists who contributed significantly to hip-hop's mainstream visibility. Other aspects of these texts trace the privatization of market conditions that have reshaped the contours of the art form from a local community practice toward the more dominant, commercial segments of the culture as a commodified, global industry.

The center also had contemporary political films such as *National Geographic — Diamonds of War: Africa's Blood Diamonds*, *Hotel Rwanda*, and *When the Levees Broke*. *Diamonds of War: Africa's Blood Diamonds* offers students of hip-hop critical lessons about political power and capitalistic exploitation of dominant countries that extract rich resources from the diamond trade with impoverished, war-torn countries within the "Third World," particularly the continent of Africa. It can be reasoned that the center's purpose for the film has much to do with reshaping youths' consciousness to counter market-driven discourses in hip-hop, given the culture's well-known consumerist obsession and fetish with wearing expensive diamond jewelry, popularly known as "ice" or "bling" to signify one's value and self-worth. The relationship between hip-hop's consumption practices of diamond jewelry in relationship to Africa's production of the commodity can be seen in Kanye West's 2005 video *Diamonds from Sierra Leone*. This song visually raised a critical awareness to the hip-hop community of the violence and crisis that took place over "conflict diamonds" in Sierra Leone. In regard to the film, one reasons to believe that if students can understand the tremendous cost at which many diamonds are purchased and sold in North America and elsewhere, and the resulting violence and bloodshed between and amongst their own ancestral community from the African diaspora, perhaps a redefinition of value and self-worth, not tied to crass materialism, may take shape in their lives. Concomitantly, the events in Africa over "conflict diamonds" in some ways reflect smaller conflicts over expensive jewelry and apparel between urban youth in U.S. contexts. In this way, the film enables students to critically read the role of power within the neoliberal commercial order of the diamond industry in shaping the consciousness of disenfranchised communities, and the consequences thereof, in global contexts between Africa and hip-hop communities in U.S. contexts.

When the Levees Broke, produced by popular cultural icon Spike Lee, is a film that chronicles the events of Hurricane Katrina. I contend the center uses this film as a hip-hop text given that several major rap artists are from the New Orleans area, which would resonate with the students. That is, many hip-hop artists, such as Lil Wayne, along with other former and current members of Cash Money Millionaires (e.g., Baby and Slim Williams, Juvenile, B.G., Mannie Fresh) and Percy Miller (aka Master P) of No Limit Records, grew up in the New Orleans community, and had family members who suffered the aftermath of Hurricane Katrina. Lil Wayne and Jay-Z also came out with songs, respectively entitled "Tie My Hands" and "Minority Report," which both critiqued the government's negligence in responding to the Katrina disaster. In addition, the event of Hurricane Katrina itself became publicly associated with hip-hop culture when Kanye West yelled out, "George Bush doesn't care about Black people" on a national network that hosted a telethon to raise funds for the victims of the natural disaster. The critical dimension of Lee's film is instructive in raising awareness to students of the political consequence of the government's negligence toward urban Black working-class communities, which signified larger social and political neglect of urban, Black working-class communities across U.S. society as a whole.

It is evident that the hip-hop youth empowerment center attempted to bridge long held cultural tensions between the Civil Rights Movement, Black Power generation, and the hip-hop generation as a political, subversive act of resistance in the construction of a pedagogy of place through hip-hop culture. Implicit within the diverse text types between the hip-hop generation and the critical Black history tradition, it seemed as though there was a political attempt to mobilize an intertextual bridge between visual and linguistic hip-hop literacies in the present moment while preserving and reclaiming a popular historical memory and integrity of past movements in the critical Black history tradition. Yvonne Bynoe states that the current tension and gap between the Civil Rights Generation and the hip-hop generation stems from assumptions that hip-hop was a fad during the '80s Black Consciousness movement, and a rejection of the hip-hop generation from the civil rights community (2004). She insists that without intergenerational cooperation amongst both factions, a new

movement suffers the potential in not having historic foundations of social, political, and economic activism, yet possessing a new vision for a new generation (Bynoe, 2004). It is in this context that the hip-hop youth empowerment center seemed to construct a pedagogy of place to preserve historical and social references of the critical Black history traditions, which could possibly provide new political insights for the students in forging new social justice movements and activities of the hip-hop generation in present-day contexts.

The hip-hop youth empowerment center was also a space in which urban youth could mobilize the cultural practices of rap music and other cultural elements (e.g., deejay, emcee, graffiti) of hip-hop to express themselves; and it provides them with a pedagogy of place for Black urban struggle and resistance in ways that are more empowering and liberating to these youth. For example, the director of the center states that when the students are able to use the discourse and narratives of rap music as a cultural process of critical self-reflection, and look inwardly at oneself, it becomes liberating and transformative to the student. He states that when students as rap artists are able to finally look at themselves in an honest way, examine their strengths and weaknesses as individuals, reflect on the troubling experiences they've had in their communities, and share all of this in the lyrics of their rap songs is growth and liberation for them.

> Reggie: ...when rappers begin to take their own...initiative and start to turn a mirror on themselves and look at ugly parts, pretty parts, questionable parts, and they can turn around and put it on a microphone, run it through a microphone, and release it, that's healing. (Personal communication, 9/12/08)

The cultural practices of rap music are in many ways a kind of spoken word performance accompanied with a beat, among other aesthetics and technical production. In this context, Priya Parmar and Bryonn Bain argue that the spoken word has to be performed to fully comprehend its meaning; and it is an integral part of a "communicative event," requiring the delivery of the oral poet and audience reception (Parmar & Bain, 2007, p. 136). For example, the director of the center states that he was not always able to understand what may

be happening in the lives of his students until he heard the lyrics in the performance of their rap songs. He was intrigued in the fact that it was the art of rhyming their life story through rap that broke the silence of pain and struggle they cope with in their daily lives. Once the students shared their personal struggles in such a public way at the youth center, they were able to communicate with the director in a more transparent manner about their obstacles or challenges in their daily lives. This gave the director of the center more information about the student that he otherwise would not have, and which subsequently, gave him some deeper perspective about the student. According to Parmar and Bain, who adopt the critical pedagogy and philosophy of Paulo Freire, the "hip-hop and spoken word poetry are just one example of cultural literacy that, as a political discourse, all people can assert their right and responsibility not only to read, understand, and transform their own experiences but also reconstitute their relation-ships with the wider society by writing, voicing, and performing these experiences" (Parmar & Bain, 2007, p. 154). While it has been a lengthy process of getting the students to open up about their lives in ways that would be empowering to them, Reggie states the students have come a long way in writing narratives in their lyrics that would accomplish this goal. There were experiences in their lives that he never would have known about unless these experiences were articu-lated in the performance of rap music. "Critical pedagogy invites students to look at 'what is' to determine 'what could be,' and to find a way to move from 'where we are' to 'where we want to be.' Analyz-ing, critiquing, and interpreting hip-hop texts and ultimately perform-ing them through the spoken word from a critical perspective allows students to ask and answer such questions" (Parmar & Bain, 2007, p. 155). Emerging from a particular urban struggle, engaged in cultural practices of resistance, "youth are producers of their culture, actively engaged in artistic projects that draw from their experiences in the streets; and actively pursue measures toward social justice" (Prier & Beachum, 2008, p. 530; Ladson-Billings & Donner, 2005; West, 2004). Subsequently, how students pedagogically understood rap and hip-hop culture in social and political terms of urban resistance shaped the way they performed their lyrics at the youth center. For example, I had an opportunity to hear a sample of Corey's lyrics, one of the local rap

artists at the center. It's interesting to note in the introduction com-
mentary into the song he invites the listener to hear about his struggles
in the streets. He then states that he takes ownership and responsibil-
ity for the life he has lived, and the struggles he has had to endure.
Corey then rhymes that he uses his observations of life in the streets
and uses those experiences to inform the messages and meanings in
his lyrics that he performs in his music. He then declares that while
some judge the life he has lived in the streets, implicitly he indicates
there are a larger set of unequal circumstances that have shaped what
makes up his life. Toward the end of the verse he talks about avoiding
gang activity, "beef," and hustling illicit pharmaceutical products of
the street. The director of the center states that students, such as Corey,
have come a long way when we consider the social location from
where the students started when they began the program at the youth
center. He says that it takes a lot for them to recognize the error of
their ways and to then redirect themselves in a more positive, trans-
formative manner. "In studying hip-hop culture as a way of life, we
are talking about marginalized people who use hip-hop to subvert,
resist politically through organized mobilization for a particular cause
that may shape policy; or discursively, through the cultural practices
of rap music (particularly the social and political form)" (Prier &
Beachum, 2008, p. 530). Interwoven throughout all of Corey's lyrics is
how he defines his life in relationship to his own struggles in the
streets. Corey's sampled text reinforces Lamar's arguments about hip-
hop as a way of life, reflective of one's lived experiences, which
emerges out of a particular struggle in the urban community. Accord-
ing to Corey, is through the cultural practice of rap music that gives
him a voice or counter narrative in which to speak about struggles
with gang activity (e.g., he talks about stripes in the hood),
fighting/violence (e.g., beef), and not hustling in the hood (e.g.,
dealing drugs). In this way, the performative element of rap music for
Corey is a cultural practice that enables him to be a "voice of the
street" to talk about his own struggles and realities in the street as a
means of overcoming them. The articulation of Corey's narratives is
reflective of the center's values and commitment of using hip-hop as a
tool for violence prevention amongst urban Black male youth in the
community. The production of counter public spheres in the develop-

ment of a pedagogy of place for Black urban struggle and resistance crucially allows one to speak in one's own voice (Haymes, 1995).

The students at the hip-hop community center understand rap music as a space and place where they can share their pains and struggles that have to be confronted in their everyday lives in the communities in which they live (Prier & Beachum, 2008). In this way, Black male youth are developing a counter public sphere or counter public space in their production of meaning about the city through hip-hop culture and rap music. That is, I see the hip-hop youth empowerment center as a culturally specific institution, constructing its own values in opposition and resistance to dominant mainstream institutions and values that have attempted to suffocate how urban Black male youth come to terms with their voice in more liberating ways. As a form of Black popular urban culture, rap music, and hip-hop culture more broadly, is reflective of urban youths' meanings they produce about their everyday lives and realities in the urban city. This is a part of the conditions by which Blacks can develop a pedagogy of place in the city through Black popular urban culture. Therefore, the formation of hip-hop as an urban youth subculture, and the cultural practices that derive from it, can be central to the larger question of how students utilize Black popular urban culture in the construction of Haymes's pedagogy of place for Black urban struggle and resistance. Subsequently, I was particularly interested in how urban Black male youth at the hip-hop youth empowerment center came to forge counter public spaces of resistance, or counter public sphere, through the physical space of the center, as well as through the cultural practices of the art. It is in all these ways that they constructed oppositional identities, where they could interpret social reality in more liberating ways through critical orientations of hip-hop culture (Haymes, 1995). They redefined the terms of place in urban territory that resisted traditional stereotypes about Black male life. The students reorganized the culturally specific space and place of the city in more emancipatory ways that affirmed their identities. The ways in which they reconstituted what urban life meant to them, and how to overcome the daily challenges and stresses of urban life, are politically resistant because the students challenge traditional conceptions of hip-hop culture that have been seen as destructive to

the character of Black life within mass culture of the media. They also confronted issues of life and death, and violence, which threaten to snuff out their very existence. This is political resistance because in the words of hooks, it is a demonstration for a love of Blackness, which does not submit to internal forms of oppression expected by culturally produced meanings and values about the meaning of Black life in dominant, mainstream society. It is in these ways that hip-hop as a Black popular urban culture functioned as a counter public space of resistance for Black male youth in relationship to unequal power relations within urban spaces of inner-city life.

Conclusion

Educational administrators, teachers, and other school officials must recognize that hip-hop is the world that many urban youths' lives emerge from. Subsequently, to deny hip-hop is to deny the social world that is shaping the identity and generation of many urban youth from working-class communities. It is to deny the sociocultural contexts (e.g., race, class, and gendered relations of power) and urban conditions that speak to who they are, and the material realities that have shaped their consciousness. In all of its complexity, its challenges, problems, insights, and possibilities, the music and the culture significantly shape the way many urban youth see themselves and construct their own realities. Hence, to render the art and culture invisible is to dismiss the humanity of young people. More important, there is also the potential to miss out on critical learning opportunities in which teachers and students might co-construct knowledge in ways that might keep urban youth in at-risk circumstances in schools rather than being displaced out of them.

The space and place of OMEC represents social justice education because it is actively taking initiative in developing new curricular and pedagogical approaches in education that allow urban youth to redefine the terms of their identities in ways that give them a sense of hope. The content and selection of books, films, and videos; the authors used: and the lessons taught are community-based forms of literacy specifically designed for the purpose of reshaping the consciousness of urban Black male youth in ways that reject essentialist,

banking models in education. These texts critically engage urban youth in subject matter that allows them to question and demystify the dialectical contradictions of social inequality that shape the conditions of their current reality. As students become aware of these conditions, they become more educated about the culture of hip-hop in ways that are more "authentic" and organic to the local experiences of their own communities. Notice that students who were participants at the center redirected their values and sense of self away from a market-centered orientation to a more community-based, political orientation, which gave a priori to matters of social justice.

Although I have provided examples of doing hip-hop as critical pedagogy beyond the schoolhouse, I am not suggesting that schools can play no part in the critical transformation of urban youth. At present, the cultural and ideological contexts that shape the values of schools have not acted in good faith, to value and cultivate critical knowledge that students bring with them to school. Many of these students are dealing with matters of life and death that demands a sense of urgency from the one public space where they otherwise spend most of their time, and which could provide them with an education crucial to their survival and overcoming of obstacles they face on a day-to-day basis. The current system of education and schooling has been oppressive by its silence and presupposed "neutrality" toward teaching and learning, and its universal approach toward knowledge acquisition. However, the assumption of schools as neutral is conversely to assume a political stance about what schools ought to be. This approach leads to considerations about universal approaches to standardized testing, the removal of "other histories" from the curriculum, and the legitimizing of an "American national identity" through a select tradition that celebrates the Western canon of intellectual achievements, theories, and ideals nonreflective of persons of color. All of this contributes to the maintenance of an official school curriculum that subsequently devalues and delegitimizes the experiences, identities, and histories of others. Decisions and choices about what to include and exclude within the hidden curriculum of schools also contribute to a misrepresentation and distortion to the image of urban youth. All of this leads to the tacit ways in which schools create structures of normalization in the

selection and approach to the curriculum, how teaching and learning take place, how rules and regulations are enforced between upper- and lower-class students, and the daily social interactions with urban youth that become racialized situations that push and displace these students out of the system (Apple, 2004).

The culture of hip-hop, however, has a different approach toward teaching and learning that engaged students in ways that might be beneficial for public school officials to consider as they attempt to bridge the gap in urban education. The community center did not attempt to structure the identity of students with predetermined, rote curricula that were removed from the complexities and struggles of their everyday lived experiences. Students were enabled to explore diverse sociocultural contexts between Tupac and the Black Panthers in relationship to the different philosophies of Malcolm and Martin, and why radical, resistant Black voices in opposition to the status quo have historically been integral to forming urban social movements for social justice. The art and cultural practice of rap allowed students to read, write, and speak their own life histories in ways that were transformative to their ontological being. Whereas public spaces within the official school curriculum often do not center, value, or give an opportunity for students' voices to be heard, the hip-hop community center gave students a chance to be critical and self-reflexive through the creative cultural practice of rhyming one's life narrative for the purpose of self-discovery and transformation of their consciousness. The center also produced a counter curriculum (Baszile, 2009) to reclaim historical struggles of the past in the critical Black history tradition, and placed these experiences in context to the present-day struggles of urban youth in the hip-hop generation (Prier & Beachum, 2008). The critical dimension of such action politically resists power, culture, and ideology of traditional schooling that historically legitimized and privileged the majoritarian values and interests of traditional white American identity. In this sense, it gives students a history, culture, and curriculum that challenge traditional American identity, and fills in the void of that which students of color are presently denied access within the official school curriculum. The implementation and practice of these methods and approaches could

be described as the beginning foundations for what I term as the development of a critical hip-hop learning community.

Conclusion: Translating the Pedagogy of Hip-Hop between the Streets and the Academy

I remember going on a job interview for a faculty position a few years ago, and one of the faculty members on the search committee asked me the question, "What do you say to those who say that hip-hop is not an intellectually rigorous area of study to be discussed in the academy?" This line of questioning made a series of presumptions on several counts. First, the question makes the assumption that the pedagogy of hip-hop is not valued as a cultural site for rigorous, intellectual, scholarship and research in the academy. Second, it makes certain presumptions about rigor and knowledge that speak to the kind of elitism that the culture of the academy often breeds. Third, the substance of the question, about its academic merits in the academy, was ill informed. Hundreds of courses on hip-hop within different disciplines and fields are now being taught all over the country, particularly amongst some of the nation's most elite universities, such as Harvard, Princeton, Duke, Brown, Cornell, and Berkeley, to name a few. In fact, so popular the topic of hip-hop has become in the academy that questions are being raised from local urban communities about the potential, hegemonic, commodification and co-optation of the culture. There is concern that prophetic forms of hip-hop, produced organically from the streets, will lose their critical edge. That hip-hop artists will become background props in a larger stage play of theory removed from the day-to-day experiences of people on the ground. There is also concern that the culture itself will be placed under a set of disciplinary apparatuses that empty out its creative and critical edge, no longer resembling the soulful resistance to the status quo that gave birth to the cultural politics of the art form. If the culture of hip-hop is not to die, as rapper Nas would suggest, these are very real concerns that should be addressed at every turn of the culture's translation into the academy. We must always keep in mind that the vitality, strength, and resilience of hip-hop's birth and pres-

ence emerged out of rejection and denial of the dominant culture that practiced social, political, economic, and racialized forms of displacement of Black and Brown peoples in urban centers across America's communities of color. Subsequently, how we develop democratic spaces and practices for hip-hop between the street and the academy in inclusive ways will be crucially important to the culture's growth and development in the 21st century. In this regard, I see the culture of hip-hop as a form of "public education" in the larger narrative of reclaiming democratic individuality, community, and society.

The study of hip-hop is the study of the soundtrack of young people's lives in all of its complexity. For too long, America has dismissed the voices of the hip-hop generation as irritating noise that is destructive to all that is "civil" in U.S. society. America never pressed the pause button to listen to her "blues people," as Cornel West often says. What is incredible are the genius and creativity that emerged among a population never expected to rise above the ashes of joblessness, poverty, incarceration, unequal education, and homelessness, in many cases. This is what Tupac Shakur so powerfully articulated with his metaphorical analogy in a poem entitled "The Rose That Grew from Concrete" (1999). His point was that if a rose grew from concrete you would never expect its will to survive through all the rubble and rock that surrounded it. You would never expect it to blossom into something beautiful and that people could value and love. He states that even though it should be considered a tremendous feat that a rose grew from concrete, people still complain about the fact that the rose grew a little crooked, has rose petals that are bent, and looks a little dirty. Instead of asking why the rose grew the way it did, he offers that we should be asking how the rose emerged from such horrible conditions to be something in life that no one expected in the first place. Where did the rose get the resilience to transform itself to beat the odds, given the conditions of confinement that surrounded it? In this context, the rose is a metaphorical, symbolic representation of urban youth of the hip-hop generation who have grown up in the most horrific and hardened (read concrete) conditions in U.S. society. This example of symbolic and metaphorical representation, reflecting urban struggles of despondent daily living for urban youth, gives valuable lessons that can be taught and learned from the culture of

hip-hop. Emcees in nonmarket forms of rap music give us a critical street curriculum by which to understand agency and social transformation in the midst of confinement, repression, and social inequality. They paint pictures with images, words, and rhymes about how to recognize the resilience and potential of urban youth as opposed to seeing them as deficits and problems. In their own way, they foreground the pedagogical conditions by which cultural movements for social justice need to be organized, particularly in urban school settings. It is up to us as critical educators to read between the lines and bars of hip-hop texts to inform how positive change might take shape in our pedagogical relations with urban youth.

So much of what I learned from youth at the hip-hop community center depended on knowing how to read the world of hip-hop through the word of their discourses. Reading the production and circulation of their discourses involves understanding how they made sense of their neighborhoods and communities; how authority figures viewed their clothes associated with gangsta identities in hip-hop; the vernacular expressions and competing interpretations around the N-word, commonly used in rap; the celebration of market relations and market identities in the entertainment industry; their discussions of "real" education and lessons learned from iconic emcees; and how the production of these discourses are read in relation to historical and social contexts of the Black experience. Reading various discourses in hip-hop, spoken through rap music and conversations with hip-hop artists at the hip-hop community center, allowed me to make sense of the production and performance of urban youths' identities in relation to their everyday lived experiences. This enabled me to understand how to read *culture* between how conditions and experiences are lived on the ground in relationship to how the social world is represented and produced in the culture and industry of hip-hop. All of this requires the critical teaching of culturally relevant knowledge in how to read hip-hop texts.

Some of the challenges in urban education have to do with misreading the cultural contexts of youth. For example, there are many teachers from middle-class communities who have never lived in or associated with urban communities; yet, they are expected to come into classrooms in urban communities from day one and solve the

"education crisis." Subsequently, they have a hard time understanding the language, attitude, and perspective of these young people. It is also possible that all the invisible ways in which urban youths' identities are read through the prism of hip-hop go unnoticed by middle-class communities of the dominant culture. This can create unexpected cultural tension between students and teachers in urban school settings. When teachers from middle-class backgrounds enter urban classrooms during their first years of teaching, there is great possibility they misread the cultural contexts from their own lives and the lives of their students. In *Pedagogy of Freedom: Ethics, Democracy, and Civic Courage* (1998), Paulo Freire suggests that we as teachers must become acquainted with the lives of our students, or become less of a stranger to them. In this context, pre-service teachers must become acquainted with, or become less of a stranger to, the culture of hip-hop to read urban life and the various representations of it. This disposition is necessary if we indeed want to bridge pedagogical relations between the teacher and the student. As pre-service teachers develop what Marc Lamont Hill calls a critical hip-hop literacy of texts in popular culture, they will be better prepared to understand the cultural contexts that impact youth culture in urban school districts.

In addition, hip-hop texts must be read and situated within larger sociocultural relations of power between the dominant culture and urban, working-class communities. Reading texts in this manner allows us to demystify the seemingly invisible ways in which schools label students gangstas based on criminal images of "thugs" in movies and lyrics celebrated in gangsta rap music; critical reading of hip-hop texts allows us to understand the labeling of mainstream society, which sees urban youth as "niggas" through "saggin'" jeans, thereby instigating the conditions by which they are sent to the office as the troublemakers of the school. A critical, culturally relevant pedagogy of these readings helps us understand the hustling ethic of the street when diplomas don't guarantee jobs that have dissipated for urban youth, and the American promise of education for socioeconomic mobility is less of a possibility for the urban poor due to neoliberal ideals of globalization and outsourcing. Culturally relevant teaching of hip-hop texts allows us to understand urban youths' affinities for hip-hop artists who teach life's lessons through the

streets, in ways that connect with the very best of the critical Black history tradition, which is in direct contrast to Eurocentric curricula currently taught within the traditional culture of urban schools. Culturally relevant teaching of hip-hop texts can inform the content and subject matter of what is taught to urban youth and how concepts are taught to their students. Or, it can merely inform how teachers connect and socially interact with students on a day-to-day basis. When students understand you are making honest attempts at understanding their social world, teachers increase the chances of disrupting the social alienation and antagonisms students may feel in school systems that have in many ways rejected them.

The teaching of culturally relevant forms of critical pedagogies in hip-hop can be used as a way in which future educational leaders can better understand cultural contexts and power relations impacting urban youth culture. In this sense, I'm interested in what *the study of urban youth and hip-hop culture can teach educators about more relevant and critical pedagogical relations with these students in urban school settings.* This pedagogical approach alters the top-down, power relationship in teaching and learning between teachers and students. Teachers and other public school officials are not assumed to posses sole authority over knowledge production; urban youth are not objects who simply receive knowledge from teachers, but have the capacity to construct their own forms of social knowledge in hip-hop that we can learn from as well. Subsequently, there is much they can teach us about the society in which they live, and what young people are learning from this society, as expressed through the culture and music. Alternative social knowledge produced through the culture of hip-hop can be read through the different discourses or modes of communication that circulate in hip-hop. In reading these discourses we can raise new questions that address pedagogical relationships between learning and teaching; power, culture, ideology, and educa-tion; society and social justice. These readings lead to questions such as, What does the discourse of hip-hop teach us about why students are resisting in schools and their communities? What does the dis-course of hip-hop teach us about their perceptions in how society views their identities? What does the discourse of hip-hop teach us about alternative pedagogies and curricular strategies that tap into

their identities and histories that are critical, hopeful, and meaningful to their everyday lived experiences?

The critical teaching of culturally relevant discourses in hip-hop can be valuable in helping us understand the devastating urban conditions that shaped the youth subculture in relationship to the subjectivity of urban youth who participate in the art form. We can learn how urban youth negotiate their identities in a neoliberal era of market consumption, criminalization and punishment, and job loss due to globalization. There are opportunities to interpret their attitudes toward urban schools, and the particular contexts that shape these attitudes. In addition, there are opportunities to explore how the culture of hip-hop is being represented or distorted in the media, and how this impacts how we view urban youth in society. We can also explore the ways in which urban youth develop a sense of empowerment and agency through hip-hop culture. There are various hip-hop discourses, particularly within socially/politically conscious strands of hip-hop, where students can engage in forms of culture critique and text analysis, to make these connections between teaching and learning in urban settings. There are also moments in which we need to understand gangsta and market-driven discourses in hip-hop. After all, these expressions represent a reflection of corporate, market-driven mentalities in the larger society, which privilege profit over people and greed over community. The most vulnerable in society are only adopting the corporate values that are privileged in the larger American society. The internalization of these values is symptomatic of larger societal relations of oppression and marginalization between dominant and subordinate communities. As educators begin to study the cultural contexts of hip-hop and the sociocultural contexts that shape it, they begin to understand the heart and soul of who these young people are, the struggles they go through, and how they respond in hopeful and despondent ways to systemic issues of racism, classism, and gendered identity formation processes in racialized contexts.

The importance of hip-hop in the lives of urban youth suggests a need to explore how culturally relevant teaching practices through hip-hop culture can mobilize and construct critical-progressive knowledge between urban youth and administrators, teachers, and

school officials who work with them on an everyday basis. As educators and pre-service teachers begin to be self-reflective about these conditions, they are better equipped to both understand and have knowledge of how to transform the cultural contexts of urban schools that have socially and politically alienated many urban youth. They are provided with new pedagogical conditions that connect teaching and learning with music and popular culture in relation to race, class, gender, culture, and community. They are enabled to open themselves up to a social world that may be different from their own reality, and have a greater knowledge about the different cultural contexts that shape the lives of students they may be working with in urban public school settings. This is particularly salient in my own experiences of teaching the study and readings of hip-hop texts to a predominantly white, pre-service teacher population who were only familiar with market-driven forms of rap music in hip-hop that reinscribe stereotypical notions of urban youth identity formation.

The critical teaching of culturally relevant pedagogies in hip-hop cannot be seen as disposable art, only important for the immediate moment and to be dispensed with soon thereafter. That is, there is a set of past and present narratives, discourses, and hip-hop texts that provide us historical contexts into contemporary concerns of urban youth, and contemporary narratives and discourses that give us some insight into the past. Subsequently, the use of non-market-driven forms of hip-hop is not isolated to popular cultural consumption and reception practices of the present moment. This approach allows us to neither dispense with nor be confined to past or present traditions in the study and readings of hip-hop texts. This is particularly important if we are to make sense of sociocultural contexts of hip-hop texts between the past and present within larger historical contexts. Taking this into account, I have designed this chapter to help critical educators, particularly in teacher education programs, understand how to read critical hip-hop texts or approach texts in hip-hop critically, and Black popular culture more broadly. Through a combination of written and visual texts, or cultural artifacts, we can understand the arguments and claims hip-hop artists or *authors* are making in relationship to culture and everyday lived experience that shape various markers of identity and difference in urban society. There are peda-

gogical ways in which educators and students can understand how to read Black popular culture and hip-hop texts within the larger cultural, political, historical, economic, and racialized contexts in which they are situated. These teaching strategies allow us to explore deeper conversations about what these texts mean in relationship to the study of different philosophical orientations and ideological discourses that have informed past and present curricular and pedagogical practices in education and public schooling. Subsequently, this work discusses how to use hip-hop texts—such as rap music—or various subgenres—such as poetry, magazines, images, documentaries, film, and readings in hip-hop—to stimulate critical dialogue about these issues. We can analyze and interpret what is being said in these texts, how they relate to critical and progressive movements in education, and the pedagogical links we can make that help us understand the lived experiences of urban youth.

In order to explain the critical teaching of culturally relevant hip-hop texts in pre-service teacher education programs, I draw from my experiences in teaching a special topics course on hip-hop in Miami University's Department of Educational Leadership. In this course I incorporate music, lyrics, videos, documentaries, film, cd covers, magazines, and other forms of media in hip-hop. These texts serve as valuable cultural entry points into critical conversations about the role of power, culture, and ideology between hip-hop, youth identity, and urban education. In order to analyze these texts in proper contexts, students need to be aware of the different theoretical and discursive lenses and discourses in hip-hop (social/political, gangsta, commercial) that can help students study and understand the different modes of identity making in urban society. Educational projects I develop involve the study of hip-hop as a form of pedagogy for youth; students are taught how to provide an examination of the role of power, culture, and ideology in shaping youth identity within the culture of hip-hop; students are taught methods and cultural processes in how to critically read hip-hop texts in popular culture; and finally, I have students explore how to conduct ethnographic snapshot fieldwork (or activist event observations) projects in actual hip-hop learning communities to examine sociocultural realities of urban youth in society.

The main questions I want my students asking as they take the course are as follows: Does the study of the culture help you better understand the everyday lived realities of urban life for disenfranchised youth? If identities of urban youth are performed and not reflected as actual lived experiences, what is being represented in the performance of the work? Do you have a better understanding of the social, political, economic, and racialized contexts that shape their attitudes and dispositions toward school and society? In studying the texts of hip-hop, do you have a better understanding of the cultural intersections between race, class, and gender that assist in the formation of youths' identities? In reading the discourse of hip-hop artists, do you come away with a new understanding of different modes of communication of urban youth that help you understand how they view their social world in complex ways? What does the study of hip-hop texts tell you about issues of democracy and social justice in urban education? My approach to the study of hip-hop in pre-service teacher education programs is not necessarily about giving them technical tools of instructional methods in hip-hop pedagogy to use in their classrooms as future teachers. It is not so much about what they are going to teach urban youth about hip-hop. In this pedagogical context, pre-service teachers are not leading the discussion of determining what hip-hop is about. The class is an opportunity for them to read the voices, narratives, and experiences of urban youth themselves, through the various discourses in hip-hop, situated in particular sociocultural contexts. They come away from the class having been taught, in many ways, by the youth themselves, altering the top-down, pedagogical relations between teachers and students.

I will also discuss the pedagogical rupture between the academy and the street that I undertake when I invite local hip-hop artists as "guest lecturers" in my classroom. The cultural work I teach on hip-hop must be connected to the city streets from which the culture was birthed. Young people are doing incredible and insightful work that is rarely recognized in mainstream media. If hip-hop is to survive, pedagogical linkages between the academy and the street are vital. I am driven to make teaching and learning seamless between the academy and the streets as part of a larger discourse that holds as a

real possible reality the ideal of education as a democratic practice. Subsequently, I give examples of how I have cultivated democratic spaces between the academy and the streets for which hip-hop is taught and practiced in ways that strengthen pedagogical relations between university and community settings. In some cases, I have invited talented local hip-hop artists to share and practice their art in my teacher education classes. For example, I have had artists come to my classes to talk about how their work is addressing the HIV and AIDS epidemic in the local community, particularly with young people. I have invited other artists who use spoken word poetry to teach urban youth about how to make the right choices and decisions after being released from juvenile detention centers. I have also invited some of these artists to use their craft to speak with urban youth about a range of issues in after-school, precollege programs. I respect and value these artists as teachers and organic intellectuals of the streets. They are committed to various forms of activism and social justice in their local communities. In addition, I discuss an arts residency program I hosted in an academic setting that featured b-boy/b-girl hip-hop artists, which connected colleges, public schools, and local community organizations in the region. It is in all these ways that I discuss how the university setting can use the pedagogy of hip-hop to connect with local citizens of the community to reaffirm democratic practices in education.

Teaching Hip-Hop in Pre-service Teacher Education Programs and the Streets

I have had the opportunity of creating, developing, and teaching a course on hip-hop as part of a pre-service teacher education program for under-graduate students. I first taught the course at Miami University, in Oxford, Ohio, in the Department of Educational Leadership. I was able to create and develop such a course within their thematic sequence of Cultural Studies and Public Life. This particular sequence draws upon the study of youth subcultures in education, and analyzes the central role of culture in understanding issues of identity, ideology, difference, subjec-tivity, and agency of youth. Although we normally have students analyze these issues through various forms of popular culture, I was afforded a

unique opportunity of developing a course around the subculture of hip-hop. This is an upper-level thematic sequence course on Youth Subcultures, Popular Culture, and Non-formal Education, which is also a required class in Miami's School of Education and Allied Professions for undergraduate education majors within the university's teacher education program. When developing any course, there is always room for ongoing reflexivity, adjustment, and revision of topics and themes that will best fit the overall purpose of the course, and some central concepts that you would like students to come away with. Subsequently, what is presented here should be seen as a working framework for those who are considering teaching a course on hip-hop in education, particularly cultural studies approaches to social foundations of education. Therefore, it should not be seen as a static document, as I am currently in the process of continuing to make some changes to this particular framework, but what is presented here gives the reader some idea of how one might approach or think about teaching such a course.

When I developed the syllabus and curriculum guide on hip-hop, I focused on the cultural production and subculture of hip-hop and youth in local (U.S. society) and globalized contexts in relationship to the cultural dimensions of race, class, and gendered contexts. The course was structured to educate students on alternative forms of knowledge construction by youth who shape an "outside curriculum" of hip-hop that is mediated by cultural, racial, and socioeconomic realities, the commodification of the cultural industry, a replacement of fixed pedagogies in cultural processes of identity making, and postmodern, globalized sensibilities that run across race, class, and gendered lines. That is, students come away with understanding that hip-hop and the youth and young adults who participate in it, construct their own curriculum and pedagogy in ways that we as educators don't traditionally think about. How knowledge is produced, identity is shaped and mediated, is constantly in flux in the ever-changing spaces, times, and cultural contexts of hip-hop. It is important for me that students come away with understanding that hip-hop is a cultural production, emerging from a set of conditions and circumstances that impact the meaning and messages in the music, images portrayed in videos, lyrics constructed in a song. It is also a way of life for young people that extends beyond the music, particu-

larly for many urban working-class communities. In some respects, it influences a way of being in the world, adopting certain lifestyles, attitudes, choices, and interests in cultural practices and activities associated with hip-hop culture. In addition, many youth and young adults are politically invested in hip-hop, where they are unified by the moral, political, and ethical dimensions of social justice and democracy. Other young people are not politically invested at all, and are more interested in various forms of technologies produced in hip-hop. In these contexts, students come away with investigating the multiple complexities involved in "hip-hop youth culture." Therefore, the conversation is not necessarily driven by "good versus bad" binaries that narrowly characterize youth in popular culture. While the moral and ethical dimensions of hip-hop are discussed, it is not limited by these particular contexts. The course attempts to help students understand the various cultural dimensions that impact the development of hip-hop in past and present contexts. It is within and between these constructs that I divided the course into the following six sections: (1) Theory, Cultural Studies, and Hip-Hop Culture; (2) Graffiti, Ethnic Minorities in Hip-hop, and Global Youth Culture; (3) Negotiating the Cultural Politics of Race, Class, Gender, and Identity Formation; (4) Social Justice Movements and Activist Hip-Hop Culture; (5) Gangstaz, Commodification, and Youth Identity Consumption; and (6) Race, Space, and Technologies of Cultural Production. Note: The four basic elements of hip-hop—deejaying, emceeing, graffiti, and b-boy/b-girl—are interwoven throughout the entire course.

The course predominantly explores hip-hop within U.S. contexts; however, I also have students take a look at international and globalized contexts that continue to widen hip-hop's influence in the world. Concomitantly, the course explores hip-hop as a subculture, popular culture, and the multiple discourses associated within historical contexts, sociological frameworks, cultural studies approaches, and cultural critiques of the music, art form, and social movement. These discourses are applied to nonformal avenues of teaching, learning, and education. Based on the course's six themes, special attention is given to the following:

- historical and social contexts that affect how youth cultures are constructed and negotiated in specific spaces, places, and times
- youth as both consumers and producers of culture
- cultural movements within hip-hop as a form of critical discourse and social and political activism
- identity politics within the power-culture relationship of hip-hop
- subjective youth identity formation within and between race, class, and gender
- cultural production and aesthetic social practice of hip-hop

There is also a set of questions I pose that guide the course. I encourage students to return to these questions throughout the course as we discuss various topics and central ideas. They are as follows:

- What are the conditions and contexts that produce hip-hop culture?
- What effect does the political economy of the hip-hop industry have on youth as consumers?
- What is the role of race, class, and gender on the subjective identities produced in hip-hop?
- What is the role of space and time in the production and meaning of hip-hop?
- How is hip-hop defined within critical discourses versus postmodern or post-structural discourses?
- How are images and representations in hip-hop both reflective of and a reproduction of the legitimization for the political, cultural, and economic contexts out of which hip-hop emerged?
- What is the difference between hip-hop culture and the culture industry of hip-hop?
- What is the meaning of hip-hop for the youth who participate in hip-hop culture versus the hip-hop industry?
- How have youth in hip-hop been abnormalized by the larger culture of mainstream society, and through what discourses of normalization makes this evident?

- What are the competing ideological critiques between mainstream society and youth?
- What are the particular contexts that shape the production of hip-hop's meaning in a particular event, activity, or discussion?
- What shapes the production and meaning of a "hip-hop" text?
- What is the curriculum and pedagogy of hip-hop?

In terms of assignments in our cultural studies and public life courses, we have students do some kind of culture critique. Students analyze some kind of "text" produced from youth culture or popular culture in general. The basic idea is that students will come away with understanding that cultural artifacts/texts produced in popular culture or youth culture have been produced with particular meanings within particular contexts. In this regard, the cultural production of these texts/artifacts does not make them fixed objects, void from the contexts that shape the production of their meaning. If we don't understand the particular context that shapes the production of a cultural artifact's or text's meaning, there is the potential of misrepresenting what message is being conveyed or communicated to the public. It is somewhat like recording someone's speech on video and playing an edited two-minute sound bite for the media that completely misrepresents the overall content and context of the message. Subsequently, I have taken the general idea of culture critique and applied it to the specific course I developed on hip-hop youth culture. In one of the assignments, students have to pick a particular hip-hop text and critique its associated cultural meanings in particular historical, social, political, economic, and/or racial contexts. Depending on the type of text they select, students also have to think about symbols, metaphors, tropes, imagery, and narrative; they also need to think about the type of discourse used in the text, and the ideology within which these discourses function. For example, students can select music, lyrics, videos, documentary, film, cd covers, magazines, and other forms of media in hip-hop to do their culture critique papers.

Hip-hop texts can be valuable cultural entry points into critical conversations about the role of power, culture, and ideology between

hip-hop, youth identity, and urban education. Perhaps one of the best examples of a hip-hop text that can be examined for the purpose of a culture critique is from Dead Prez's album *Let's Get Free* (2000). The CD includes numerous images on the cover, with a mission statement inside the cover that expresses an ideological critique of neoliberalism. Although they have some of the most powerful critiques of racism and capitalism in urban society, I've made personal decisions to edit and present nondefamatory versions of Dead Prez's lyrics in some of their songs for the purpose of class discussion. I normally don't edit or censor lyrics just because of the profanity involved. After all, how language is expressed also gives insight into the anger and resentment involved when oppressed communities combat racial, economic, social, and political disenfranchisement. However, some artists use language at certain moments, particularly of the sexually exploitative nature, for the mere purpose of shock value. In my humble opinion, although I'm sure others may argue differently, these lyrics add nothing to the political discourse of an artist's overall message. These matters notwithstanding, I have used Dead Prez's lyrics in songs such as "They Schools." This track talks about powerful everyday lived experiences of urban youth in the postindustrial city, how the educational system is disconnected from these realities, the ways in which the institution of schooling functions as a disciplinary apparatus on Black students, and at the same time voids incorporating knowledge for critical citizenship, empowerment, social change, and transformation of their communities. Keep in mind, Dead Prez is a group widely considered of the socially and politically conscious discursive genre in hip-hop culture, who draw from the critical traditions of artists such as Public Enemy and KRS-One. In order to get students to critically think about social justice issues in urban education, I have had students do a culture critique and textual analysis of Dead Prez's socially/politically conscious lyrics to the song "They Schools." Students were to answer the following questions: What is the author's/artist's philosophical orientation and ideological critique of schools? In what ways are youths' sense of agency being affected by the particular power relations between youth and schools? Identify and explain the specific discourse used by the artist and its relationship to their philosophical orientation

about education and schooling. How do they discuss issues of identity and difference in relationship to their experiences in schools? Given the context of the lyrics, how would you define the meaning and role of hip-hop for urban youth? Why? Subsequently, having students give a cultural critique of critical hip-hop texts provided them with important insights into the predispositions, attitudes, and overall sense of alienation that many youth experience in school systems, and the larger social, political, racial, and economic factors that have displaced them in urban society.

As a public intellectual, Cornel West has made great strides to connect life in the academy to the democratic energies of socially and politically conscious artists of hip-hop culture. In 2007, he gathered several artists (e.g., Talib Kweli, M1 of Dead Prez, KRS-One, Rhmefest, Malik Yusef) within this genre to create a CD entitled *Never Forget: A Journey of Revelations*. In contrast to market-driven commercial discourses of hip-hop, West designed a pedagogy of this text to speak to a range of social justice issues that are pertinent and relevant to working-class and urban communities. The pedagogy and curriculum of the cd intentionally and necessarily makes the textual bridge between the institution of slavery up until the present moment. For example, there is a visual image and rare photograph of captured slaves being taken aboard the Dutch HMS *Daphie* in 1868, which is a period in time when slavery was "legally" abolished. However, the photo of gaunt faces and bodies the size of skeletons, cramped on a ship, reveals it was still being practiced in certain places. In terms of the narrative structure of lyrical production, West situates America as the great imperial empire, and the artists on each track speak to issues such as the racial politics and aftermath of 9/11, the disproportionate incarceration of Black and Brown peoples within the prison industrial complex, ideological critiques of the Bush administration at that time, etc. The visual images on the inside cover of the CD also communicate these messages. In addition, West further makes the audience aware of his intent to produce what he calls a "danceable" education between the academy and the streets when he displays a picture of him giving a lecture, with the word *paideia* (a Greek word that means "education") inscribed on the chalkboard. Given the image of him teaching about paideia as a democratic practice in the academy is

situated and placed within the context of a rap CD, West is implicitly suggesting the artists themselves, as organic intellectuals, are speaking frank truths in matters of social justice through their lyrics, and that there is much we can learn from these teachers of the street. He is intentionally blurring the lines between the public pedagogy of hip-hop and academic teaching in the academy to reinforce the idea that education is about democracy for all citizens. I went over the visual images of this particular CD with the students to help them think about how images are produced and shaped within social, political, economic, and racialized contexts.

I have also had students read the narrative images of Hurricane Katrina through the YouTube video of Lil Wayne's song "Tie My Hands." While we listen to the lyrics students can see visual images of dead bodies floating in flooded streets, the urban displacement of concentrated ghetto communities, the dismantling of homes, and the late response of the Bush administration. The discursive event in Hurricane Katrina enabled us to discuss the political implications between race, class, and social inequality in U.S. society. In this instance, students read semiotic, multi-semiotic, and linguistic texts about the discursive events of Hurricane Katrina as educational narratives that speak to the broader racial, social, political, and economic implications between the nation-state and the urban populace of New Orleans. These texts reveal how the local event signified larger social and political neglect of urban, Black working-class communities in U.S society. I often place these texts within the contexts of social and political neglect of local urban public schools across inner-city communities in the United States. It is through these narrative texts where students can unearth deeper meanings about social injustice in urban local communities within U.S. contexts in relationship to deeper discussions about democracy and education.

Education happens not only in classrooms, but in the streets. In my class on hip-hop, I feel it is important to come up with educational projects that enable my students to connect with the local origins of the culture in urban communities. As hip-hop becomes popular in the academy, we must be careful not to divorce ourselves from local artists who are a part of a legacy of local citizens who practice the art (e.g., deejay, emcee, graffiti, b-boy/b-girl) to express the cares and

concerns of local urban communities from urban working-class conditions. As in the larger politics of corporate America, there is the potential for higher education institutions to become gatekeepers of the art, commodifying and exploiting the culture of hip-hop without regard to collaborative efforts between the academy and the community. These communities in hip-hop, which we are now studying in the academy, have obviously given America so much to think about, particularly in matters of social justice and democracy. Otherwise, we would not be studying hip-hop in several academic disciplines (e.g., English, sociology, education, Africana/Black world studies, linguistics, urban studies) across some of the nation's most elite universities as mentioned earlier. Subsequently, I am very much wedded to the idea of connecting the academy to the streets and the streets to the academy. In doing so, I frequently invite hip-hop artists from the local community to share some of their work with my classes. They don't just share their work, but I arrange class discussion in a way that they are seen as teachers and knowledge brokers, and are asked questions from the students themselves about the mission and purpose of their work in hip-hop culture. The hip-hop artists and poets I have invited are committed to prophetic discourses in hip-hop, raising critical questions to the nation-state, exposing its lies and contradictions to the meaning of democracy, and institutional forms of corruption to the soul of young people and America as a whole. These are youth and young adults who see a larger political purpose in the meaning and message of their work. They are not seeking fame and wealth in the market-driven discourses of the hip-hop industry. It is out of their moral desire to speak truth to power about the conditions of social injustice in their communities, how young people are suffering under the weight of oppression, and seek social transformation in the mind, body, and soul of urban youth, as well as the soul of America as a whole. They are teachers and organic intellectuals of the streets, often sharing a set of tragic and painful experiences that young people go through, the conflicted choices they make, and how they might redirect their life paths. Their audiences have typically been urban youth who may have committed violent crimes or drug-related offenses, and have been in and out of the criminal justice system. As with the young people in my study, many of the audiences to which

they present their work are on the verge of dropping out of high school. These students have families who have suffered drug addiction, siblings or relatives who have been gunned down in the streets, and many see hustlin' as the only option to survive. Subsequently, when artists present this work to my classes, students gain some perspective into the everyday lived realities or representations of urban youth, which may reflect similar narratives of the most vulnerable students they might potentially work with urban school districts. I want to reemphasize the point that I do not just invite any hip-hop artist or poet to my classes. I take the culture of hip-hop seriously enough that I understand that not all rap music is the same. Neither can we assume that artists who produce different discourses in hip-hop have the same motivations in the performance of their work. As discussed throughout this book, there are different discourses in hip-hop that communicate different representations within different sociocultural contexts of youth culture. I have studied and have been a part of cultivating democratic spaces for young people in urban communities where socially and politically conscious discourses are valued and respected, and shaping a critical intellectual environment the cultural work of hip-hop deserves. Subsequently, the youth and young adults I work with are gifted individuals who have spent years designing culturally relevant curricula and pedagogies for the audiences they serve in urban public life. There is a moral and political purpose behind the work they perform with young people that is about social transformation, democracy, and social justice.

I not only invite hip-hop artists to the academy, but I invite the academy to the streets of hip-hop. In our cultural studies and public life thematic sequence, we call this assignment an activist event, observation, and write-up. I have students attend a particular event in a local community where the cultural practice of hip-hop is being performed by young people. It is their job to observe the participants and attendees of the event. They are prodded to ask questions such as, What type of fashion is being worn by young people at the event? What do the cultural, symbolic texts on their clothes represent in the meaning of their production? What is the overall purpose or motivation in attending this particular event in the community? What messages are being communicated by young people that suggest

some overarching theme into the issues they are concerned about? Some hip-hop events may be more political in nature, and represent activities that are more socially and politically conscious in the production of their work. This was the case when students had the rare opportunity of seeing the Watts-Prophets perform, who happened to be in the area at the same time my class was in session. The Watts-Prophets are considered as the "Last Poets" of the West Coast rap/spoken word movement. Last Poets and the Watts-Prophets are both seen as pioneers of rap music, particularly the social and political form during the 1960s. In other cases, students attended hip-hop concerts, which represented more of gangsta/market-driven discourses in hip-hop. These events were also observed and critiqued, with different messages, meanings, and purposes represented in the life of young people. Again, students might ask questions about the representations of symbolic texts at the event. What messages are being communicated in the music? What is attractive about gangsta rap that says something about teenage rebellion? What are some of the implicit and explicit purposes for which attendees are gathering for these particular events? When students attend any hip-hop event, they must analyze the occasion within its sociocultural context. When my class attends different types of events, it allows for greater diversity of discussion that brings to light the fact that hip-hop is not monolithic or confined to a fixed worldview.

I also have students do a short interview with a person connected to hip-hop culture. Basic questions include, What does hip-hop mean to you? Why did you get involved with the culture? If it's related to rap (the emcee element), what is the motivation in performing the kind of lyrics you do in the songs you create? If it's related to the dance element (b-boy/b-girl), what do you want communicated to the audience in the movement of your routines? If it's related to graffiti, what does the public marking of your graphics represent to you as an artist? If it's related to the deejay, why is it important to "move" the crowd, and what is the audience looking for in the timing and selection of particular songs? In terms of critical reflection, are there any connections with responses to these questions in relationship to the social, political, ideological, economic, and racialized contexts that shape the production of different discourses in hip-hop? These are

beginning questions to get the students started in their interviews, and serve as examples of the kinds of questions I am looking for them to ask as they seek to better understand hip-hop in more critical ways as a youth subculture.

I also have had students do some form of creative expression project. It is an opportunity for students to draw upon the creative energy that embodies the soul of hip-hop. The point here is that part of understanding a youth subculture is to in some way engage or participate in that subculture. For example, I have had one student, to my surprise, who was a hip-hop artist, and he decided to develop an entire CD as part of his creative expression project. Other students have developed collages that give visual representations of the different discourses produced in hip-hop. We are enabled to see how images themselves produce different discourses and messages within and between socially/politically conscious discourses, gangsta discourses, and market-driven discourses in the hip-hop industry. There were other students who gave powerful PowerPoint presentations, which displayed visual images in hip-hop, related to a particular theme of injustice, that went along with their own self-produced poem to tell a story about the attitudes and perspectives of urban youth within the genre of social and political discourses. All students who present visual or auditory presentations also turn in a written paper to give the audience some context in the cultural production of their work. In the future, I could also see the potential of students developing blogs and websites that reflect different representations of youth identity in hip-hop culture.

In the culminating project, students may incorporate various aspects of prior research they have conducted with respect to their culture critique, activist observation, interviews, and creative expression papers/projects. The culminating paper must, in some way, shape, or form, draw upon the historical, ideological, economic, political, and racialized sociocultural contexts that shape different youth identity formations and meanings in hip-hop. The paper should also connect the subculture of hip-hop and youth identity to the larger project of democracy and social justice. The majority of the students are education majors, so it is my expectation they take what they have learned about urban youth in hip-hop and apply it to certain aspects of

pedagogy or educational leadership more broadly. However, I have had other students who were social workers, and so they applied what they learned in the course to help them think about the attitudes and perspectives of youth in relationship to badly needed social services and disrupted cohesiveness of the family structure that are reflected in the lyrics of rap music. I also encourage the students to think about their own experiences with hip-hop when they grew up, and ask themselves how and why they related to the culture, if at all. If they did not relate to the culture in any meaningful way, what was different about their own cultural context that gives explanation to their discon- nectedness in critically engaging with the culture? How do they see the culture now, given the course's expectations in taking the study of hip- hop as a serious scholarly endeavor? What perceptions did they have about hip-hop and urban youth identity prior to taking the class, versus their perceptions now? How do theory and course concepts in hip-hop help them think about their understanding of the challenge and poten- tial of youth identity in urban communities? Students are expected to respond to these questions of critical reflection throughout the culmi- nating project/paper.

I have also hosted live hip-hop lectures, workshop demonstra- tions, and performances that connected the university with public school districts and local communities. For example, I had the opportunity of writing a grant that invited public school districts, across a five-county region, to the university setting to learn about the culture of hip-hop broadly, and the b-boy/b-girl element more specifically. The grant was written as a part of a two-day, perform- ing arts residency. Professional hip-hop artists were invited to the university to perform live demonstrations of turntablism (e.g., the deejay element of scratching on a record), emceeing, beat-boxing (e.g., vocal instrumentation of a beat), B-boying, and various styles of hip-hop dance to accompany lectures from the artists themselves. Persons in attendance also gained an appreciation of the costumes, lighting, instrumentation of music, choreography, and the overall production of dance-theater performance not typically associated with or respected and recognized in hip-hop culture. The events attracted cultural studies in education and African American history scholars, traditional dance studios, church communities, community

centers, recreation centers, youth organizations, professional dance organizations, colleges and universities in surrounding areas, music departments, musicians, poets, local hip-hop artists, theater enthusiasts, fine arts communities, and the general public. Audience members had an opportunity to join in and participate with the artists during the main performance, which featured the b-boy/b-girl, deejay elements. The workshops included curriculum packets, which gave participants an overview of hip-hop as an art form, which includes information about the four basic elements of hip-hop. These education packets, sent to the community, also provided the purposes of workshops and main performances by the artists, which were to educate the larger public on the creative expression of hip-hop, which was for these artists, orchestrated primarily through dance, or the b-boy/b-girl element of hip-hop. These artists educated the broader public about hip-hop as a form of dance theater. The audience came away with an understanding of the historical context of performing the b-boy/b-girl element in hip-hop, and the creative, artistic expression of hip-hop culture, more broadly.

I also set up dialogue sessions for the community to learn about the motivation and life experiences of the hip-hop artists who were performing in the residency. What was particularly interesting for me was hearing how most of the artists, who came from different ethnic backgrounds, had expressed gratitude for being able to perform and express themselves in front of a public audience. Many of them stated that if they did not have the opportunity for performing and making a living by being in the group that they would be on the streets. I immediately thought about the young people I worked with at the community center, who made similar statements to me. There is something about this culture, if constructed in a positive and prophetic way, that gives young people hope and opportunity in a society that has rejected them. As we move forward in the 21st century, the pedagogy and culture of hip-hop must be considered as a vital democratic space, where new teaching and learning strategies can be deployed to tap into their creative energies and intelligence.

Conclusion

What is evident in this chapter is that the teaching and study of hip-hop are not reducible to what you hear on the most popular radio stations, or dictated by what we see on popular, cultural, television programs. That is, this is a discussion that moves us beyond beats, rhymes, and lyrics, and helps us think about hip-hop as a critical, culturally relevant form of pedagogy in urban education. Critical and relevant pedagogies in hip-hop are ultimately concerned with matters of social justice in urban education. It is about understanding how urban youth in hip-hop make sense of asymmetrical relations of power in society through the culture. Reading and interpreting urban youths' social and political narratives in hip-hop can create new pedagogical conditions by which pre-service teachers develop new critical knowledge of how urban youth make sense of power, culture, and ideology in urban society through youths' production of critical and relevant hip-hop texts. As pre-service teachers engage in hip-hop as a culturally relevant form of pedagogy, they gain critical awareness of how students understand their social world, how teaching and learning can connect to this new knowledge, and how they might go about everyday social interaction with these students. While this chapter discusses some of the pedagogical possibilities in teaching hip-hop in pre-service teacher education programs, it should not be seen as a prescription for how to go about teaching such a course. What is presented here should be seen as a reflexive, working model to help us move the conversation forward in what may be possible in 21st-century, urban, pre-service teacher education programs. If we are going to teach and prepare the next generation of educators and administrators who will work with students of color in urban public schools settings, we must give them the tools to socially read, interpret, and make sense of the most significant form of popular culture that impacts youths' reflections and representations of urban life, hip-hop.

It is my hope that this text will help teacher educators and pre-service teachers in teacher education programs understand how to read hip-hop as an art, cultural practice, and way of life for urban youth to advance larger democratic conversations about youths' everyday lived experiences in urban public schools and the larger society. This discus-

sion builds upon existing literature in the fields of cultural studies, popular culture, and critical pedagogies which suggest that youth are increasingly negotiating their own notions of self and identity through popular culture that contrast with technical efficiency models in education and schooling. The traditional culture of schools has become far removed from the everyday lived experiences and identity affirmation of youth in popular culture. As a result, unofficial curricula, such as rap music and hip-hop culture, have taken on increasing salience for youth, and urban Black youth in particular (Dimitriadis, 2001; Prier & Beachum, 2008). This work is a part of a growing body of scholarship and research that is looking at nontraditional curricula and pedagogical approaches in education and schooling that can assist with advancing more progressive, critical thinking about how knowledge is produced through the arts, how it shapes the identity of young people, and what this means in how public institutions of education might go about shaping different learning experiences between youth, popular culture, schools, and the communities that surround them. I have found that popular culture, and hip-hop in particular, provides students with innovative and culturally relevant ways in helping them understand larger ideas and concepts related to social justice, identity, difference, race, class, and gender. This is particularly true when I have applied a cultural studies approach to social foundations of education in pre-service teacher education courses I have taught. It is my contention that if the culture of hip-hop is approached in a serious and critical manner, it can be an innovative and relevant way of helping students understand complex theoretical ideas between philosophy, theory, culture, and practice in education and schooling. The teaching methods and practices discussed here aim to mobilize new discourses that will facilitate better interactions between students and teachers in classrooms. This work also seeks to explore how the study of hip-hop in pre-service, teacher education programs might contribute to reshaping curricular and pedagogical models in urban teacher education programs. Furthermore, it is my hope this work will also contribute to educational scholarship and research that advance discussions related to issues of power, culture, and schooling to further extend the progressive and transformative agenda of a more democratic education.

Glossary of Hip-Hop Terms

B-boy/b-girl The dance element in hip-hop. This cultural practice draws from multiple influences, which include, but are not limited to, martial arts movies, capoeira, and James Brown.

Deejay Cultural practices of the deejay require the scratching (manual rewinding) of vinyl records on two turntables, mixed to a repetitive break beat in rap music.

Discourse refers to different modes of communication (e.g., rituals, language, images, symbols) that are produced and circulated within and between different networks of communities and institutions such as media, government, schools, and hip-hop. Sociopolitical, gangsta, and commercial discourses refer to the different modes of communication in hip-hop deployed by youth, given particular social, political, economic, and racialized contexts. The different modes of communication deployed by young people, whether perceived as positive or negative, are constructed and shaped in response to the material conditions reflected in their communities. (See Table 1 in chapter 2 for more explanation of each discourse.)

Freestyle Improvisational style of rapping that requires the delivery of unrehearsed rhymes in a comprehensible, syntax structure.

Graffiti The artistic marking and name recognition on public space. Sidewalks, buildings, and trains are but of a few of the texts that are marked to display this recognition.

Hip-hop culture, broadly, is an urban youth culture defined as a way of life for youth and young adults. It encompasses rap music (the act of rhyming over a break beat), the production of cultural practices (e.g., DJ, emcee, b-boy/b-girl, graffiti), and urban-influenced forms of popular culture (e.g., fashion, film, sports, magazines, music videos, movies). Historically, it was an urban youth subculture that emerged out of deindustrialization and urban working-class struggle on the

heels of the latter part of the Civil Rights Movement in the late 1960s, early '70s. The lifestyle, message, meanings, and representation of the music and culture have largely been shaped in response to socioeconomic conditions of the urban community.

Hip-hop industry refers to the political economy of the market-driven culture of hip-hop. While the industry of hip-hop cannot be separated from the culture of hip-hop, as an institution, its motives and interests are driven primarily by the market of corporate culture. In this regard, the local origins of the culture, emerging from urban working-class struggle, are commodified and exploited into the motivations and interests of the hip-hop industry, which has become a multibillion dollar enterprise. The institutions of the hip-hop industry include, but are not limited to, music, movies, fashion, film, advertising and marketing of products, and video games.

Rap is the art of rhyming (similar to poetry but different in syntactical structure) over a break beat in hip-hop music.

Text Any object in the public sphere of society that can produce meaning. This can include, but is not limited to, music (e.g., rap lyrics), buildings, images, media, television, clothes, policy documents, and photos. The type of objects usually include semiotic (visual), linguistic (written), and oral (speeches) texts.

References

Anderson, E. (1994). The code of the streets. *The Atlantic Monthly, 24,* 81–94.

Anderson, E. (2008). Against the wall: Poor, young, Black, and male. In E. Anderson (Ed.), *Against the wall: Poor, young, Black, and male* (pp. 3–27). Philadelphia: University of Pennsylvania Press.

Apple, M. W. (1996). *Cultural politics and education.* New York: Teachers College Press.

Apple, M. W. (2001). Comparing neo-liberal projects and inequality in education. *Comparative Education, 37*(4), 409–423.

Apple, M. W. (2004). *Ideology and curriculum.* New York: Routledge.

Baszile, D. T. (2009). Deal with it we must: Education, social justice, and the curriculum of hip hop culture. *Equity and Excellence in Education, 42*(1), 6–19.

Bynoe, Y. (2004). *Stand & deliver: Political activism, leadership, and hip-hop culture.* Brooklyn, NY: Soft Skull Press.

Castro, A. (2010, March 12). Texas education board approves conservative curriculum changes by far-right. Retrieved from http://www.huffingtonpost.com/2010/03/12/texas-education-board-app_n_497440.html

Carlson, D. L. (2005). Hope without illusion: Telling the story of democratic educational renewal. *International Journal of Qualitative Studies in Education, 18*(1), 21–45.

Carlson, D. L., & Apple, M. (1998). *Power/knowledge/pedagogy: The meaning of democratic education in unsettling times.* Boulder, CO: Westview Press.

Carlson, D. L., & Dimitriadis, G. (2003). Introduction. In D. Carlson & G. Dimitriadis (Eds.), *Promises to keep: Cultural studies, democratic education, and public life* (pp. 1–35). New York: RoutledgeFalmer.

Chang, J. (2005). *Can't stop won't stop: A history of the hip-hop generation.* New York: St. Martin's Press.

Collins, P. H. (2004). *Black sexual politics.* New York: Routledge.

Dance, L. J. (2002). *Tough fronts.* New York: RoutledgeFalmer.

Dantley, M. (2005). African-American spirituality and Cornel West's notions of prophetic pragmatism: Restructuring educational leadership in American urban schools. *Educational Administration Quarterly, 41*(4), 651–674.

Davey, B., & McEveety, S. (Producers), & Reynolds, K. (Director). (2000). *187* [Motion picture]. United States: Warner Bros.

Davis, A. (2003). *Are prisons obsolete?* New York: Seven Stories Press.

Davis, M., & Clark, H. R. (1992). *Thurgood Marshall warrior at the bar, rebel on the bench.* New York: Birch Lane Press.

Day, B. (1974). *Sexual life between Blacks and whites: The roots of racism.* New York: Thomas Y. Crowell.

Dead Prez. (2000). They schools. On *Let's get free* [http://www.ohhla.com/anonymous/deadprez/get_free/tschools.prz.txt]. Retrieved February 19, 2008, from http://www.ohhla.com/all.html.

Debord, G. (1983). *Society of the spectacle.* Detroit, MI: Black and Red Press.

Delgado, R., & Stefancic, J. (2001). *Critical race theory: An introduction.* New York: New York University Press.

Dimitriadis, G. (2001). (Rev. ed. 2009). *Performing identity/performing culture: Hip-Hop as text, pedagogy, and lived practice.* New York: Peter Lang.

Dolby, N. (2003). Popular culture and democratic practice. *Harvard Educational Review, 73*(3), 258-284.

Dr. Dre. (1992). Lil ghetto boy. On *The Chronic* [http://www.ohhla.com/anonymous/dr_dre/chronic/geto_boy.dre.txt]. Retrieved December 18, 2008, from http://www.ohhla.com/all.html

Duncan-Andrade, J., & Morrell, E. (2008). *The art of critical pedagogy: Possibilities for moving from theory to practice in urban schools.* New York: Peter Lang.

Dyson, M. E. (2001). *Holler if you hear me: Searching for Tupac Shakur.* New York: Basic Civitas Books.

Dyson, M. E. (2004). *The Michael Eric Dyson reader.* New York: Basic Civitas Books.

Dyson, M. E. (2007). *Know what I mean? Reflections on hip-hop.* New York: Basic Civitas Books.

Epstein, J. S. (1998). *Youth culture: Identity in a postmodern world.* Malden, MA: Blackwell.

Ferguson, A. (2003). *Bad boys: Public schools in the making of Black masculinity.* Ann Arbor: University of Michigan Press.

Ford, G. (2003, May). *Who killed Black radio news?.* Retrieved from http://www.blackagendareport.com/content/who-killed-black-radio-news

Ford, R. (2006). G'ology. *The Source, 200,* 78–85.

Forman, M., & Neal, M. A. (Eds.). (2004). *That's the joint! The hip-hop studies reader.* New York: Routledge.

Fraser, N. (1991). Rethinking the public sphere: A contribution to the critique of actually existing democracy. In *Social Text* (pp. 56–80). Durham, NC: Duke University Press.

Freedman, D. (2003). "They need someone to show them discipline": Preservice teachers' understandings and expectations of student (re)presentations in dangerous minds. In D. Carlson & G. Dimitriadis (Eds.), *Promises to keep: Cultural studies, democratic education, and public life* (pp. 245–261). New York: Continuum.

Freire, P. (1998). *Pedagogy of freedom: Ethics, democracy, and civic courage.* New York: Rowman & Littlefield.

Freire, P. (2004). *Pedagogy of the oppressed.* New York: Continuum.

Gates, H. (2004). *America behind the color line.* New York: Warner Books.

Gause, C. P. (2001). *How African American educators "make sense" of hip-hop culture and its influence on public schools: A case study.* Unpublished dissertation, Miami University, Oxford, OH.

Giroux, H. (1983). *Theory and resistance in education: A pedagogy for the opposition.* South Hadley, MA: Bergin & Garvey.

Giroux, H., (1996). *Fugitive cultures: Race, violence, and youth.* New York: Routledge.

Giroux, H. A. (2003). Spectacles of race and pedagogies of denial: Anti-Black racist pedagogy under the reign of neoliberalism. *Communication Education, 52*(3/4), 191–211.

Giroux, H. A. (2004, February). Class casualties: Disappearing youth in the age of George W. Bush. *Workplace: A Journal of Academic Labor,* 6(1). Retrieved November 4, 2006, from

http://www.cust.educ.ubc.ca/workplace/issue6p1/giroux04.html.

Giroux, H. A. (2004, August). Neoliberalism and the demise of democracy: Resurrecting hope in dark times. *Dissident Voice.* Retrieved June 23, 2008, from http://www.dissidentvoice.org/Aug04/Giroux0807.htm.

Giroux, H. A. (2006a). *Academic entrepreneurs: The corporate takeover of higher education.*

Giroux, H. A. (2006b). *America on the edge: Henry Giroux on politics, culture, and education.* New York: Palgrave Macmillan.

Goodman, A. (2008, June). LA school teacher fired for being too "Afrocentric"; Arizona bill proposes to prohibit teachings critical of western civilization. Retrieved from http://www.democracynow.org/2008/6/18/la_school_teacher_fired_for_being

Gordon, L. (1997). *Her majesty's other children: Sketches of racism from a neocolonial age.* New York: Rowman & Littlefield

Gordon, L. (2000). *Existentia Africana: Understanding Africana existential thought.* New York: Routledge.

Hayes, K. (2007). Appreciating the landscape that urban youth of color must navigate to become effective social actors in our civil society. In J. Kincheloe & K. Hayes (Eds.), *Teaching city kids: Understanding and appreciating them* (pp. 193–207). New York: Peter Lang.

Haymes, S. (1995). *Race, culture, and the city: A pedagogy for Black urban struggle.* Albany: State University of New York Press.

Hebdidge, D. (1997). Subculture: The meaning of style [1979]. In K. Gelder (Ed.), *The subcultures reader* (pp. 130–144). New York: Routledge.

Hill, M.L. (2009). Wounded healing: Forming a storytelling community in hip-hop lit. *Teachers College Record,* 111(1), 248-293.

hooks, b. (1990). *Yearning: Race, gender, and cultural politics.* Boston: South End Press.

hooks, b. (1992). *Black looks: Race and representation.* Boston: South End Press.

hooks, b. (2004). *We real cool: Black men and masculinity.* New York: Routledge.

Ibrahim, A. (2003). Marking the unmarked: Hip-Hop, the gaze and the African body in North America. *Critical Arts: A South-North Journal of Cultural and Media Studies, 17*(1/2), 52–70.

Ice-T. (1990). New Jack hustler [http://apps.facebook.com/ lyricsdomain/artist/icet/song/new_jack_hustler]. Retrieved October 30, 2008.

Jackson, R. (2006). *Scripting the Black masculine body: Identity, discourse, and racial politics in popular media.* Albany: State University of New York Press.

Johnson, T., Boydon, J. E., & Pittz, W. J. (Eds.). (2001). *Racial profiling and punishment in U.S. public schools: How zero tolerance policies and high stakes testing subvert academic excellence and racial equity.* Oakland, CA: Bridging the Gap between Analysis and Action Applied Research Center.

Kelley, R. D. G. (1996). *Race rebels: Culture, politics, and the Black working class.* New York: The Free Press.

Kelley, R. D. G. (1997). *Yo' mama's disfunkional! Fighting the culture wars in urban America.* Boston: Beacon Press.

Kellner, D., & Share, J. (2007). Critical media literacy, democracy, and the reconstruction of education. In D. Macedo & S. Steinberg (Eds.), *Media literacy: A reader* (pp. 3-23). New York: Peter Lang.

Kharem, H. (2006). *A curriculum of repression: A pedagogy of racial history in the United States.* New York: Peter Lang.

Kincheloe, J. (2007). City kids: Not the kind of students you'd want to teach. In J. Kincheloe & S. Steinberg (Eds.), *Studies in the postmodern theory of education: Vol. 306. Teaching city kids: Understanding and appreciating them* (pp. 3–38). New York: Peter Lang.

King, C. R. (2007). Reading race, reading power. In D. Macedo & S. Steinberg (Eds.), *Media literacy: A reader* (pp. 197–205). New York: Peter Lang.

Kitwana, B. (1994). *The rap on gangsta rap: Who run it? Gangsta rap and visions of Black violence.* Chicago: Third World Press.

Kitwana, B. (2002). *The hip-hop generation: Young Blacks and the crisis in African-American culture.* New York: Basic Civitas Books.

Ladson-Billings, G. (1999). Just what is critical race theory, and what's it doing in a nice field like education? In L. Parker, D. Deyhle, & S. Villenas (Eds.), *Race is...race isn't*. Boulder, CO: Westview Press.

Ladson-Billings, G., & Donner, J. (2005). The moral activist role of critical race theory scholarship. In N. Denzin & Y. Lincoln (Eds.), *Handbook of qualitative research* (pp. 279–301). Thousand Oaks, CA: Sage.

Lamont Hill, M. (2010). Critical pedagogy comes at halftime. In Dyson, M., & Daulatzai (Eds.). *Born to use mics* (pp. 97-114). New York: Basic Civitas Books.

Leonardo, Z. (2007). The war on schools: NCLB, nation creation and the educational construction of whiteness. *Race Ethnicity and Education, 10*(3), 261-278.

Light, A. (1998). *Tupac Shakur*. New York: Three Rivers Press.

Lipman, P. (2004). *High stakes education: Inequality, globalization, and urban school reform*. New York: RoutledgeFalmer.

MacLeod, J. (1987). *Ain't no makin' it: Aspirations and attainment in a low-income neighborhood*. Boulder, CO: Westview Press.

Mahiri, M. (2005). *What they don't learn in school*. New York: Peter Lang.

Mallott, C., & Porfilio, B. (2007). Punk rock, hip-hop, and the politics of human resistance: Reconstituting the social studies through critical media literacy. In D. Macedo & S. Steinberg (Eds.), *Media literacy: A reader* (pp. 582–592). New York: Peter Lang.

Mandel, R. (Director), & Frumkes, R., & Simonelli, R. (Writers). (1996). *The substitute* [Motion picture]. United States: Orion Pictures/Live Entertainment.

Marable, M. (1994). The Black male: Searching beyond stereotypes. In R. Majors & J. Gordon (Eds.), *The American Black male: His status and his future* (pp. 69–77). Chicago: Nelson-Hall.

Marable, M. (2002). *The great wells of democracy: The meaning of race in American life*. New York: Basic Civitas Books.

Matthews, A. (2006). Self destruction. *The Source, 201*, 62–68.

McNeil, L., & Valenzuela, A. (2001). The harmful impact of the TAAS system of testing in Texas: Beneath the accountability rhetoric. In G. Orfield & M. L. Kornhaber (Eds.), *Raising standards or raising*

barriers: Inequality and high-stakes testing in public education. New York: A Century Foundation Book.

McPhail, M. (1994). The politics of complicity: Second thoughts about the social construction of racial equality. *Quarterly Journal of Speech, 80,* 343–357.

McPhail, M. (1996). *Zen in the art of rhetoric: An inquiry into coherence.* Albany: State University of New York Press.

Murtadha-Watts, K. (2000). Theorizing urban Black masculinity construction in an African-centered school. In N. Lesko (Ed.), *Masculinities at school* (pp. 49–71). London: Sage.

Nicolaides, S. (Producer), & Singleton, J. (Writer/Director). (1991). *Boyz in the hood* [Motion picture]. United States: Columbia Pictures.

Noddings, N. (1988). An ethic of care and its implications for instructional arrangements. *American Journal of Education, 96,* 2, (215-230).

Noguera, P. (2008). *The trouble with Black boys: And other reflections on race, equity, and the future of public education.* San Francisco: Jossey-Bass.

Noguera, P. (2005). The trouble with Black boys: The role and influence of environmental and cultural factors on the academic performance of African-American males. In O. Fashola (Ed.), *Educating African-American males: Voices from the field* (pp. 51–78). Thousand Oaks, CA: Corwin.

N.W.A. (1989). Fuck tha police. On *Straight Outta Compton* [http://www.ohhla.com/anonymous/nwa/straight/fuck_tha.n wa.txt]. Retrieved October 30, 2008, from http://www.ohhla.com/all.html

Ohio Department of Education: Teacher counts. Retrieved August 7, 2009, from http://ilrc.ode.state.oh.us/PublicDW/asp/Main.aspx.

Parmar, P., & Bain, B. (2007). Spoken word and hip-hop: The power of urban art and culture. In J. Kincheloe & K. Hayes (Eds.), *Teaching city kids: Understanding and appreciating them* (pp. 131–156). New York: Peter Lang.

Perez, T. (2010, September). Remarks as prepared for delivery by assistant attorney general for civil rights Thomas E. Perez at the civil rights and school discipline: Addressing disparities to ensure

equal educational opportunities conference. Retrieved from http://www.justice.gov/crt/speeches/perez_eosconf_speech.php

Perry, I. (2008). Tell us how it feels to be a problem: Hip-hop longings and poor young Black men. In E. Anderson (Ed.), *Against the wall: Poor, young, Black, and male* (pp. 165–177). Philadelphia: University of Pennsylvania Press.

Perry, T., Steele, C., & Hilliard, A. (2003). *Young, gifted, and Black: Promoting high achievement among African-American students.* Boston: Beacon Press Books.

Powell, K. (2003). *Who's gonna take the weight? Manhood, race, and power in America.* New York: Three Rivers Press.

Prier, D. D. (2006). A relevant Black male curriculum. *Encounter: Education for Meaning and Social Justice, 19*(3), 25–26.

Prier, D. D., & Beachum, F. D. (2008). Conceptualizing a critical discourse around hip-hop culture and Black male youth in educational scholarship and research. *International Journal of Qualitative Studies in Education, 21*(5), 519–535.

Public Enemy. (1988). *It takes a nation of millions to hold us back* [CD] New York: Def Jam Records.

Public Enemy. (1990). Fight the power. On *Fear of a black planet* [CD]. New York: Def Jam Records.

Quantz, R. A., Cambron-McCabe, N., & Dantley, M. (1991). Preparing school administrators for democratic authority: A critical approach to graduate education. *The Urban Review, 23*(1), 3–19.

Rose, T. (1994). *Black noise: Rap music and Black culture in contemporary America.* Middletown, CT: Wesleyan University Press.

Rose, T. (2008). *The hip hop wars: What we talk about when we talk about hip hop and why it matters.* Philadelphia: Basic Civitas Books.

Sanders, S. (January, 2010). Black teenage males crushed by unemployment. Retrieved from http://www.npr.org/templates/story/story.php?storyId=122367407

Scott, D. (Producer), & Hughes, A., & Hughes, A. (Writers/Directors). (1993). *Menace to society* [Motion picture]. United States: New Line Cinema.

Shakur, T. (1991). Trapped. On *2Pacalypse now* [CD]. New York: Interscope Records.

Shakur, T. (1999). *The rose that grew from concrete.* New York: MTV Books/Pocket Books.

Simmons, R. (2001). *Life and def: Sex, drugs, money, and God.* New York: Crown.

Sims, M. (2007, October). Hip-hop stars rally for Jena Six. Retrieved from http://www.usatoday.com/life/music/2007-10-04-1454160090_x.htm

Simpson, D., & Bruckheimer, J. (Producers), & Smith, J. (Director). (1995). *Dangerous minds* [Motion picture]. United States: Hollywood Pictures.

Snoop Dogg (1993). http://www.ohhla.com/anonymous/snoopdog/dogstyle/aintnf un.snp.txt. Retrieved, December 18, 2008, from http://www.ohhla.com/all.html

Spirer, P. (Director). (2003). *Beef* [Motion picture]. QD3 Entertainment.

Stop the Violence All Stars. (1989). Self destruction 12. On *Self destruction* [http://www.ohhla.com/anonymous/misc/hip-hop/self_des.stv.txt]. Retrieved October 30, 2008, from http://www.ohhla.com/all.html

Street, P. (2003). *Deep poverty, deep deception: Facts that matter beneath the imperial helicopters.* Paper presented at The Illinois Welfare Reform Symposium, June 17, 2003, Chicago, Illinois.

Watts, E. K. (2004). An exploration of spectacular consumption: Gangsta rap as cultural commodity. In M. Forman & M. Neal (Eds.), *That's the joint! The hip-hop studies reader* (pp. 593–609). New York: Routledge.

Weis, L. (1985). *Between two worlds: Black students in an urban community college.* London: Routledge.

Weis, L. (1990). *Working class without work: High school students in a de-industrialized economy.* New York: Routledge.

West, C. (1994). *Race matters.* New York: Vintage Books.

West, C. (1999). *The Cornel West reader.* New York: Civitas Books.

West, C. (2004). *Democracy matters: Winning the fight against imperialism.* New York: Penguin Press.

West, C. (2007). Bushonomics. On *Never forget: A journey of revelations* [CD]. Santa Monica, CA: Hidden Beach.

Wexler, P. (1992). *Becoming somebody: Toward a social psychology of school.* Washington, DC: Falmer Press.

Willis, P. (2003). Food soldiers of modernity: The dialectics of cultural consumption and the 21st-century school. *Harvard Educational Review, 73*(3), 390–415.

Wilson, W. J. (2008). The economic plight of inner-city Black males. In E. Anderson (Ed.), *Against the wall: Poor, young, Black, and male* (pp. 55–70). Philadelphia: University of Pennsylvania Press.

Wilson, W. J., Quane, J. M., & Rankin, B. H. (1998). The new urban poverty: Consequences of the economic and social decline of inner-city neighborhoods. In F. R. Harris & L. A. Curtis (Eds.), *Locked in the poorhouse: Cities, race, and poverty in the United States* (pp. 57–78). Lanham, MD: Rowman & Littlefield.

Zehr, M. (2010, October). Obama administration targets 'disparate impact' of discipline. Retrieved from http://www.edweek.org/ew/articles/2010/10/07/07disparate_ep.h30.html

Index

About the Author

Darius Prier is currently an assistant professor in the Department of Educational Foundations and Leadership in the School of Education at Duquesne University. He received his Ph.D. in Educational Leadership from Miami University, Oxford, Ohio. Much of Prier's research agenda focuses on the cultural intersections between youth, popular culture, and social justice education in schools and communities. Prier has taught courses in Sociocultural Studies in Education; School and Community Relations; Introduction to the Teaching Profession; Multicultural Education; Ethics, Education, and the Teaching Profession; Social Justice in Educational Settings; and Introduction to Doctoral Studies in Educational Leadership.

Studies in the Postmodern Theory of Education

General Editor
Shirley R. Steinberg

Counterpoints publishes the most compelling and imaginative books being written in education today. Grounded on the theoretical advances in criticalism, feminism, and postmodernism in the last two decades of the twentieth century, Counterpoints engages the meaning of these innovations in various forms of educational expression. Committed to the proposition that theoretical literature should be accessible to a variety of audiences, the series insists that its authors avoid esoteric and jargonistic languages that transform educational scholarship into an elite discourse for the initiated. Scholarly work matters only to the degree it affects consciousness and practice at multiple sites. Counterpoints' editorial policy is based on these principles and the ability of scholars to break new ground, to open new conversations, to go where educators have never gone before.

For additional information about this series or for the submission of manuscripts, please contact:

Shirley R. Steinberg
c/o Peter Lang Publishing, Inc.
29 Broadway, 18th floor
New York, New York 10006

To order other books in this series, please contact our Customer Service Department:

(800) 770-LANG (within the U.S.)
(212) 647-7706 (outside the U.S.)
(212) 647-7707 FAX

Or browse online by series:
www.peterlang.com